CANARY ISLANDERS
of
SAN ANTONIO

CANARY ISLANDERS
of
SAN ANTONIO

Edited by Hector Rafael Pacheco

THE
History
PRESS

Published by The History Press
Charleston, SC
www.historypress.com

Cover photo of plaza courtesy of Bexar County Archives, San Antonio, Texas.

First published 2018

Manufactured in the United States

ISBN 9781467138215

Library of Congress Control Number: 2018940090

Notice: The information in this book is true and complete to the best of our knowledge. It is offered without guarantee on the part of the authors or The History Press. The authors and The History Press disclaim all liability in connection with the use of this book.

CONTENTS

FOREWORD

Who were these people from the Canary Islands who accepted the invitation (royal orders) from King Philip V of Spain in 1729 to venture to the New World, which had already taken the name of Nueva España? We know these people were made up of at least four or five different cultures and had become a strong community of small islands off the west coast of Africa.

Early reports from explorers and, later, from the various priest houses in Mexico told of the fertile lands, moderate climates and plentiful water sources—all of which excited the people of Spain. The need for Spain to populate was due to French intrusions, leading the king to order more than four hundred families to go to the New World.

By this time, families from the Canary Islands were being considered and later accepted to make the long and dangerous journey (some even volunteered). Not much is known about the voyage across the Atlantic Ocean, and ships eventually landed on the shores of Cuba. From this point, the travelers made decisions about staying in Cuba, traveling to South America or journeying to Vera Cruz, Mexico. More is known about the small group of Canary Islanders, who numbered fewer than sixty.

Supported with food, tools, carts and livestock from one of the priest houses, Canary Islanders were also accompanied by priests and soldiers. Adhering to the royal orders, they eventually arrived in Nueva España. The rugged and dangerous travel lasted for one full year. Along the way, they experienced death, newborn life, marriages, illness and much discomfort

due to often unfavorable weather conditions. After a year, fifteen families arrived in San Antonio de Valero on March 9, 1731.

From these fifteen families, today we have and continue to enjoy what they contributed to the city of San Antonio, the county of Bexar and the great state of Texas. When talking to descendants about their ancestors, one can learn about how families selected their leadership, how they were instrumental in forming the first civil government (as ordered by the king) and how they laid out the plazas and built the first courthouse and the first church, known today as San Fernando Cathedral. Many of the stories have been handed down through generations, and there are those who still seek out early, original writings. Stories are often confirmed by documents found in the Bexar County Spanish Archives.

Yet not all is favorable. Researchers and historians who do not have any connections to the Canary Islanders might describe these people as somewhat selfish and arrogant. They perhaps will show how these families controlled the local government; took and occupied the better lands and ranchos; built the better structures like the church and the Casa Reales (courthouse), which borrowed help from the mission Indians; and, lastly and very importantly, controlled and had much authority over the water sources.

Nonetheless, the Canary Islanders were a committed people, always showing their allegiance to the king, the church, their culture and the Spanish laws regarding lands, water rights, ownership of property by women, branding of livestock and so much more.

As the reader progresses through the pages that follow, he or she will likely find colorful family stories and research from original source documentation that will paint the beautiful voyage, the travels and the contributions made by the Canary Islanders.

—ALFRED RODRIGUEZ
Former Archivist for Bexar County, Texas

Chapter 1

TEXAS SON

UNHERALDED PATRIOT

By Anthony Delgado

San Antonio and Texas lost a member of one of its oldest families 160 years ago—a son who fought in many of its struggles for independence and whose death would help bring to an end another struggle, the Cart Wars. This is the story of that man who lost his life that day, and it is based on facts found among the Bexar Archives, San Fernando church records, old newspapers and other historical documentation.

It was Saturday, September 12, 1857, at about 4:00 p.m. It was like many September afternoons—hot and humid. Tensions were high along the long, dusty Ox Cart road, which stretched more than 120 miles between San Antonio and the Gulf of Mexico, where freighters hauled goods to and from ships docked along the coast at Indianola. For several months, disgruntled Anglo freighters from areas around Karnes and Goliad Counties had frequently attacked Tejano and Mexican *carreteros*, or freighters, from San Antonio. These marauders wrecked carts and damaged goods, and on this particular Saturday, a group of masked men viciously attacked the Tejano *carreteros*, leaving four wounded and one murdered: Jose Antonio Delgado. Who was Jose Antonio Delgado? And why would this Tejano's murder garner the attention of Governor Elisha Pease?

THE FAMILY HISTORY

At the time of his death, Jose Antonio Delgado was sixty years old and a member of one of the oldest families in San Antonio. He was one of nine children born to Clemente Delgado and Maria Gertrudes Saucedo and only one of four who would survive childhood. He was the great-grandson of Juan Delgado, Catarina Leal, Vicente Álvarez Travieso and María Ana Curbelo, all Canary Islander families who established the first civilian community and government in San Antonio in 1731.

Undoubtedly, it was Jose Antonio's forefathers who inspired him to serve his community. His father, grandfathers and great-grandfathers were all government officials who served in many capacities, including as *primer alcalde*, *regidor* and *alguacil* mayor, as well as soldiers in the local militia. Their history in San Antonio began on March 9, 1731.

The Delgado family was one of several who traveled for a year and thousands of miles by sea and land from the Canary Islands at the request of King Philip V of Spain to create and settle the first civilian community, then called San Fernando de Béxar, in the Province of Texas. Among these fifty-six pioneering individuals were Jose Antonio Delgado's great-grandparents— Juan Delgado, Catarina Leal, Vicente Álvarez Travieso and María Ana Curbelo. Juan Delgado and Catarina Leal were just teenagers—nineteen and sixteen, respectively—when they married in Cuautitlán in September 1730 as they were traveling on foot from the port city of Veracruz to what we now know as San Antonio, Texas. Like Juan and Catarina, Jose Antonio's other great-grandparents, Vicente Álvarez Travieso and María Ana Curbelo, also married in Cuautitlán while journeying to their final destination.

One, of the many things the Spanish government did well in the colonial times was to record events and information. The Spanish Crown recorded and described in detail at Cuautitlán in November 1730 the names and physical attributes of the fifty-six members that composed the sixteen Canary Islands families. The Canary Islands Descendants Association website has descriptions of these families, providing some invaluable insight as to what these early Tejano pioneers looked like. Vicente Álvarez Travieso, listed as the head of the seventh family, is described as having "broad shoulders, round face, thin nose, light brown eyes, thick beard, fair complexion, [and] chestnut curled hair," while María Ana Curbelo is said to have also been "broad shouldered, [with] fair complexion, long face, light brown eyes, chestnut hair and eyebrows, thin nose." Both Vicente and Maria Ana were natives of the island of Lanzarote along with Juan Delgado and Catarina

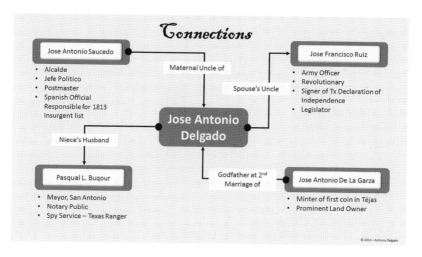

This is the family tree for Jose Antonio Delgado, as compiled by Anthony Delgado, his fourth-generation great-grandfather. *Courtesy of Anthony Delgado.*

Leal. Juan, the head of the twelfth family, is described as having a "good physique, broad shoulders, round face, dark complexion, meeting eyebrows, brown eyes, chestnut hair and eyebrows and the beard is beginning to show." Catarina Leal, listed as being only sixteen years old, was described as being "medium height, [with a] dark complexion, flat face, flat nose, lively brown eyes, black hair and eyebrows." Many of these traits continue to show up in the numerous descendants who still live in San Antonio, ten generations or more separated from their pioneering ancestors.

While all the ancestors are important in our family's collective story, two stories of Jose Antonio's ancestors stand out the most for me and likely influenced Jose Antonio—that of his great-grandfather Vicente Álvarez Travieso and father, Clemente Delgado.

Vicente Álvarez Travieso was a lifelong servant to his community and one of the most litigious among his peers. In August 1731, the first municipal government was established in Texas, where Vicente was appointed as *alguacil* mayor. In this capacity, he served as the chief constable responsible for law and order within the community. It was only a few years after arrival in New Spain that Vicente began using his position to challenge the authorities. He used the legal process to successfully raise and settle his concerns and the concerns of the larger civilian community. In 1735, unable to receive proper medical care locally, he sued and secured approval to travel to the nearest, largest community for medical attention—Saltillo in Coahuila, Mexico, 346

miles away. A few years later, Vicente would again challenge authorities, this time religious authorities, on behalf of his community.

As the San Fernando de Béxar's civilian community began to grow and expand in population, it also grew in occupations. In 1731, the civilian population started out farming and slowly took on ranching as an occupation, something they were very familiar with from their time in the Canary Islands. However, Vicente and his neighbors felt that their ranching success was hampered by the mission friars and their monopolization of the vast ranchlands. The five missions surrounding the Béxar community, along with the Espíritu Santo Mission to the south, owned lands stretching from present-day San Antonio to as far east as Gonzales and the Guadalupe River and as far south as Goliad—ninety-one miles away. Vicente petitioned the royal authorities via the courts and lawsuits for relief. His petition was eventually approved, opening the possibilities for the community members to seek and get approved land grants for ranching purposes. Vicente established his ranch, Las Mulas, southeast of San Antonio near the present-day border of Wilson and Karnes Counties. Other Tejano community members would, over the course of several years, be granted thousands of acres. These pioneering ranching families would turn their cattle enterprises into endeavors that would benefit not just the local economy but also the warring colonists to the east during one of their most trying times: the American Revolution.

Many of the Tejano ranchers, including members of the Travieso and Delgado extended families, like Jose Antonio's paternal grandfather, Jacinto Delgado, remain unrecognized for their significant contribution resulting in the successful American Revolutionary War efforts. At the request of Spanish and American government officials and under the leadership of Spanish general Bernardo de Gálvez, the Tejano ranchers rounded up and drove more than eleven thousand head of cattle from Texas to Louisiana between 1779 and 1783. These cattle, once received in Louisiana, were then put on ships and sent up the Mississippi to feed starving, war-torn Americans who were fighting against the British for their independence. These ranchers' contributions were recorded in the Spanish records, and a scant few are recognized as Patriots by the Daughters and Sons of the American Revolution lineage societies. While the American Revolution might have been the first independence movement involving Jose Antonio's ancestors, it would not be the last.

Clemente Delgado is another Tejano who figured large in Jose Antonio's life and one who had a significant role in the San Fernando de Béxar

community and in Texas's earliest independence movements. Clemente Delgado was born on October 8, 1760, in La Villa San Fernando de Béxar to Jacinto Delgado and Rita Álvarez Travieso. Both of his parents were children of the original fifty-six Canary Islanders who arrived in 1731. Clemente was the only child born to his parents, as his mother died before his first birthday. His father did not remarry until Clemente was in his early twenties. Clemente, at age twenty-three, married Maria Gertrudes Saucedo, sister of Spanish Patriot Jose Antonio Saucedo, whose life story is shared in *Tejano Leadership in Mexican and Revolutionary Texas* (published in 2010). These brothers-in-law would eventually find themselves on opposite ends of a significant conflict.

Clemente's life centered on being a rancher and an elected official, serving the community at various levels on the town council. Clemente and his father, Jacinto, ranched alongside his maternal grandfather, Vicente Álvarez Travieso, and the extended Travieso family at their Las Mulas ranch many miles southeast of San Antonio. When not at their ranch, the Delgado family also had a home on the town plaza (now known as Main Plaza) that was established by Clemente's family's founding patriarch, Juan Delgado, in 1731 near San Fernando Cathedral. Over the years, Clemente gained the trust and faith of his community and of the Spanish government. This loyalty would be tested.

Father Miguel Hidalgo's September 16, 1810 cry for freedom from oppression in Dolores, Mexico, would be heard 690 miles away in San Antonio, Texas. Juan Bautista de las Casas, a retired Spanish army officer, led a miniature revolution in Béxar shortly following Father Hidalgo's *grito*, or cry, overthrowing Spanish governor Manuel Salcedo. Aiding De las Casas was Gavino Delgado, Clemente's first cousin. At the time of this revolution, Clemente was a Spanish loyalist and on the opposite side of his cousin Gavino. Town officials gathered and led a counterrevolution against De las Casas. When it became evident that De las Casas's mini-revolution was not going to last, Gavino quickly turned back to being a Spanish loyalist. As part of the counterrevolution, a municipal council of leaders was appointed, responsible for reconstituting Spanish law and rule. Clemente was appointed as one of these council members. He was praised for his loyalty, and shortly following the counterrevolution, his fellow community members placed great faith in his abilities and loyalties and elected Clemente as the *primer alcalde* in 1812.

While San Fernando de Béxar was in turmoil with a revolution and counterrevolution, other forces were at work to bring about further disorder.

One of Father Hidalgo's coconspirators in the revolution was a gentleman named Bernardo Gutierrez de Lara. While Father Hidalgo was garnering support for his revolution in and around Dolores in New Spain, Gutierrez de Lara went north to solicit assistance from the United States. After visiting with Secretary of State James Monroe and representatives from other foreign governments for his plans to establish an independent Texas, Gutierrez de Lara then traveled through Louisiana, where he and others would form the Republican Army of the North and fight the Spanish army under an emerald green flag. The Republican Army of the North invaded and overtook the Spanish forces at Presidio La Bahía in present-day Goliad in the winter of 1812 and would remain there until the early months of 1813. From Goliad, Gutierrez de Lara and his Republican Army would move northward to San Antonio, where they were again successful in defeating the Spanish army at the Battle of Rosillo and Alazán Creeks. Bernardo Gutierrez de Lara was replaced as the leader of the Republican Army by José Álvarez de Toledo y Dubois. The Republican Army of the North's success against the Spanish army would soon change.

Spain sent General Joaquín de Arredondo to quash Álvarez de Toledo and his Republican Army. On August 18, 1813, Arredondo and his well-equipped 1,500-plus army battled against the Republican Army made up of Americans, Tejanos and Native Americans. The Republican Army was decimated. More than 1,000 Republicans lost their lives on the battlefield. Those who did not die in battle were brought back to town and executed in the town plaza. Arredondo sent royalist troops out to round up escaping Republicans, with orders to execute them on the spot. Those who survived had bounties placed on their heads. Jose Antonio Delgado and his brother Jose Maria, along with other survivors of the battle, successfully escaped and made their way to Louisiana, a U.S. territory since 1803, where they sought refuge. With orders from Arredondo, Jose Antonio Saucedo—Clemente's brother-in-law and Jose Antonio Delgado's maternal uncle, as well as undoubtedly his namesake—along with Luis Galan penned the names of the "insurgents" (the term the Spanish chose to use to describe the Republicans who fought or had some role in the Battle of Medina), along with a listing of their property that was seized. Clemente Delgado's name appears on this list, along with ninety-five others—many his first cousins. The Delgado plaza home, Clemente's property in La Villita and cattle from their ranch were seized and redistributed to loyalist soldiers and citizens. A deportation order, signed by Ignacio Perez, was issued in 1814 banishing Clemente to Monclova, along with a few other revolutionaries. Where exactly Clemente

spent his years in exile is unknown; however, it would not be long before he returned to San Antonio and to government life.

Clemente returned to San Antonio in about 1819. The town council minutes from March 1820 show that Clemente was given the council's "blessing" and a certificate as a good citizen authorizing him to reestablish his home within the community. His La Villita property, acquired sometime around 1811 and seized following the Battle of Medina, would be returned to him six years following his petition dated in 1822. It was around this time that his sons Jose Maria (and his family) and Jose Antonio would return to San Antonio. Following their return to San Antonio, Clemente's government service continued. Upon his death in 1833 and his wife's death in 1835, their property, including the land in La Villita, was distributed to their children Maria Josefa, Encarnación and Jose Antonio, as well as to his daughter-in-law Juana Curbelo on behalf of his minor grandchildren born to his deceased son Jose Maria.

JOSE ANTONIO'S LIFE

Jose Antonio was only a teenager when he first took up arms in defense of an independent Texas. According to his obituary, published in 1857, Jose Antonio fought alongside his father, Clemente, brother Jose Maria and about 1,400 other Republican forces under the leadership of General Jose Álvarez de Toledo y Dubois. After fleeing Texas and seeking refuge in Louisiana, he once again took up arms under General Jackson battling the British in the Battle of New Orleans. Less than a decade later, Jose Antonio Delgado was back in San Antonio.

Several reasons can be attributed to a person's involvement in the struggles for independence by the early residents of Texas. While ideology and common interests may have been factors, family played a large part, and it no doubt played a significant role in Jose Antonio Delgado's decision to participate in not only the Battle of Medina but in other major events as well. Besides taking inspiration from his father, Clemente, one of ninety-six insurgents identified by his maternal uncle, Jose Antonio Saucedo, Jose Antonio's rebellious, fighting spirit was undoubtedly inspired by his wife's maternal uncle, who seemed to share his and his father's political views: Lieutenant Colonel Jose Francisco Ruiz, a fellow expatriate, revolutionist and signer of the Texas

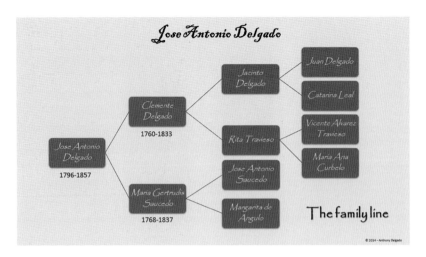

Jose Antonio Delgado was connected to several individuals who played a prominent role in Texas's early history. *Courtesy of Anthony Delgado.*

Declaration of Independence. Francisco Ruiz, like Jose Antonio and his father, was also banished with a price on his head for his role in the 1813 rebellion. Colonel Ruiz was not the only influential connection.

Jose Antonio Delgado was well connected to several major players in Texas's early revolution. John "El Colorado" Smith, another Texas revolutionary compatriot, was the husband of Lieutenant Colonel Ruiz's niece María de Jesus Delgado Curbelo. Jose Antonio was an active player in the Texas revolution and the 1835 Siege of Béxar, couriering messages from the patriots in San Antonio to Sam Houston and General Rusk, and these connections undoubtedly proved helpful for Texas in winning its independence.

Jose Antonio would continue battling for Texas. It is believed that when Texas was invaded in 1842 by General Woll, Jose Antonio once again answered the call to service for his beloved homeland. Research continues to determine his exact role. His service to the community following the Mexican-American War would take on a different role—that of a *carretero*, or cart driver/freighter.

Carreteros played an important role in the moving of goods across Texas. Major goods would come into Texas through the coastal port at Indianola. Ox carts were used to haul these goods to and from the coastal port and points across Texas, including San Antonio, which at that time was a major distribution point. The carts had large wheels and could

carry as much as five thousand pounds each. The carts were pulled by oxen and would be arranged in trains, some with as many as seventy-five carts. The carts were independently owned, and a glance through the 1850 census shows that many residents in the San Antonio area had as their major occupation "cartman."

In the early months of 1857, Anglo freighters in South Texas began to cause havoc with the San Antonio–based Tejano and Mexican freighters. The freighters and citizens of South Texas did not hide their disgust for the Spanish-speaking citizens of San Antonio. Newspaper articles from Karnes and surrounding areas in 1857 were filled with derogatory, slanderous language directed toward the Tejanos. The South Texas freighters were angry because the San Antonio freighters hauled goods for a lesser price than what they sought for the same service. They destroyed carts, maimed or killed the Tejanos' horses and oxen and on September 12, 1857, wounded four Tejano *carreteros* and killed Jose Antonio Delgado.

Jose Antonio's murder unsettled those in his ancestral home of San Antonio. The community was not going to sit idly by after the senseless death of one of its oldest and most respected family members. Citizens and political leaders in San Antonio—many of them with business, political and familial ties to the Delgados—were in an uproar and immediately sought the assistance of Governor Pease to stop the violence and provide protection for the *carreteros*. Failure to do so would adversely affect not only the San

The San Antonio Ledger
A Democratic Journal

| Vol VII | San Antonio, Texas: Saturday, September 19, 1857 | No. 33 |

Obituary – The subject of this notice, JOSE ANTONIO DELGADO, was born in 1796 in San Antonio de Bexar and was killed in Karnes county on September 12th, 1857. His father, Clemente Delgado, was one amongst the first emigrants to the New Phillipines, holding until his death important government offices. Jose Antonio Delgado and his brother J.M. Delgado urged by an earnest longing for liberty were among the first to enroll themselves under the Republican banner of General Toledo and Majors Long and Ross. After defeat of this party by Arredondo on the Medina in the year 1813, the brothers, with many of their companions who had fought in the cause of liberty fled to the Trinity river. The two brothers escaped swimming the river, the remainder of the party, being captured, were shot. From Texas, Mr Delgado went to Louisiana, where he had the honor of fighting under Gen. Jackson at the Battle of New Orleans. In 1830 he returned to San Antonio, and in 1835 he rendered important services to Texas, by carrying, at the most imminent personal risk, dispatches from Messrs. Maverick, Cocks, Holmes and J.W. Smith to Gen. Rusk, which resulted in the taking of this city by Col. Milam—What a deplorable catastrophe, that a man, who throughout his life had rendered such valuable aid to the cause of liberty, should have fallen basely murdered by the hands of a set of dastardly assassins, who are a disgrace to the American name. *Requiescat in pace.*

Reproduced using information found in the September 30, 1857 Telegraph. Cushing, E. H. The Weekly Telegraph (Houston, Tex.), Vol. 23, No. 28, Ed. 1 Wednesday, September 30, 1857, newspaper, September 30, 1857; Houston, Texas. (texashistory.unt.edu/ark:/67531/metapth235960/: accessed July 21, 2017), University of North Texas Libraries, The Portal to Texas History, texashistory.unt.edu; crediting The Dolph Briscoe Center for American History.

This is a reproduction of Jose Antonio Delgado's obituary as it was printed in the *San Antonio Ledger* in September 1857. *Courtesy of Anthony Delgado.*

Antonio–based freighters but the entire population as well. The price of goods would skyrocket or, worse, hunger and starvation would soon be felt by many across the state. Governor Pease responded, and the army issued an order to have troops accompany the freight trains to and from the port. In the latter part of 1857, the troubles ceased and order was restored. The death of Jose Antonio Delgado brought an end to the hostilities along the Ox Cart road and to the lifelong service of a son of Texas and an unheralded patriot.

Jose Antonio Delgado's life was not unlike many others in his family and those of his neighbors. The many Tejanos who founded and fought to create the Texas we now know and love remain in the shadows of history. It is through efforts like this that we hope to bring these stories out from the shadows and into the light.

Note: When visiting Maverick Plaza in La Villita, you stand on the property that once belonged to, was seized from and was returned to Clemente Delgado. This is also where you will find a historical marker dedicated to Jose Antonio's nephew John Smith.

CONCEPCÍON CHARLÍ AND MY CANARY ISLANDS CONNECTION

By Armandina Galan Sifuentes

Never in my wildest dreams did I think I would be so connected to this beautiful city of San Antonio, Texas. The Alamo, the beautiful missions, San Fernando Cathedral. As I child, we would visit with family and friends. Xavier V. Sifuentes—my boyfriend then and now my husband and lifelong partner—would take me often on dates to these places. In my heart, I felt a special attraction, a certain connection tugging inside me when we were there. As it turns out, my feelings were very much on target. I do have several ancestors who are connected to these places. The feelings I now have are pride, honor and respect for the ancestors who came from across the ocean and for those who were born here at the Mission de Valero. My genealogy trek began in 1993, when we heard of an organization called the *Asociacion de Reclamates* in Edinburg, Texas, a group focused on researching the original Spanish land grants given by the king of Spain in 1767. One of those land grantees was Joaquín Galán. My cousin Minerva Galán Burton and I teamed up to do some research. We needed to link our ancestor Tomás Galán to Joaquín Galán as direct descendant in order to qualify for any compensation.

The family chart and old letters that my uncle Luis Galán had given me back in the 1970s formed the foundation of our research. This was the beginning of a long and continuous genealogy journey, in the hopes of leaving our families with a concise family history. We were younger

when we started this venture; now we are older and slower, with our vision not so good for reading those microfilms and working on translations of documents. We have spent hours and hours doing research, accumulating binder after binder of documents, certificates, maps and deed records while forming our own library.

This ambitious effort in linking our sixth-generation grandfather Tomás Galán to Spanish land grantee Joaquín Galán opened up the doors for membership into the Daughters of the Republic of Texas. We provided the required documentation and proofs for membership, and in 1996, Tomás Galán was approved for his service to the Republic of Texas as a provider of supplies in Captain Philip Dimmitt's command in Goliad, Texas. Tomás Galán also petitioned for land in Refugio County, and in 1834, he was granted 1.25 leagues of land in Refugio County. This was the beginning of our discovery of one ancestor that changed with the continuous research work on different family lines. We found several other ancestors who contributed to the founding of the Villa de San Fernando in ranching, transportation of goods and as ministers of the Methodist faith during those early years. My discovery and connection to the Canary Islands came through the research work I was doing for a descendant of Toríbio Losoya.

Here is my story of a great Texas lady (*una dama Tejana*), born at, reared in and a resident of Mission de Valero—an eyewitness, a survivor to the Siege and Battle of the Alamo and a woman who lived under five Texas flags. The many struggles this fantastic, courageous woman experienced formed a person of strong moral character, enabling her to face any challenge in her life.

I discovered that Toríbio Losoya's mother was Concepcíon Charlí, who was first married to Ígnacio Miguel Gortarí, the grandson of my Canary Islands connection. Polonia Travieso, the daughter of the seventh Canary Islands family (Vicente Álvares Travieso and María Ana Curbelo), married Miguel Gortarí, a man of European descent. I was so excited to find the connection I needed to my Canary Islands ancestor, Vicente Álvarez Travieso, who lived in the Providence of Téjas under Spanish rule. I spent many hours at the Texana Genealogy, the sixth floor of the Central Library, going through all the San Fernando church books. Vicente Álvarez Travieso was from Tenerife, Canary Islands, and he married María Ana Curbelo from the island of Lanzarote, Canary Islands. They married in Cuautitlán, Mexico, just before embarking on their continued journey to Texas.

The Isleños arrived in Spanish Texas on March 9, 1731, and quickly organized themselves in the task of founding the Villa de San Fernando. Within the time frame of five months, they formed the first civil government in Spanish Texas on August 3, 1731. They formed the first city council, on which two of my ancestors held lifelong positions: Juan Leal Goraz was the first *alcalde* (mayor) and Vicente Álvarez Travieso was the sheriff. All the city council spots were lifetime positions held by the Isleños, and many of the laws they established for the Villa de San Fernando de Béxar are still being utilized by our city council today.

They also helped build the church named San Fernando. The Isleños families became integrated by marriage to other Isleños or locals from the Mission de Valero and Villa de San Fernando. Many marriages and baptisms took place in the mission church until the San Fernando church was built. The plaza in front of the church was named *Plaza de las Islas* for the Canary Islanders, but over the years, new names have been given to the plaza, burying the true history of the space in front of San Fernando Cathedral. The Isleños homes were built around the church and plaza.

Miguel Gortarí and Polonia Travieso's son Ígnacio Miguel Gortarí married Concepcíon Charlí. Ígnacio Miguel Gortarí was born on July 30, 1764, in the Villa de San Fernando and baptized on August 8, 1764, at the San Fernando church. Concepcíon's birth name was María Concepcíon Noberta de los Ángeles, born on July 10, 1779, in Mission de Valero and baptized on July 19, 1779, in the San Fernando church. Ígnacio Miguel Gortarí was fifteen years older than Concepcíon, who was fifteen years old. He was wealthy, a well-established rancher with his own ranch and cattle. The record for their circa 1794 marriage has not been located. Concepcíon's parents were of great help in the mission, working in varies capacities with the mission Indians, caring for the sick, washing, mending their clothes and doing carpentry work. Pedro de los Ángeles Charlí, father of Concepcion Charlí, also was a barber and in charge of the sacristy.

The service they provided to the mission Indians was recognized by the mission priest Francisco Lopez of the order of the College of Our Lady of Guadalupe of Zacatecas and minister of Mission San Antonio de Valero. He granted land to Pedro de los Ángeles Charlí (a Frenchman) and his wife, María de Estrada (second wife of Spanish descent). This was a small stone dwelling within the wall on the southwest corner of the Alamo complex. Ígnacio Miguel Gortarí and Concepcíon had two sons, Elíjio and Miguel, as well as María Santa, an adopted daughter. Elíjio Gortarí married María

21

Josefa Coúrbier on November 22, 1823, and died on March 25, 1834, of wounds fighting the Indians. He was buried at the Campo Santo Burial Ground. Miguel Gortarí, born circa 1803, married Santa Flores on May 16, 1830, and later buried Santa Flores in the Campo Santo Burial Grounds. During the peaceful years, I imagine that Concepcíon was a content mother and wife enjoying a normal life in the Mission de Valero along with all the other mission residents, watching her children play on the very same ground that had been her playground. She was a young woman of about twenty-three around 1802 when she received the news that her husband, Ígnacio Miguel Gortarí, had been killed by Indians. He had gone to check on his land and livestock when he was killed. For a young wife with small children, this was devastating. Although under stressful circumstances, Concepcíon was left a wealthy widow by the standards of those days, not only acquiring her husband's wealth and properties but also later inheriting the property her father willed to her in 1805.

Concepcíon had married into a Canary Islands family with great landholdings and property. Her father-in-law, Vicente Álvares Travieso, had one of the largest ranches in south Bexar County, called Las Mulas, with a large herd of cattle and other farm animals, located near present-day Floresville, Texas. The Travieso home was located on the corner of Commerce and Soledad, now a savings and loan company. María Ana Curbelo's parents' *quínta* (larger than a lot) was also on Soledad, between Nueva Street and Dolorosa on the east side of the courthouse.

Concepcíon, an attractive young widow, found herself handling all the legal aspects of her husband's and father's estates. Most likely she sought some legal advice and council from her neighbor, Ventura Losoya, who later became her husband. Losoya was a master tailor, a resident and neighbor of Concepcíon's well known in the mission for his work. Ventura Losoya and Concepcíon Charlí Gortarí married circa 1807 and had a son named José Toríbio, born on April 11, 1808; a daughter named Juana Francisca, born in 1816 in Natchitoches, Louisiana; and another son named Juan Anselmo, baptized in San Fernando on July 19, 1822.

Even in the quiet and peaceful years, rumors of unrest reached the residents of Mission de Valero and Villa de San Fernando, instilling fears of war. Hints of independence from Spain became a revolution, and those who desired independence often received cruel reprisals. Many *bejáreños* became fearful for their lives. For a very short period after the Battle of Medina in 1812–13, Texas was a republic under a green flag. These were very unstable times, and there were many conflicts. Ventura Losoya's

family connections with patriotic relatives who fought for freedom against oppressive governments placed them in a precarious situation. They decided to leave their mission home in order to avoid any hostilities or reprisals, so they traveled to Louisiana.

When Concepcíon married Ventura Losoya, she joined a family who believed in independence, liberty and freedom, along with a few revolutionary ideals. Her father-in-law, Miguel Losoya, and her brother-in-law Domingo Losoya had property in the Villa de San Antonio and ranches in south Bexar County, present-day Martinez-Losoya, Texas. As the Losoya men were strong patriots and clamored for independence, Ventura and Concepcíon knew that they would be targets of the Spanish royalists. The Losoya men were no strangers to fighting for freedom and human rights. They were certainly not cowards. Toríbio Losoya joined his grandfather and uncle in fighting for freedom from the oppressive governments of Spain and Mexico. Exactly when the Losoya family left to Louisiana is not known, but Concepcíon was expecting a child when they left; shortly after arriving, she gave birth to Juana Francisca in 1816, so it's very possible that they left in the later part of 1815 or 1816. My eighth-generation grandmother's home, located on the southwest corner of the Mission de Valero, was a stone structure and received substantial damage during those early battles, but the family was able to repair the home.

Texas was soon under Mexican rule from 1821 to 1836 and under the Mexican flag. Texas would be known as Coahuíla y Téjas, a new government, with new rules and a new constitution that included many changes for all Texas residents. Ventura died between 1822 and March 6, 1836. Exactly when is not known, but by the Siege of the Alamo and Battle of the Alamo, Concepcíon had become a widow once more. Rumors of Texas seeking independence from Mexico again arose in the midst of the Villa de San Fernando and Mission de Valero as early as the fall of 1835. From her house, Concepcíon could see the activity of General Cos in fortifying the outer ditches of the mission and clearing trees. However, she continued to live a normal life in the mission. I can only image her feelings of uneasiness and insecurity when she and the other mission women would talk about the rumors of another war.

Her son Toríbio had married María Francisca Coúrbiere and had children of his own. Concepcíon also had little Juan Anselmo, and Concepcíon's daughter, Juana Francisca, was married to Eliel Melton, quartermaster of the Alamo under William Barrett Travis. It is not known whether Juana Francisca Losoya Melton was living with her mother or in

other quarters in the Alamo with her husband. When the news came to all the residents of the Villa de San Fernando and Alamo compound on February 22 that General Antonio López de Santa Anna had made camp at the Medina River, they were given notice to take immediate steps to leave or find safe havens. Imagine with me the desperation felt by Concepcíon in that moment: "Do I leave to go to the family in south Bexar County? Will we reach the ranch?"

In her anguish, desperation and fear, she decided to join the other women and their families inside the Alamo church. She took what food supplies she could carry. For the next thirteen days, Concepcíon, Juan Anselmo and Juana Francisca Melton stayed inside the Alamo church. Those with them included the Gregorio Esparza family, with four children, and other community members such as Dolores Cervantes, Desídora Munoz, Pétra Gonzales, Andrea Castañon Villanueva, Victoriana Salinas and her three little girls, the Navarro sisters Juana and Gertrudis, Aléjo Perez Jr. (an eleven-month-old child of Juana Navarro Perez Alsbury), Trinidad Saucedo, Bettie (Jim Bowie's cook), Susana Dickson and her daughter, Angelina. During the terrible days of the siege, Concepcíon and the other women inside the church stayed very busy caring for the wounded Texians and Tejanos, cooking and calming their terrified children.

Given all that occupied Concepcíon, she would still listen for her son Toríbio's voice and try to get a glimpse of him. To hear his voice would surely bring comfort to her, knowing he was alive. Concepcíon was concerned for her daughter-in-law and her grandchildren, as she did not see them in the church. Toríbio, a young married man with a wife and family, was an experienced fighter. María Francisca Coúrbiere Losoya found a safe haven for her and her children.

Many visitors to the Alamo today ask the question, "Why did we lose the Alamo?" What most history books fail to mention is that Texas and the Alamo belonged to Mexico and that General Antonio López de Santa Anna was coming to take possession of property owned by Mexico and being occupied by Texians. While the Alamo was under siege, a group of delegates was gathering at Washington on the Brazos to declare Texas's independence from Mexico, which took place on March 2, 1836. The Texians and Tejanos at the Alamo, unaware of the results of the meeting at Washington on the Brazos, continued to fight in the Alamo for what they believed in: liberty, freedom, justice and independence!

On the fateful day of March 6, 1836, Santa Anna's troops readied the assault on the remaining troops inside the Alamo compound, sealing the

fate of all the men fighting there. The battle lasted eighteen minutes, but for the women and children inside the church, it was an eternity. When the battle was over, the room in which they had taken refuge was opened by a Mexican soldier. They feared for their lives. Concepcíon held her son close to her, as did every mother with children, and the older women stayed close to one another. The horror they must have felt as they saw all the smoke and dust and smelled the gunpowder that filled the air as they were hurriedly escorted out of the room into the Alamo courtyard. Concepcíon Charlí, Ana Esparza, Petra Gonzales, Susan Dickson and Juana Francisca Losoya Melton desperately glanced at the bodies on their way out in search of their loved ones, but they were not allowed to stop. Texians, Tejanos and Mexicans were dead in the courtyard. With heavy hearts, a terrible sinking ache fell over them, but they were determined to overcome their anguish for their children. They did not know what fate would be waiting for them.

For Concepcíon, her loss was greater, for on that morning of March 6, 1836, she lost a son and son-in-law and, on their way out of the Alamo, witnessed the total destruction of her home, located on the southwest corner of the Alamo complex. Her house had been a focal point because of its location and therefore received tremendous damage from the Mexicans due to the eighteen-pounder cannon that was situated on the roof of her house by the Texians. To all in the Mission de Valero, her home was known as Charlí's House. These brave survivors of the Siege and Battle of the Alamo were taken to the Musqúiz House, where they were fed and made as comfortable as possible under the circumstances. This house was not unfamiliar to Concepcíon, for in friendlier times it was a place frequented by the residents of Mission de Valero. The women and children regained some composure and slept without hearing gunfire.

On the following day, March 7, 1836, they were taken to the headquarters of General Antonio López de Santa Anna at the Iturbíde House, where each one was given a serapé and two pesos, with instructions to leave and make their own way. How they must have felt is unimaginable—likely a mixture of abandonment and anxiety—yet these survivors or widows were now alone to support their children. Some women would restart their lives from scratch, while others fared better because of family support. The other women not taken to General Santa Anna included Dolores Cervantes, Desídora Munoz and Trinidad Saucedo and her three little girls. They left the Alamo compound during the three days of amnesty offered by General Santa Anna. The following were not in the group taken to the Músquiz

home: Juana Navarro Perez Alsbury, her son Aléjo, Gertrudis Navarro and her sister; they were all taken by a relative to a safer place the night before the battle. For Andrea Castañon Villanueva and Bettie, it's not known where they were after the battle.

After the battle, Toríbio's wife, María Francisca Coúrbiere Losoya, entered the Alamo grounds with Father Refugio de la Garza, priest of San Fernando Church, to look for her husband's body and identify him. The affidavit of Father Refugio de la Garza can be found in the Bexar Archives Spanish Collection. Toríbio Losoya, along with all the fallen defenders, were not buried but burned in the funeral pyre ordered by Santa Anna. The only one who received a Christian burial was Gregorio Esparza, requested by his brother Francisco Esparza, who was Santa Anna's cook.

Concepcíon Charlí Gortarí de Losoya, Juan Anselmo Losoya and Juana Francisca Losoya Melton left to join her Losoya family in south Bexar County. Not much is known after they got to the Losoya ranch; one can only speculate that that they stayed long enough to recover their finances and property somewhat. As for Juana Francisca Losoya Melton, a very young widow herself, we are left wondering what happened to her. She is not mentioned in any Texas census. Could she have gone back to Louisiana?

Texas soon entered a new era. It was now a republic under a new Lone Star flag, with a new government, a new president and a new rules for all Texans. Concepcíon Charlí de Losoya and her family were now residents of the Republic of Texas. Texas had an interim president, David G. Burnet; in 1836, Sam Houston was elected the first president of Texas. In 1838, Texas saw a new president, Mirabeau Bonaparte Lamar, and in 1841, Sam Houston was elected president a second time. Concepcíon and her family remained loyal citizens of the Republic of Texas. She and the family lived elsewhere in the Villa de San Fernando due to the extensive damage to her home on the Alamo complex. One historical footnote sees Concepcíon playing Cupid for her grandson Miguel Cantú, son of Jesús Cantú, and her adopted daughter, María de los Santos Gortarí. How she arranged for her grandson to meet and fall in love with María Gertrudis Navarro, who had been in the Alamo during the siege but was not the battle, we will never know, but they married on July 26, 1841, at San Fernando Church. This is important to me because later on, other family lines connect to this marriage. Concepcíon's son Juan Anselmo Losoya, who was with her in the Alamo during the siege and battle, was married on September 15, 1842, at San Fernando Church to Juana Rocha.

Concepcíon had several properties that she needed to deed to her children and grandchildren. Once again, the Land Records and Spanish Collection of the Bexar Archives were extremely useful. One only has to search the Charlí, Gortarí and Losoya names to obtain the land transaction deeds. The Republic of Texas ended on February 19, 1846; a new era began for the twenty-eighth state of the Union.

Once more my eighth-generation grandmother and her family were new Texas residents, this time of the United States of America under the leadership of President James Polk. There was a new flag to honor and new rules for the residents. During this time, Concepcíon deeded to her Gortarí grandchildren (children of Miguel Gortarí) the Mission de Valero property in May 18, 1850. Concepcíon died on June 3, 1860, at the age of eighty-one. There is a discrepancy regarding her age recorded on the death certificate, which states her age as one hundred. It's possible that the person giving the information regarding her age was not sure of her date of birth. James Buchanan was president at the time of her death. My ancestor, in her lifetime, was a resident of Spanish Texas, a resident Tejana under the short-lived Republic of Texas in 1812–13, a Mexican-American citizen and resident during the Coahuíla y Téjas Mexican rule and, at her death, an American citizen of the United States of America.

Her legacy continues through her Gortarí and Losoya descendants. A beautiful bronze statue of her son Toríbio Losoya sits between the River Center Mall and Henry B. Gonzales Convention Center. Losoya Street was named after Toríbio, a fallen hero who fought and died in the Alamo on March 6, 1836. Concepcíon's house has a historical plaque at the southwest corner of where her house was located along the Alamo complex wall. The church La Trinidad United Methodist, located today at 300 San Fernando Street, was where Reverend Creséncio A. Rodriguez, with his first wife, Gertrudis Gortarí Gil, served as pastor from 1878 to 1880. Gertrudis Gortarí Gil was Concepcíon's great-granddaughter. The church's first location was on Produce Row, now the Market Square. There are many Gortarí and Losoya descendants who have several connections to the sixteen Canary Islands families who helped build this small presidio that became the busy Villa de San Fernando and, eventually, the beautiful city of San Antonio. There are so many places in town that at one time were occupied by the Isleños. Many of them had homes in La Villita. I feel sadness when developers from other states come into San Antonio and their only interest is the real estate, showing

little regard for any historical significance they may be tearing down and leaving only remnants of history. Gertrudis Navarro Cantú's home still exists and is occupied by a descendant in south Bexar County. Thank goodness that a developer has not gotten ahold of that piece of property, or that history would be gone too. We lived on some acreage in south Bexar County that was in Domingo Losoya's land grant. In the little community of Saspanco, Texas, near Elmendorf, Texas, several Travieso families still live, occupying ancestral lands.

CONCLUSION

Along with my daughters, grandchildren, great-grandchildren and other descendants, we are the voices of our ancestors. We want to pass on to our families their enormous sacrifice, accomplishments, bravery and determination to have a better life for their families. We are proud to be

Reverend Creséncio A. Rodríguez and Cristina C. Strasburger (second wife) and family. He was first married to Gertrudes Gortarí Gil in 1866. He was pastor of La Trinidad United Methodist Church in 1878–80 and then in 1882–84 with his second wife. *Courtesy of Armandina Sifuentes.*

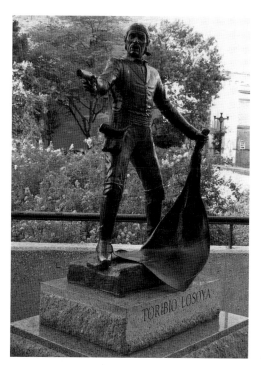

Left: Statue of Toríbio Losoya, defender of the Alamo, who died on March 6, 1836. He was my seventh-generation great-uncle and the son of Concepcíon Charlí Losoya. *Courtesy of Armandina Sifuentes.*

Below: From my mother's family album. Cristina Strasburger de Rodríguez, surrounded by her children and the children of Gertudes Gortarí Gil de Rodríguez (Creséncio's first wife), taken in Eagle Pass, Texas, in 1925. *Courtesy of Armandina Sifuentes.*

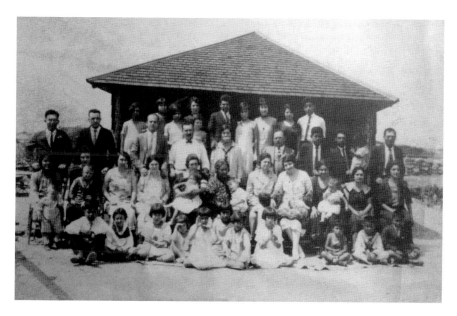

the descendants of Juan Leal Goraz, Vicente Álvares Travieso, María Ana Curbelo, Ana María Arocha, Joaquín Leal, Concepcíon Charlí Gortarí de Losoya and many other ancestors who were contributors to the forming of our great state of Texas.

We are proud native-born Texans with deep Hispanic heritage roots that can be traced across the ocean. Our ancestors' legacies matter because they were the founding families of this beautiful city of San Antonio. Our Hispanic heritage is at the very core of our existence in this great state. Our Hispanic ancestors came from proud, honest, hardworking families who fought for freedom, liberty, equality and justice. In the passing of time, we were here yesterday, we are here today and we will be here tomorrow.

AND I AM

By Joann Herrera

When I was a youngster, I wasn't interested in family history or genealogy. All I knew was that I wanted to play or read. But I did pick up a thing or two during those times when my grandparents would try to tell me about family. One, I knew that I had Polish blood in me because I was always told that I had a paternal Polish grandmother. Our family always referred to her as "Mariana, la Polaca," which means "Mariana, the Polish One." In fact, I have her old iron bed. My grandfather Manuel Garcia gave it to my daughter when she was born. My daughter was the first great-grandchild, so I suppose that's why we were lucky to get the bed. He said he didn't know if it came with her from Poland or if she got it somewhere here in Texas. All he knew was that it belonged to her. The other thing I knew was that I was Indian. I knew that because my maternal grandfather, Domingo Ramirez, would tell me that I was "pura India," which translates to "all Indian." He used to tell me that because I was always running and yelling. He told me that I had a paternal grandfather who was "Indio," that he had long hair and that he liked going around shirtless. I imagined that grandfather to be Comanche, as I was enamored of horses—and who were the greatest horsemen of all time? Now as an adult, it amazes me that Grandpa Mingo saw my other grandpa as "Indio" when I am nearly sure that he is "Indio" too. Oh well.

As I grew older, I found myself interested in my family history and tried to find out all I could about them. I would visit cemeteries, read books and ask

questions. It didn't matter where I visited—the first place I would go to was a cemetery. Some people thought I was ghoulish, but I didn't care. I liked doing that. Maybe it was an old ancestor calling me.

As I started researching, the first lost relative I found was Juan N. Seguín. This grandfather was a very well-known man. Through him, I was able to join the Daughters of the Republic of Texas. In fact, I have just been elected to be our chapter president for the term 2017–19.

Several years ago, I attended the funeral of my aunt. Her sons, my cousins, knew that I was into researching family, and one of them asked me if I had found our Canary Islands line. What Canary Islands line? The only thing I knew about the Canary Islands was that it was part of Spain, and I thought there must be a lot of canaries that lived there. Well, the first thing I learned was that Canary doesn't refer to the bird but to dogs (as in canine). The next thing I found out was what Ralph, my cousin, was talking about. I started my Canary Islands research.

It didn't take too long for me to find my lineage to Salbador Rodríguez, the eighth family of the original sixteen families who founded San Antonio in 1731. It turns out that my father's mother was a direct descendant of Rodríguez. I had much of her history because she's the link I have to Juan N. Seguín. Once I found this link, I was able to trace my family back to three other families of the original sixteen families. The other three are the second family, Juan Curbelo and Garcia Perdomo y Umpienes; the ninth family, Francisco de Arocha and Juana Curbelo; and the fourteenth family, María Rodríguez de Bethéncourt. I am related to Rodríguez and Bethéncourt families through my father's side and Curbelo and de Arocha through my mother's side. I have chosen to elaborate some on my De Arocha line.

Francisco de Arocha and Juana Curbelo arrived in San Antonio on March 9, 1731. By the way, March 9 is my husband's birthday and our anniversary. They were the ninth family of the original sixteen Canary Islands families who came here.

Don Francisco was elected the first *escribano de conséjo y público* (secretary and notary public) of the first *cabildo*, or city council, that was established in August 1731. This was a great accomplishment because most people of that time did not read and write. My grandfather De Arocha did.

Don Francisco and his wife had fifteen children, the eldest being Simón. Simón was born shortly after the Isleños arrived in San Antonio. He served in many offices, including as judge, city clerk, military commander and *alcalde* (mayor) two times. He married María Ígnacia de Urrútia. Simon

and his brother owned San Rafaél de Pataguilla, a ranch in Floresville, and supplied cattle for the American Revolution.

One of Símon's grandsons was José María de Arocha, who was my fourth great-grandfather. This grandfather served at one time under the command of my third great-grandfather, Juan N. Seguín. When José María was killed in 1841 (some accounts say 1838), he was serving under the command of Manuel Flores, who was another of my third great-grandfathers. He was killed in an Indian attack.

Chapter 4

THE CANARY ISLANDS AND ME

By Julia Lopez

My ancestors arrived in what is now Texas in 1731. That statement both astounds and pleases me. I like the ring of it—it sounds *determined*, much like the people who came before me.

I wasn't always interested in genealogy and wholeheartedly wish I had listened as my mother tried so often to provide historical familial information to me, the youngest and *favorite* of her six daughters. Had I listened instead of only pretending to, let's just say I'd be a lot farther along in my genealogical research. I really mean *our* research—that of my sisters, Norma Rojas and Martie Gonzales, who would be instrumental in getting our research off the ground. They spent long days marching through cemeteries and courthouses, and although I was glad to receive their information, I was slow to connect the dots and had a hard time keeping all the people and information straight. Then we spent an entire day at Catholic Archives of Texas in Austin. There we found a baptism record for a baby we were unaware of—four generations back. On that day, our ancestors became real to me.

I also met a new cousin, Mrs. Estella Martinez Zermeño of Goliad, Texas. Estella has amassed vast genealogy documents and holds more information in her head than I could ever hope to. I got bit all right and bit well. I love a good hunt and have a competitive spirit when it comes to learning new information. In addition to being members of Canary Islands Descendants Association, my sisters and I are members of the Daughters

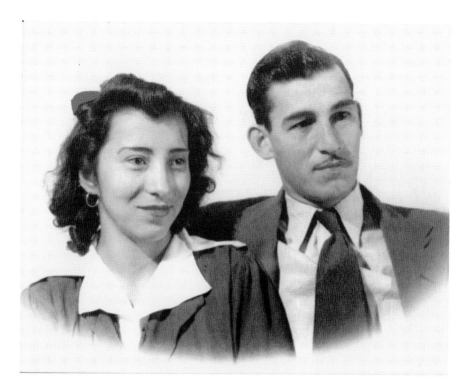

Pomposa "Peggy" Rubio Garcia and Ramon E. Garcia. *Courtesy of Julia Lopez.*

of the Republic of Texas and Daughters of the American Revolution, so you can well imagine that we've paid some good and costly research dues thus far.

I won't claim that I even knew where the Canary Islands were when we first learned of our ancestry. I know now and will visit my homeland in the coming months. I'm proud of my Canary Islands ancestors. The Cabreras were one of sixteen families sent by King Philip V in 1730 to settle the then Spanish territory in present-day San Antonio. The Cabreras accepted this journey that would define my life today. One year after commencing their trip across the Atlantic Ocean, they walked and rode horseback across Mexico and into present-day Texas. The journey proved to be a testament to the character of the Cabrera family. Grandparents Juan Pedro and Maria Rodriguez de Bega Cabrera both fell ill and died in Mexico, leaving their children José, Ana and Marcos to complete the journey as orphans. Juan Pedro was born in about 1680 in Lanzarote, Canary Islands, Spain, and died on August 9, 1730, in Pueblo de Apa on the Vera Cruz Road in Mexico. His

wife, Maria, was born in about 1690 in Lanzarote, Canary Islands, Spain, and died on October 20, 1730, in Cuautitlán, Mexico.

The Cabreras lived for many years in San Antonio de Béxar before moving to Goliad. The eldest, José, was born in 1715 in Lanzarote and completed the journey as a fifteen-year-old head of the family. The second eldest, Ana, was fourteen years old upon arrival and later married another Canary Islander, Ignacio Lorenzo de Armas. Ana was born in 1717 in Lanzarote and died on October 10, 1757, in La Villa de San Fernando de Béxar. De Armas was one of the four single men forming the sixteenth family of Canary Islanders.

I am a direct descendant of Marcos Cabrera, the youngest of the three Cabrera children. Marcos was born in Lanzarote in about 1724 and was six years old upon his arrival in San Antonio. He died on March 8, 1769, in La Villa de San Fernando de Béxar. He married twice: Maria Magdelena de Avila and, later, Maria Celedonia de Vargas, both at La Villa de San Fernando de Béxar. Marcos, a soldier at the Presidio, was killed by Indians while on patrol. I saw a document detailing the land that Marcos traded to his cousin for two horses—yes, the very land given by the king to each of the Isleños with which to build their lives. Still, horses were needed, too.

Marcos's third great-granddaughter, and my second great-grandmother, Theresita Cabrera, married Juan Rubio in 1858 at Immaculate Conception Church in Goliad, Texas. Theresita was the daughter of Mariano Cabrera and Miguela Mancha. Mariano was granted land in Goliad for his service to the Republic of Texas, having provided beef for Captain Philip Dimmitt's troops in 1835 during the Battle of Goliad. So it was Mariano who provided our link to the Daughters of the Republic of Texas.

My mother, Pomposa (Peggy) Rubio, was born and raised in Goliad. She lived with her grandparents Francisca de La Garza and Juan Rubio II until her beloved grandmother's death. Francisca was the daughter of Antonio de La Garza and my mother's namesake and great-grandmother, Pomposa Bontan, of French ancestry. My mother married Ramon Garcia in 1940, and after my dad's short tour in the U.S. Navy (Pacific theater), they moved to Victoria, Texas, where they were both self-employed. Both Pomposa and Ramon were born in Goliad, and as with most of their ancestors, our family has had and continues to have strong roots in Goliad today.

Let me tell you something about my dear Mama, a master dressmaker, a wonderful baker and cook, a chain smoker, a friend to everyone she met and a very determined lady. She wasn't educated, but she *was* a master— she could size you up in a few minutes. She knew your dress size before you replied to her inquiry. For the sake of politeness, let's just say that some

ladies were less than honest about their dress sizes. She'd purse her lips as if to keep the words inside her mouth. And then she would take a few measurements: your shoulder to your waist, your shoulder to your wrist for long sleeves…well, you get the message. Out of her notes on a scrap of paper came a beautiful dress. I realized later in life that my mother had to have very sharp math skills to translate those measurements enabling her to sew the way she did.

My mother sewed for very wealthy people in Victoria. If they ever looked down on her, I never saw it. She gave her opinion freely—"too tight, too long, doesn't hang right, I don't like the way that fits"—and her customers listened and complied. Sometimes after they left, she's inspect the price tags still dangling from new clothes they needed altered. She shook her head as if to say, *"Está loca."* You could tell when she was unhappy by the way she pursed those lips. I studied her face very carefully, trying to predict her mood or response to any number of a million or so questions or requests I bombarded her with daily. I did not wish to see her purse those lips and avoided that as all costs. She was my protector, my healer, my nurturer, my confidante, and I watched her every move, wanting to please her and make her proud. I never dared declare that I was bored or she would send me to "read a book and report back to her." Actually, I declared boredom all the time—I loved to read, and she loved hearing the stories. Sometimes I'd embellish a little, and she'd look at me over top of her glasses. I'd smile and continue. Maybe I wanted to see if she was listening. She was. She was a strong Democrat. She was a patriot; she loved this country of ours. She had a particular penchant for Oliver North and had strong opinions during the Iran-Contra hearings.

We come from a long line of patriots, tracing as far back as 1750, when Marcos was a soldier at the Presidio de San Antonio de Béxar. His son Vizente Cabrera enlisted to be a soldier in 1785 when he was twenty-two years old. I found his enlistment record in the Bexar Archives in the Center for American History at the University of Texas–Austin. Vizente's height was listed as five-foot-one and his religion as Roman Catholic and Apostolic. The document went on to give his description: stocky build and black hair and eyebrows, with a wound under his left eye. Thank goodness the Spanish were meticulous scribes. Otherwise, I'd never know of his features some 230 years later.

Our ancestors Miguel Becerra and Diego Cadena were soldiers at Presidio La Bahía during the American Revolution, and their service continued to all branches of the armed forces, law enforcement and the government.

Rosters from the presidios at La Bahía and San Antonio de Béxar also list our Cabrera, Becerra, Cadena, Bontan and De la Garza ancestors. My ancestor Manuel Becerra was part of the town council in Goliad in about 1820. Manuel was a guide for Stephen F. Austin—those records were found on the General Land Office in Austin.

Our ancestors have been involved in every battle, skirmish and war, including the Battle of the Alamo, the American Revolution and both world wars. Our present-day relatives served in Vietnam, Desert Shield and Desert Storm. I think that explains a lot. We're a feisty bunch—ones to stand on principle. We love a lively debate and do not back down when we believe in something.

I sometimes wonder why these families left the Canary Islands. Were they forced or enticed, or did they choose to make the voyage? What were they promised? Did they agree to make the journey knowing they would never return to their homeland? Whom did they leave behind?

Documents found at the Briscoe Center for American History detail the Canary Islanders' journey. One can read about where they stopped to rest along the way and how they were given money, provisions and horses to help make the journey. Travel is logistically easy today. You can arrange stops and layovers as you please. Travel in 1730–31 was unimaginably difficult without fully understanding where you were going, considering the loss of your parents along the way and being so tired…so incredibly tired. And maybe a little frightened too.

As a mother, I wonder who cared for the orphans during the voyage after the deaths of their parents. Who saw to it that they were provided for? Those questions led me to the Bexar Archives, which contain Spanish colonial documents, including the official writings pertaining the Canary Islands settlers, both during the journey and after their arrival. Upon arrival, the settlers were given land where the Main Plaza and San Fernando Cathedral presently stand in San Antonio, Texas. The documents detail how lots were drawn to decide the locations of each family's home. The documents contain the settlers' physical descriptions and what those early days were like upon their arrival. So descriptive are the writings in the Bexar Archives that one can research where an ancestor's land was located. Work began shortly after their arrival to form the first city government, or *cabildo*. And before long, San Fernando Church was built for and by the Canary Islands settlers. It stands today on the very same land.

I have a lot to learn about the history of my ancestors, but I've learned a lot as well and I'm happy to share, educate and encourage others when

I can. What I know for certain is that my ancestors played pivotal roles in Texas history. They were not immigrants, as this was Spanish territory— they simply relocated to a different part of Spain or Nueva España (New Spain). I know of their contributions to help form the Texas that we love today. They were here long before Texas was a Republic. They were born here, and although many lost their Spanish land grants, they remained right here in Texas. They were here long before the Declaration of Independence was signed in 1776 and way before the Battle of the Alamo in 1836.

We still live in Goliad, Victoria and surrounding areas. I love to wander around Presidio La Bahía today. When I look out toward the Fannin Monument, I know that my ancestors owned that land. When I look around the grounds, I know that my family walked that land more than two hundred years ago. It's comforting, and those thoughts fill me with pride.

The story of the arrival of the Canary Islands settlers in 1731 and that of the early Tejano patriots is seldom told in Texas history classes or in many of the books that have been written about Texas history. That is slowly changing as we begin to tell our own stories. Many of my friends are authors and passionate storytellers. Others are serious about Texas history and feel compelled to set the record straight. We share information on social media, at Hispanic genealogical and historical conferences, at meetings and over coffee and *pan dulce*. There's a pride that's ours alone. We are picking up the effort to tell the stories ourselves like no one else can tell them—like no else will cherish and honor them. As we continue on this journey, we pay homage to those who came before us—those who sacrificed life and limb and who, through their lineage, continue to be a determined bunch even today.

With the recent unveiling of the Tejano monument on the grounds of the Texas State Capitol, in the front yard, I might add that we all stand a little taller and a little prouder as we research the lives of our ancestors. We share stories that our children only pretend to listen to. I bet one day they'll wish they had listened, but so it goes. The difference is that now we save our stories digitally. Although we still tell those accounts verbally, and that's critical to raising children who know where they come from, we'll likely hand our descendants a thumb drive containing all their ancestral information. I'm sure they'll lose it until later in life when they "need" it. And then the research will continue. My mom started this research back in the 1970s, when she and my cousin Sandra Rubio spent days walking the cemetery in Goliad and documenting the graves in longhand. I cherish those documents today and know that my sweet Mama is thrilled with our success as she guides our research from heaven.

My prayer is that the stories of those brave souls will begin to unfold so that they can take their proper place in history. Our ancestors are calling on us to tell their stories! I hear that call in the quiet as I walk the grounds of Presidio La Bahía in Goliad, as I rip open the packaging on a Texas history book or as I find some document that ties me to a new ancestor. I'll keep up the hunt. I have to—it's both my birthright and my legacy.

Chapter 5

SOLVING THE MYSTERY OF ME
AND HOW I CAME TO BE

By Alice Calderon Rivera

La Bahía

I was born on the on the seventh day of the seventh month in 1943 in Goliad, Texas, a half mile from Presidio La Bahía (Fort of the Bay) and a quarter mile from Mission Espíritu Santo. My parents were Reynaldo Calderon and Saríta Calderon. Reynaldo was the son of José Calderon and Juanita Rodriguéz, and Saríta Cabrera was the daughter of Vizente Cabrera and San Juana Charles, daughter of José María Charles and Adelaide (Adela) Liendo Gentry.

We lived in a very humble house next to the San Antonio River about one hundred yards from the railroad tracks. The tracks were between two tall embankments, and I loved to sit on the embankment closest to my house and watch the train cross on the bridge over the San Antonio River, daydreaming, wondering where it had come from and where it was going. Its sound and vibrations were comforting to me. At that time, we had no air conditioning, so I slept next to the window, where I could hear the night sounds through the screen. Every night, I could hear that familiar train blow its whistle as it approached. Today, when I hear a train whistle, I get that nostalgic feeling, recalling my sweet childhood. I still miss that sound from long ago.

My father, Reynaldo Calderon, worked at the downtown Kohler Grocery Store, but on weekends, he would take me and my friends down to the river

The Presidio La Bahía (Fort of the Bay). *Courtesy of Alice Calderon Rivera.*

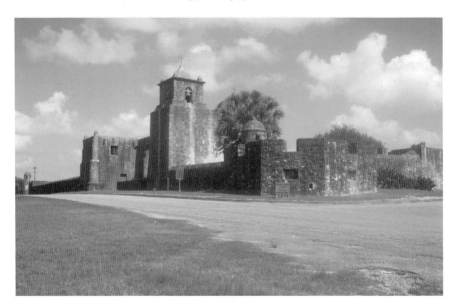

Side view of Presidio La Bahía. *Courtesy of Alice Calderon Rivera.*

for some fishing. We attended Mass every Sunday at the Presidio La Bahía, walking past the Mission Espíritu Santo to the Presidio, and afterward spent the day visiting my Cabrera uncles, aunts and cousins. They all lived within walking distance of the Presidio.

My cousins lived next to the Presidio La Bahía, and they believed that the Presidio was haunted. They claimed that, at times, they could hear singing, laughter and guitars playing coming from inside the courtyard, but upon running to check it out, all became silent again. After that, it was easy for me to envision the Spanish soldiers sitting around a campfire behind the stone walls of the presidio.

I was fascinated by the huge, colorful fresco that covered the entire back wall of the Presidio. It was of the Angel of God announcing to Mary that she was to give birth to Jesus. This beautiful, unique fresco was painted in the mid-1940s, and Uncle Nicholas Cabrera assisted the Corpus Christi artist, Antonio Garcia. Nicholas did the plasterwork, and he told us that every time the original surface would sweat, another wall had to be built about a foot from the original for the fresco, but he just kept on working. The artist,

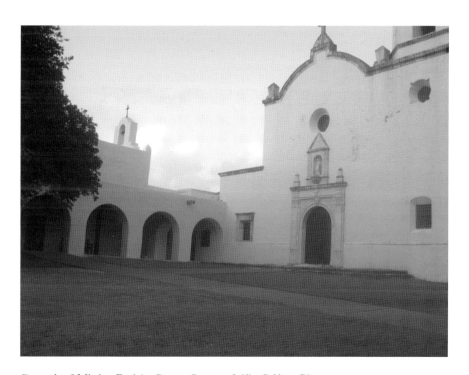

Grounds of Mission Espíritu Santo. *Courtesy of Alice Calderon Rivera.*

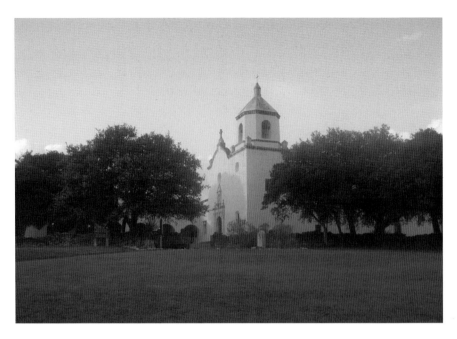

Side view of Mission Espíritu Santo. *Courtesy of Alice Calderon Rivera.*

Antonio, refused to work by himself after hearing unexplained sounds and voices coming from within its walls. Henry Wolf, a reporter for the *Victoria Advocate*, wrote an article about the making of the fresco titled "Unexplained Sounds in the Sanctuary at La Bahía!"

Uncle Nicholas knew so much about the history of La Bahía. He lived across the road from the Presidio, as did his brother, Manuel. One day, he was interviewed by a reporter from History & Heritage of Goliad County, and he said that his father, Macario Cabrera, had told him that his family had helped build the mission. They had hauled sand from the river up the high banks to the mission, piled on cowhides and all done by hand. There were no carts or wagons involved. His brother, Manuel, was the caretaker for the Presidio La Bahía and never seemed to be afraid of being alone in the church.

My parents were aware of the history of La Bahía. They took a picture of me when I was about two or three years old, holding up one of the two cannons in front of the Fannin monument, and as an adult, I had a picture taken with the cannon. I am forever grateful to my parents, who knew that I would someday find out the significance of the cannons in front of the Fannin monument.

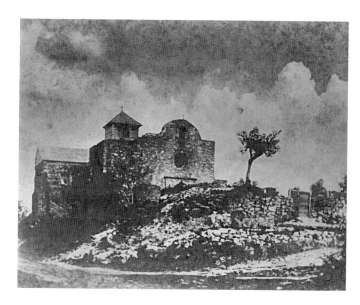

Presidio La Bahía
before restoration.
*Courtesy of Alice
Calderon Rivera.*

Alice Calderon participates in her First Holy Communion procession in 1950 around
Presidio La Bahía. *Courtesy of Alice Calderon Rivera.*

Bones Discovered in La Bahía

In 1928, a group of Boy Scouts came upon what looked like pieces of charred human bones and teeth. Judge White suspected that they were the remains of Colonel James Fannin and his four hundred men who had been executed by a firing squad in 1836 by the order of the Mexican general Santa Anna. The land where the remains were found belonged to my uncle, Manuel Cabrera. The judge asked him to sell his property, which was located adjacent to the La Bahía Cemetery. Uncle Manuel sold two acres for a mere fifty dollars. In 1939, a dedication of the pink granite monument was held, with the names of the four hundred men engraved on its walls, and in front of the monument were two cannons.

Historians called it a massacre because the Anglos had no idea they were going to be executed. The Anglos believed they were being marched away from the Presidio, possibly to be set free. Instead, they realized that the soldiers were going to shoot them, so they ran for their lives. While some did escape, the majority did not. The leader in command of the Presidio wanted to release the men, but he had strict orders from Santa Anna to execute the prisoners.

A few days earlier, the Anglo Americans had entered the Alamo, proclaiming independence from Mexico, but General Santa Anna and his soldiers fought the Anglos, killing most of the men, and recaptured the Alamo. The names of some of the Anglos who died became famous, such as Jim Bowie, Davy Crockett, William B. Travis and more. These two incidents were the call to all Anglo Americans to join the fight for the independence from Mexico, and in the end, Santa Anna and his men were captured at the Battle of San Jacinto. The Anglos had won their independence, and from then on, the cry was "Remember the Alamo and Remember Goliad!" Those words resounded throughout the world, making life very hard for all Spanish and Mexican citizens. Santa Anna sold out Mexico. Anglo Americans blamed all Mexicans for the death of Colonel Fannin and his four hundred men, as well as for the deaths of the men at the Alamo in 1836. It did not matter to them that Juan Seguin and hundreds of his men had helped them win their independence from Mexico—without their help, they would never have achieved that goal. But they, too, were treated like the enemy.

Our parents suffered many humiliating indignities in the 1900s. There was great racism. Their children attended a Mexican school in 1935, while the Anglos attended a whites-only school. The African American children had their own school. My mother, Saríta Cabrera, attended the fourth-

The Fannin monument. *Courtesy of Alice Calderon Rivera.*

through seventh-grade classes. My mother was one of the brightest students in school, and she mentioned that even her teacher felt sorry that she could not go any further in her education. It was assumed that students like her would not be educated beyond that point. There was widespread segregation against Hispanics in restaurants and theaters, as well as prohibitions against their use of restrooms.

My mother, Saríta Cabrera Calderon, fought back by joining the new organization LULAC under the leadership of her cousin Placido Martinez. This was the way to secure their constitutional right to vote and, most importantly, to end segregation in schools and improve the quality of education available to all Hispanic children. Yet my parents never told us what they went through. They were happy for the new freedoms available for their children. They had me join the Girl Scouts of America and were so proud of all the badges I achieved throughout those years. I still recall visiting the hospitals with my Scout uniform, bringing our handcrafted gifts to the patients. I loved music, and in junior high, I became part of the school band, marching in formation and playing my clarinet at the football field each week. My parents were so proud the day I graduated and received my high school diploma.

Mr. Shaw: Treasure Hunting at the Presidio

I did not have to wonder long about the cannons located in front of the Fannin monument. It was easy to find answers because I knew the person who had discovered those cannons. Mary Louise Shaw and I were cousins as well as best friends ever since we were children. Her father, Andrew V. Shaw, was a treasure hunter, and he found and dug up those cannons. It was fascinating to look into the glass case in the small café he owned in La Bahía. There were coins, Indian arrowheads, pots, chains and so many other old things from the past. Mr. Shaw loved to share his adventures with us. He told us that in 1936, he owned a Charlie Meyers metal detector, which he loved, but it had gotten him into a mess of trouble.

One night, Mr. Shaw told us, he was on the grounds of the Presidio when the needle on his metal detector went crazy, indicating that there was something metallic buried in the yard. He asked the priest at La Bahía for permission to excavate the southeast corner of the yard. The priest allowed him to dig, but only at night. Mr. Shaw suspected that they were the cannons Colonel Fannin and his men had buried in 1836 before retreating from the oncoming Mexican army. Their cart could not carry all of the artillery, so they spiked the cannons with square nails and buried them. So, one hundred years later, in January 1936, Mr. Shaw and his treasure hunter buddy, Mr. Hickle, gathered a crew to help them dig. They worked at night, digging at the spot indicated, and were gone by dawn.

One night, things went weird. First, they heard the braying of a donkey, yet there was no donkey anywhere near. The men took off, leaving Mr. Shaw by himself. He told us that he heard a sound like marching coming closer, and then suddenly someone or something grabbed his leather jacket. He slipped out of his jacket and swung his flashlight around, but no one was there. That was the end of digging for that night. Needless to say, he said that the workers he had hired refused to go back, and he had to find a new crew the next day. One of his helpers was my uncle, Manuel Cabrera; the others were the Perez brothers, Pedro, Esteban and Toby.

The next night was cold, and the wind was blowing as they resumed digging, using axes, grubbing hoes and shovels, going deeper. They looked up and saw a man standing there, looking down at them. He was dressed as a Spanish soldier and had a handlebar mustache, and somehow, Mr. Shaw knew who he was—it was his partner, Manuel Cabrera, named after an ancestor of the same name born in the 1700s. He could see right through

him, and suddenly the man walloped Mr. Shaw on the side of the head with a blow that knocked him out. His men poured water on him to snap him out of it. Mr. Shaw walked away and stopped at a nearby house, where an old Mexican woman sat on her porch. She had heard the commotion. When he told her what had happened, she told him that Manuel Cabrera was one of the Presidio soldiers who had been dead for more than a century. She warned him not to dig anymore.

But Mr. Shaw continued to dig more and found the two cannons along with two skeletons in the hole. One had a musket ball in its skull. The other had a stone tomahawk buried in its head. The bones were covered up after the cannons had been excavated from the hole. That was when the trouble really started for poor Mr. Shaw. He removed the cannons to his other home in Normana, Texas. Somehow, the Texas Rangers learned about the discovery, and Mr. Shaw was arrested but later released. Mr. Shaw took responsibility for his actions, and no charges were brought against any of his hired crew. Mr. Shaw and Mr. Hickle were paid fifty dollars each by the commissioner of the Goliad State Park after signing affidavits relinquishing any and all interest in the cannons and artifacts.

Mr. Shaw had also unearthed another cannon that had been spiked and plugged by Colonel Fannin and his men. Today, this cannon is displayed on the northwest bastion of the Presidio La Bahía. He would be proud to know that it is the most photographed cannon in Texas. The other two cannons are standing guard over the Fannin monument—the same cannons my parents had me take a picture with.

THE CABRERA FAMILY

Around 1994, while researching census records, I found my great-grandfather Mariano Cabrera, born in 1811 in San Antonio de Béxar. In the July 23, 1817 San Fernando de Béxar Census, he is listed under the Barrio del Norte as no. 129. Mariano Cabrera was six years old and listed in the household of Rosalia Rodríguez, eighty-five years old, who is believed to have been his grandmother. There was only one Rosalia Rodríguez in San Antonio, and it is believed that she was the daughter of Patricio Rodríguez.

Mariano married Miquela Mancha, daughter of Nazario Mancha and María de Jesus Gomez from La Bahía. Nazario Mancha was the owner of huge ranch with hundreds of acres of land and many heads of cattle. Nazario

is listed in the 1810 Espíritu Santo Census as residing in La Bahía, an owner of a wooden house and four horses. Mariano and his wife, Miquela, moved to La Bahía del Espíritu Santo in 1834.

Mariano Cabrera and an attorney had drawn up a Second Class "B" Claim against the Republic of Texas certifying that Mariano had provided beef to Captain Philip Dimmitt and his men in 1835 and was owed $155. After the Anglos had captured La Bahía, Geo. M. Collingsworth joined the main army at Béxar and left Captain Dimmitt in command of the fort at Goliad. The beef Mariano sold to Dimmitt was to feed his men. Dimmitt remained in charge of the fort in Goliad until January 12, 1836, relieved by Captain Peyton Wyatt and his men from Alabama. Many of Dimmitt's men remained at La Bahía under the command of the young and inexperienced Colonel James Fannin. This debt was finally acknowledged and paid by the Republic of Texas eighteen years later on August 31, 1853.

Receipt for debt paid by the Republic of Texas for beef purchased from Mariano Cabrera in 1835. *Courtesy of Alice Calderon Rivera.*

After the capture of Santa Anna, his second in command, General Vicente Filosola, was ordered to retreat by the Mexican government. He evacuated 1,200 troops from San Antonio and combined them with forces in La Bahía to continue his retreat to Matamoros, Mexico. General Filosola advised the people of La Bahía to leave and save the lives of their families or the Anglos would kill them. Already, people in La Bahía had seen hooded men outside their homes, making all kind of strange noises, even shooting into their home in the middle of the night trying to scare them into leaving their homes. In the mornings, there were Mexicans hanging from trees. The Anglos wanted any property they could get their hands on. They wanted the livestock, and they were willing to kill for it. They were evil and greedy and believed that to the victors belonged the spoils. The La Bahíans had no one to help them; there was no law to turn to.

Mariano realized that the threat was real, so he and his family loaded their belongings in their wagon and left La Bahía, and along with them were the Carvajal, the Lazo and the Liendo families. They all went to the San Loretto Rancho, about three and a half miles from Brownsville, and leased land from Juan and Miquel Tijerina, a very prominent family in the valley at the time. This information I received from my cousin Estella Zermeno.

Mariano and Miquela had two children born in Brownsville, Teresita, in 1840, and Macario Cabrera was born on March 23, 1842. After they thought it was safe, they returned home. Many of the families no longer had houses to return to. Mariano's father-in-law, Nazario Mancha, was tricked into selling his huge ranch for a quarter of what it was worth.

In 1858, Mariano Cabrera and his mother, Gertrudes Castro, petitioned the State of Texas for a headright certificate, which he had never received. He died in 1838. The certificate featured a name that was of the utmost importance for us in pushing our family search forward. In this document, Gertrudes Castro and her son, Mariano, claimed that they were the sole heirs of José Manuel Cabrera and his estate. The petition stated that Gertrudes Castro was the widow of José Manuel Cabrera and that Mariano was his son; at the date of the Declaration of Independence, he was a resident citizen of Texas, a married man and the head of a family. He had not left the country to avoid any participation in the struggle for independence, nor had he refused to participate in the war, nor did he give any aid or assistance to the enemy. At last, we had a document that had the name of Mariano's father, José Manuel Cabrera.

In the Goliad census of 1870, Mariano and his wife, Miquela, were listed with their children: Macario, Manuel, Pabla, Celestina and Mariano's

mother, María Gertrudes Castro, one hundred years old then. Mariano died sometime after this.

In 1882, attorney Juan Barrera of San Antonio wrote a letter to the grandchildren of Nazario Cabrera, who were trying to recover the Mancha land that had been sold without their permission as legal heirs. The attorney had been unsuccessful in recovering the property. There was no proof. This happened to many families with large ranches and lots of land—either they were forced to sell by the Anglos or tricked into signing away their property.

The Cabrera/Carvajal Connection

Mariano's son, Macario Cabrera, married Restituta Carvajal, daughter of Anastacio Carvajal and Canuta de la Cruz. This marriage became the link between the families of Cabrera and Carvajal. The original correct spelling was Carvajal, but many times the name was spelled "Carbajal," "Caravajal" or "Carabajal."

I am the proud descendant of the Spaniard Don Mateo de Carvajal, born in about 1690. He and his wife, Josefa Angela Guerra, were born in Santiago Apostol, Monclova, Coahuila. Mateo Carvajal had four children born in Monclova from 1710 to 1719. His brother Cristobal had eight children from 1699 to 1720.

Geronimo Carvajal was also from Santiago Apostol in Monclova, Coahuila. Geronimo and Cristobal are listed as soldiers on the Alarcón Expedition of 1718. This expedition founded San Antonio de Béxar. It is believed that Geronimo Carvajal was Mateo and Cristobal's brother. Geronimo married María Zapata de Menchaca on January 21, 1719. They had one child, María Ysabel Carvajal, on January 5, 1728.

In about 1720, Mateo and Cristobal de Carvajal left Monclova and settled in San Antonio de Béxar, where they had more children. They are considered some of the earliest settlers at San Antonio de Béxar.

My Carvajal ancestral heritage comes from Mateo Carvajal, and this is the line of descent. Jose Nicolas de Carvajal was born on February 10, 1712, in Santiago Apostol, Monclova, Coahuila. He married Catharina Martinez. His daughter was María Concepción de Carvajal, who married Cavo (Corporal) Domingo Peres, who was born in about 1740, son of José Peres Casanova and Paula Granado, Canary Islands descendants.

Joseph Nicolas de Carvajal was born in January 1748 in Villa de San Fernando de Béxar and married Josefa de Mora.

Ygnacio Nicolas Carvajal was born on September 10, 1783, and married María de los Ángeles, daughter of Don Lorenzo Reynier and Encarnación de la Garza of La Bahía, daughter of Don Bernardo de la Garza, a muleteer.

Anastacio de Carvajal, son of Ygnacio de Carvajal and Maria de los Ángeles, was born in 1821 in La Bahía and married Canuta de la Cruz on June 3, 1851. His daughter, Restituta Carvajal, was born on May 6, 1852, and married Macario Cabrera, born on March 23, 1842, in Brownsville, Texas.

Vizente Cabrera was born on December 8, 1877, in Goliad and married San Juana Charles, daughter of José María Charles and Adelaida Gentry, daughter of William Henry Gentry and Jesusa Liendo.

Saríta Cabrera, daughter of Vizente and San Juana, was born on February 27, 1920. She married Reynaldo Calderon, son of José Calderon and Juanita Rodríguez, the latter born in Corpus Christi in 1888 and the daughter of Anastacio Rodriguez and Refugia Rodriguéz.

Finally, I, Alice Calderon, was born on July 7, 1943.

Mariano and José María de Carvajal

I wrote earlier about the names engraved on the Fannin monument. An important fact must be told. One of the names engraved on the monument belongs to my family. Mariano de Carabajal (Carvajal) signed the First Texas Declaration of Independence from Mexico in 1835, which was drawn up and signed at La Bahía.

On December 2, 1835, Second Lieutenant Mariano was a member of Captain Philip Dimmitt's company of volunteers, a Tejano fighting with Texans. On the battlefield, he gave a moving speech as to the reasons why they should not surrender. He was also a member of the San Antonio Greys. His parents were José Antonio de Carvajal Peña and María Gertrudes Sanchez Soto, born in San Fernando de Béxar.

His brother was the famous José María Jesus de Carvajal, who renounced Catholicism and became an ardent Protestant. Aided by Stephen F. Austin, José became the official surveyor for Martin de León Garza in about 1830 and laid out the town of Victoria. He married De León's daughter, María del Refugio. He also acted an interim secretary for the *ayuntamiento* of Béxar

and in 1835 was elected deputy from Béxar to the legislature of Coahuila and Texas. The legislature authorized him to publish the laws and decrees of the state in English and Spanish in 1839. Domingo de Ugartechea ordered José de Carvajal arrested for attempting to stir up rebellion. Carvajal left for New Orleans, where he joined Fernando de León in chartering the *Hannah Elizabeth* to supply the Texas forces. The vessel was captured by Mexicans, and José was imprisoned at Brazos Santiago and then at Matamoros, where he escaped to Texas. Carvajal was elected to attend the Convention of 1836 at Washington-on-the-Brazos but did not attend.

Mariano and José María were the descendants of Don Mateo de Carvajal (Nicolas, José Manuel, José, José Francisco and their father, José Antonio de Carvajal).

LORENZO REYNIER

I promised to relate more about my French great-great-great-grandfather, Don Lorenzo Reynier, an incredibly interesting individual.

Lorenzo Reynier and his wife, Encarnación Garza, had the following children: María Regina, fifteen; María Ines, eleven; Felix, nine; María de los Ángeles, four; and Juan, two. In the 1810 census records, they owned a wooden house with lot and land title granted by the governor of the province, Señor Manuel Muñoz. They owned three horses and one mule. His wife had nineteen cows in addition to that. Lorenzo also enjoyed a lifetime pension of three reales, bestowed on him by King Carlos III in 1785 for his service to the Crown.

This was fascinating to find! Research revealed a letter that answered all my questions. The answer is found in a detailed report of his life that he submitted at the request of the governor:

CORONEL SEÑOR MANUEL MUÑOZ, GOVERNOR OF THE PROVINCE OF TEXAS:

In accord with the order by Señor Governador of the Province of Téjas, el Coronel Señor Manuel Muñoz, I will explain that I was born in 1750 in the city of Marseilles, Province of the Kingdom of France, to Christian parents, José Reynier and Margarita Moran. I was baptized in the Parroquia de San Martin of the same city, named Lorenzo Reynier;

immersed in the faith. My Godparents were Lorenzo Caynas and Isabel [illegible]. *My father was a laborer, died when I was seven years old. Alone with my mother, I had to provide for myself.*

In 1763, I sailed to Santo Domingo with an uncle [tio hermano], *and worked as a jornalero, a day laborer on a merchant boat. When my uncle died, I sailed to New Orleans, Louisiana and traveled the territory for 8 years between the years 1764–1771. In Natchitos,* [Natchitoches] *I traded with the Agusten-Tuchens Indians for one year in Enlargataguacana in East Texas.*

I visited with Don José Menchaca to ratify the peace treaty which the Yotnas nations had abused in this Presidio, while I was there, Don Atanacio de Mesieres appointed me to the rank of Alferez (ensign or 2ⁿᵈ Lieut.), of the Señor governor of the Province, el Baron de Coronel Riperda, and petitioned me to go to the Tancagua Indian Tribe, the only ones, who were being obstinate and stubborn and had not signed the peace treaty in the Province. I accepted and then left the Tahuacanes Indians and went to the Tancagues who had 40 capitanes who were lazy, shiftless men, and was able to bring them back to the Presidio where they established the peace treaty with the governor in 1773. The Indians returned to their ranches. I was tired of so many miseries, so I stayed and lived in the vicinity and worked for one year. I came to La Bahía and stayed one year as a single person.

In 1775, I married Barbara Gertrudis Maldonado from La Bahía and worked as a laborer. This continued until I left to join the Cibolo Expedition in 1783, begun by Don José Antonio Curbelo to San Miguel de Cuia Piedras. I was blessed to receive 3 reales daily and I was happy to return to Presidio La Bahía in 1785. My wife, Barbara died in 1791.

I remarried in 1792 to Encarnación de la Garza and spent time traveling, managing foreign interests. I sailed into the Port of Las Pasos, New Orleans where I was arrested in 1795 and all my foreign goods were confiscated. These goods belonged to Teniente Don Juan de Castañeda. [Note: Bernardo de la Garza posted bond for Lorenzo on January 11, 1796.] *Tired after this delay, I went to San Luis Potosi where I made a declaration of the goods and returned to La Bahía, then to the capital where I made a report of what had occurred, placing it in the hands of Governor Muñoz on January 12, 1796. The governor wrote a letter from San Antonio with orders to return all confiscated goods back to me, stating that I was a member of the community of La Bahía, with my passport, asking the President of San Luis Potosi to lift the embargo on goods coming to the Presidio where my wife and family lived. The governor*

stated that I received pension of 3 reales daily which the king had given me and I had never done anything wrong, having abided by my passport, which I had presented here and not being from another country. I should not have been arrested. He stressed that all confiscated goods be returned to me.

Lorenzo Reynier

Family from 1800 to 1900

Vizente Cabrera, my grandfather, son of Macario Cabrera, was born in 1877 in La Bahía. He worked as a clerk in a downtown grocery store in Goliad. He married San Juana Gentry, daughter of José María Charles and Adelaida Gentry, in 1907.

They had the following children: Corporal Jasper Cabrera, born on May 28, 1916, who served in the United States Army and is buried in the La Bahía Cemetery; Armando Cabrera; Micaela Cabrera; and Saríta Cabrera (my mother), who was born on December 27, 1920, and married Reynaldo Calderon on April 17, 1939. My grandfather Vizente died in 1948 in Goliad and is buried at the La Bahía Cemetery, next to the Fannin monument.

Reynaldo was born on December 2, 1912, son of José Calderon and Juanita Rodriguéz. Reynaldo had only one brother, Encarnacíon Calderon, who married Matiana Muniz. Their grandparents were Encarnacíon Calderon and Josefa Salinas Macías. The Calderon family was Jewish. Extensive DNA tests traced their origin to Israel, as well as their migration through the Mediterranean, Spain, Mexico and then to the United States. Further research into the Holocaust led me to find several Calderon and Rodriguez names marching to the death camps. Thus, I, too, am Jewish.

San Juana's mother, Adelaida Gentry Charles, was born in 1860 to First Lieutenant William Henry Gentry and Jesusa Liendo in La Bahía. William Gentry was born in Kentucky in 1826 and served in the military

Reynaldo Calderon with daughters Alice and Gloria Mae. *Courtesy of Alice Calderon Rivera.*

Reynaldo Calderon on the railroad overpass. *Courtesy of Alice Calderon Rivera.*

during the Civil War under the command of Captain Greenwood, Bevily Company, for the Home Guard Company for Charco, Precinct no. 2, in Goliad, Texas, Twenty-Ninth Brigade, in August 1861.

William Gentry and Jesusa Liendo had the following children: Alfonso Gentry in 1853, Augustine Gentry in 1859 and Adelaida in 1861, according to the 1870 U.S. Census. Adelaida's first marriage was to Macario Garcia, who proved to be an unfaithful husband, and they were divorced. They had one son, Lauriano Garcia.

Encarnación Calderon, Reynaldo's brother. *Courtesy of Alice Calderon Rivera.*

Adelaida then married José María Charles, who was born in 1849 in Mexico. Research revealed that after the Franco-Mexican War, the French had been defeated. The French survivors fled to the high mountains of Monterrey to avoid prosecution. The last name Charles has been in census records in that area in Mexico since the 1840s, according to my cousin Ricardo Charles from Galeana, Nuevo Leon. The area is high in the mountains, fifty miles south of Monterrey. Ricardo believes that our great-great-grandfather was José Francisco Charles, still under genealogical investigation at this time.

Adela Gentry and José María Charles had three children: Christina Charles, born in 1886; San Juanita Charles, born in 1877; and Willie Charles, born in about 1890. In the 1900 census, Jesusa Liendo, born in December 1830, is listed as head of the family and a widow; also present were her son Alfonso Gentry and her grandchildren Christina, San Juana, Willie Charles and Lauriano Garcia. Adelaida must have died, as there are no further records, and her husband, José María Charles, is listed as living alone at the age of fifty.

OPENING THE DOOR TO THE PAST

In my search, I was joined by my cousin Estella Zermeno. After Uncle Nicholas Cabrera died, his daughter Lucinda told us that she had found two old documents that her father had been saving for many years that might be of interest. The first document was a military enlistment record written in Spanish, which we translated; the other had already been translated. They were the military enlistments of two soldiers: Vizente Cabrera in 1785 and José Manuel Cabrera in 1785.

The mystery of my ancestral roots was revealing itself at long last. These documents led us to San Antonio and the Canary Islands Descendants Association. The organization informed us that our ancestors had been sent

Tias *alcalde* Jose Cruz presents the Municipal Coat of Arms to Patsy Dill Moss, vice-president of the CIDA. On left is Alice Calderon, translator, and on the far right is Dot Benge. *Courtesy of Alice Calderon Rivera.*

Descendants celebrate the arrival of their Canary Islands ancestors. *From left to right*: Stella Cunningham, Alice Calderon and Alicia Berger. *Courtesy of Alice Calderon Rivera.*

by King Philip V of Spain to settle in Texas. They had left their home in Lanzarote, Canary Islands, Spain, in 1730 and had arrived in San Antonio in 1731. Their path led to Presidio La Bahía and the Espíritu Santo Mission.

The Canary Islanders arrived in San Antonio on March 9, 1731, so it was so appropriate that on March 5, 2000, I received my certificate and became a Canary Islands Descendants Association member. It was time for San Antonio to celebrate that arrival, and I was so happy to be a part of it. Dignitaries from Lanzarote attended the event, as well as San Antonio officials, and Archbishop Flores of the Catholic Diocese of Texas was present at the San Fernando Cathedral. It was a grand event. Television reporters were taping everything, and so was the *San Antonio Press*. From that day forward, I learned everything I could about my ancestors.

The Recruitment of Isleños to Téjas

King Philip V sent a *cédula* in 1729 to the intendant of the Canary Islands, Don Bartolomé de Casabuena, and notified the *alcalde*s of each island of the king's request for volunteers wishing to settle in New Spain. The French from Louisiana had tried to invade Spanish territory, and he needed the presence of Canary Islanders to deter them. The *alcalde*s reassured the citizens that the French forces were small and that the Spanish soldiers would never allow them to enter New Spain again.

The two council members of the island of Lanzarote, Don Juan Leal Goraz and Don Antonio de los Santos, met with Don Casabuena in Santa Cruz, Tenerife, to learn of all the details concerning embarking on such a venture. After the long session, Goraz and De los Santos agreed to take the proclamation and display it to the public, promising to recruit the necessary number of families.

Isleño families were recruited during the following months in town meetings around the island and at the *Ayuntamiento de Teguise*. Church fathers encouraged the parishioners with grand descriptions of Nueva España. They were urged to accept their king's generous offer to colonize La Provincia de Téjas. The king would pay all their travel expenses and provide them with all the necessities along the journey and even pay them at the end of the journey. They would sail to Cuba, then reach Vera Cruz, Mexico, and then sail down the coast to Espíritu Santo Fort. There were glowing reports of the rich, fertile lands and an abundance of water.

Juan Manuel Cabrera and his wife, María, daughter of Domingo de Bega and Leonor Rodriguéz, were natives of Lanzarote and had three children: fifteen-year-old Josef, thirteen-year-old Ana and six-year-old Marcos. Juan Manuel was thirty-nine years old and was the water bearer for the island, routinely ferrying spring water across the strait from the next island of Fuerteventura. Nearby lived María's sister, Ysabel, who married the town councilman, Don Antonio de los Santos, and had five children. They had signed up for the expedition to Téjas and encouraged Juan Manuel and María to join them. Juan and María made the decision to join the expedition. There was a flurry of excitement as they sold their land, animals and household goods.

After months of preparation, the time had finally come for the journey to Veracruz and, from there, to sail down the coast to San Bernardo, La Bahía del Espíritu Santo, the location the Marqués de San Miguel de Aguayo recommended; he had assured the king that the settlement would be perfect for the Canary Islanders.

On March 27, 1730, Juan Manuel Cabrera and his family began boarding the 183-ton *navio* (ship) *Santísima Trinidad, Nuestra Señora del Rosario, y San José*, under the command of Captain Joseph Jacinto de Mesa. The family carried one and a half bushels of *gofio*, which everyone else carried, as well as one box and one mattress. Don Juan Leal Goraz was accepted as the leader. Goraz was blind in one eye, but his mind was keen and he found it easy to make quick decisions.

They sailed from Santa Cruz de Tenerife and arrived at the La Boca del Moro of Cuba on May 10, 1730, and after nearly one month on the island of Cuba, they boarded the brigantine *Santo Cristo de San Roman y Nuestra Senora de Guadalupe*, under the command of Tomas Lopez Pintado. Twelve days later, on June 19, 1730, they arrived at Veracruz, Mexico.

The Cabrera family had entered a land unlike any they had ever seen. The temperature was extremely hot, and mosquitoes were feasting on everyone. The people were dark-skinned. They soon learned of a tropical disease raging in Veracruz; people were dying, and they had been exposed. There was panic when some of their fellow travelers became sick with high fevers and died. The disease took the lives of several of the Isleños, and Juan Manuel Cabrera began to feel unwell.

To make matters worse, General Inspector Pedro de Rivera had sent a letter warning Viceroy Casafuerte not to send the Canary Islanders to San Bernardo del la Bahía del Espíritu Santo. He had inspected the area and found the fort abandoned. Sailing down the coast was dangerous because

of the English ships and pirate ships that were ready to attack any Spanish vessel. There were Karankawa Indians who would not hesitate to massacre the Isleños. The land was dry, as there was no water. The best place would be near the Presidio de San Antonio de Béjas. There were rivers of rushing waters, fish, fertile lands and forests where rabbits, geese and ducks ran wild.

Rivera told the viceroy that the Marqués de San Miguel de Aguayo had lied to His Excellency. The viceroy's main concern was moving the Isleños out of Veracruz and away from the wretched tropical disease before anyone else died. They were to go to Cuautitlán, just north of Mexico City. From there, he would provide them with the necessary supplies to make the trip to San Antonio de Béxar. The viceroy had plans for the Isleños; they were to establish the first civil government and settlement for Spain.

The leader of the Isleños, Don Juan Leal Goraz, was very upset when he was informed that they were not going along the coast but instead were going overland by horse and cart over dangerous Indian territory, a trek that would take months. It took time to convince Juan Leal that they had no other choice.

The group consisted of twenty-one men, seventeen women and eighteen children—fifty-six Isleños in all. Half of the children were under the age of seven. To lead the caravan, the viceroy appointed Francisco Duval as the guide and conductor for the journey.

The Cabrera children had never been on a horse before, and even six-year-old Marcos was expected to learn to ride. The route chosen by Brigadier Rivera and Duval was to go north to Xalapa (Jalapa) and Perote, which ascended to the plateau and the Valley of Pueblo at a slower pace. It would be easier for the women and children to make the ascent into the mountains, stopping just outside Xalapa to make camp in Piedras Negras, where the air was thinner and cooler. They had reached an elevation of 4,700 feet above sea level.

On August 23, 1730, day 149, they were on the road to Apa. It was the middle of the rainy season for this part of the highland—an area, their guide Duval told them, where the Teotihuacan and Toltec civilizations got their starts. It was cold and the air thinner; Juan Manuel Cabrera was in trouble. The caravan was brought to a halt because he was finding it difficult to breathe. He could no longer withstand the effects of the altitude. María cried as her children Josef, Ana and little Marcos watched in horror as their father gasped for each breath until there was no more. The women wailed as the body was prepared for burial. He was only thirty-nine years old and had grown up with the people from Lanzarote and was related to most of them.

A small funeral was held, and the priest traveling with them gave Juan his last Catholic rites. He was buried on a lonely Apa roadside three days before the party arrived at Cuautitlán.

RESTING AT CUAUTITLÁN, MEXICO

On August 27, 1730, day 153, at about five o'clock in the afternoon, after fourteen days on the road from Veracruz, the Isleños arrived at Cuautitlán. The pleasant climate seemed like an oasis for the weary travelers. The *alcalde* of the city, Francisco de Lara, welcomed them on behalf of Viceroy Casafuerte, escorting them to houses that had been prepared for them.

At this time, they were celebrating five marriages. Francisco Arocha married Juana Curbelo, Vicente Álvarez Travieso married María Curbelo, Antonio Rodríguez married Josefa Niz and José Leal married Ana de los Santos (María's niece, daughter of Don Antonio de los Santos and Isabel Rodríguez de Bega) and Juan Delgado married Catalina Leal, daughter of the leader of the expedition, Juan Leal Goraz. There were fiestas and much celebration, and it was a time for music, food, singing and dancing.

In October, the *alcalde*, Domingo de Lava of Cuautitlán, wrote to the Marqués de Casafuerte about the health conditions of the Isleños. He wrote that María Rodriguez de Bega, widow of Juan Cabrera, accompanied by her three small children, was gravely ill, suffering from *dropica* (dropsy), as demonstrated by her enlarged abdomen. The surgeon, Fray Bernave de Santa Cruz, summoned from Mexico City to attend the sick, had informed him that ten Isleño patients had recovered, except for María Cabrera. *Dropica* appeared as a cutaneous edema, beginning with a mosquito, spider or bee sting. Most likely she had been bitten by mosquitoes like her husband. Although the symptoms and disease were different, dropsy was still considered to have grave consequences. The mosquito bite resulted in myoedema, an increased tendency to hold water within the connective tissues. De Lava informed the Marqués de Casafuerte that the surgeon had performed three procedures to remove the liquid, but to no avail. On October 20, 1730, María died. She was buried in the parish church of Cuautitlán and listed as a Spaniard who had received the sacraments by Friar Luis Marin.

Josef, Ana and Marcos were now orphans. Their parents had wanted so much to give them a better life, yet now they were gone from their lives. Their

only consolation was having their mother's sister, Isabel, and her husband, Antonio de los Santos, to help reach their destination. The Isleños were a close-knit group and most were related in some way, so it fair to assume they were all sympathetic and protective of those children.

Finally, on March 2, 1731, day 340, at last, the final leg of their journey was to begin. The trip from Veracruz up to this point had taken about seven months; they were now within a week's journey to complete this monumental task. A few days later, they made camp in the usual circle, and only a small portion of the horizon was visible because of the trees and shrubs. The Canary Islanders were physically and mentally exhausted and went to their tents soon after supper. Josef, Ana and Marcos had their tent next to their aunt and uncle. The weary travelers fell into a deep sleep. The soldiers posted their sentries for the night. At about midnight, a band of Indians made its way to the livestock. The sound of stampeding horses accompanied by the loud whoops of the Indians terrified everyone. They were Lipan Apaches, considered the most treacherous tribe in the province. Extremely cruel, they liked to surprise their enemies, killing old people and keeping the men for sacrifice. They would sell the boys and eat the small children. The soldiers followed them and were able to recover all but two horses. Needless to say, the women and children were frightened.

The Isleños were angry and felt betrayed. When they were recruited, no one informed them about the Indian situation. There was a war going on in Téjas like nothing they had ever seen. They were born on an island in the Canaries—maybe there was a drought, but certainly they did not have to worry that someone was watching them, waiting for the opportunity to scalp them or eat them. It was clear to them that their lives would forever be in danger from the Indians of Téjas.

They refused to continue the journey. Duval sent a courier into San Antonio with message for Captain Juan Antonio Perez de Almazán, describing what had happened and requesting that additional soldiers be sent to guard the settlers during rest of the journey. Captain Almazán sent twenty-five men to reinforce the soldiers. The Indians did not know they now had additional soldiers, so the next night, the Apaches tried once again to steal more horses while the Isleños slept. However, this time the soldiers repelled the attack and killed several of the Apaches.

Auditor de Guerra Don Juan Manuel de Olivine Rebelled had laid out an itinerary that allowed the Isleños 25 *jornadas* (journey days) with 4 extra days for rest, thus allowing them 29 days to travel from Cuautitlán to Saltillo. From Saltillo, they would take 23 journeys, with 2 days' rest at

Monclova and 2 days' rest at the Presidio del Norte. The second segment of the journey was to take a total of 33 days to travel from Saltillo to the Presidio de San Antonio de Béxar. The entire journey was to take 62 days. They left Cuautitlán on November 15 and arrived in San Antonio on March 9, a total of 115 days.

This was a journey that today no one would have the courage to make under similar circumstances. This group of Canary Islanders showed a great deal of courage, perseverance and persistence in order to start a new life in a land that was completely unfamiliar to them. This was the beginning of the Villa de San Fernando de Béxar and the permanent occupation of the province of Téjas. They had traveled on a journey of more than 6,800 miles, taking 347 days in total.

The following is a complete list of the Canary Islanders who answered the call of King Philip V asking volunteers to immigrate to America. The initial group of ten sailed from Santa Cruz, Canary Islands, to Havana, Cuba, where they were joined by the brothers Ignacio Lorenzo and Martin Lorenzo de Armas from San Sebastian in Gomera. Manuel de Niz and Salvador Rodríguez joined in Veracruz, Mexico. The final two Isleños, Francisco Arocha and Vicente Travieso, joined in Cuautitlán, Mexico, completing the following list. They finally reached their destination, San Antonio de Béxar, where they were to establish the first civil government and settlement in the Province of Texas for Spain.

- The Juan Leal Goraz family, born on the Island of Lanzarote.
- The Juan Curbelo family, born on the Island of Lanzarote.
- The Juan Leal Jr. (*el Mozo*) family, born on the Island of Lanzarote.
- The Antonio Santos family, born on the Island of Lanzarote.
- The Joseph Padron family, born on the Island of La Palma.
- The Manuel de Niz family, born on the Island of Grand Canaria.
- The Vicente Álvarez Travieso family, born on the Island of Tenerife.
- The Salvador Rodríguez family, born on the Island of Lanzarote.
- The Francisco Arocha family, born on the Island of La Palma.
- The Antonio Rodriguez family, born on the Island of Grand Canaria.
- The Joseph Leal family, born on the Island of Lanzarote.

- The Juan Delgado family, born on the Island of Lanzarote.
- The Josef (José) Cabrera family, born on the Island of Lanzarote.
- The Maria Rodriguez-Provayna Granadillo family, born on the Island of Lanzarote.
- The Mariana Meleano Delgado family, born on the Island of Lanzarote.
- Felipe de la Cruz Perez and José Antonio Perez, brothers, born of the Island of Tenerife and Martin Lorenzo de Armas and Ignacio Lorenzo de Armas, brothers, born on the Island of Gran Canaria.

THE ARRIVAL OF THE CANARY ISLANDERS TO SAN ANTONIO DE BÉXAR

On March 9, 1731, day 347, they marched through the wide gate of the stockade that surrounded the fort of San Antonio and entered the Plaza de Armas at the southeast corner of the Presidio at eleven o'clock in the morning, accompanied by the beat of a drum roll and the cheers of the soldiers and their families. The plaza is today known as Military Plaza. Having been made aware of the Isleños' arrival, the civilians and soldiers of Béxar came out to the plaza to welcome the new settlers by firing a salute into the air with their weapons. The Spaniards Don Mateo Carvajal and his sons, Manuel and Nicolas, who were part of the royal soldiers in San Antonio—as was his brother, Cristobal Carvajal, and his children—would have been there to welcome them, not knowing how in the future the Carvajal and Cabrera families would become united with the marriage of Don Macario Cabrera and Restituta Carvajal in 1869.

The time to begin the establishment of the first civil government in Téjas had begun. After they were given temporary housing, surveys were taken so that each family would be given a plot of land to build their home. The next step was attending an assembly to hear Captain Almazán read a dispatch from the governor on behalf of King Philip. He ordered that the Canary Islanders were be given the title of "Hijos Dalgos" (noblemen) and were to establish a civil government; they would declare the first city in the Province of Téjas and name the new settlement "Villa de San Fernando."

Each head of the family received the noble title, which was perpetual, to be passed on to each generation. Each male would be called "Don," a title

worthy of respect. After the death of his parents, Juan Manuel and María Rodriguez de Bega, young Josef, at fifteen, was considered the head of the Cabrera household. When young Josef's name was called and he was given the title of "Hijo Dalgo," it was also not a temporary title; it was permanent, to be passed on to every Cabrera male from generation to generation.

There was a drawing for *suertes* (luck), or lots for each head of the family. Josef (also called Joseph) was of medium stature and had an olive complexion, a round face, a Roman nose, smallpox scars, brown eyes, chestnut hair and a thick lower lip. Joseph drew the first lot, next to Antonio de los Santos and his wife, Isabel Cabrera, sister to Josef's mother, María Cabrera. He soon joined the royal militia at the San Fernando de Béxar fort after having built their house, which was most likely a structure called a *jacal*—a hut with a thatched roof and walls made of upright poles or sticks covered with mud or clay. The property was located on the south side of the San Fernando Church. One half of the land facing the plaza was their property, and the other half belonged to José Perez de Casanova, facing the Presidio.

In 1749, Canary Islander Joseph served as a corporal as part of the roll of the complement of the garrison of the La Bahía Presidio of Nuestra Señora de Loreto, as well as the nearby fort La Bahía del Espíritu Santo, both located in Goliad. He served under the command of Captain Don Joachin de Orobio y Bastherra. The captain was respected by the soldiers and treated fairly by him. In November, Captain Orobio y Bastherra was removed, accused of defrauding his men and mismanaging the Presidio. Governor Pedro del Barrio Junco y Espriella took depositions from Corporal Joseph Cabrera and other officers. Because of these reports, Captain Orobio y Bastherra was absolved of all charges and warmly commended for his satisfactory management of the post.

Located on major trade and military routes, La Bahía, which was built of stones, was the only Spanish fortress for the entire Gulf Coast from the mouth of the Rio Grande to the Mississippi. It was a crucial Spanish settlement along with San Antonio de Béxar. In 1749 and 1771, the La Bahía garrison stopped French and English intruders. We know that Josef survived because at some point, he returned to San Antonio, where he died on February 13, 1786. Joseph Cabrera was buried at the San José Mission. Father Pedro Noreño gave him the last rites and signed the book.

His sister Ana Cabrera was described as thirteen years old when they arrived in San Antonio. She was of medium stature and had a slender face, an olive complexion, brown eyes, chestnut hair and eyebrows and a thin nose. Ana married fellow Canary Islander Ygnacio Lorenzo de Armas in

1737, five years after they arrived in Béxar. Ana died on October 10, 1757, at age forty in the Villa de San Fernando de Béxar. The priest signing the burial book was Padre Pedro Ygnacio Ramos.

Ygnacio Lorenzo de Armas and Ana Cabrera had the following eight children from 1744 to 1752: Juana Lorenzo de Armas, Juan Agustin Lorenzo de Armas, Ana Paula Lorenzo de Armas, Vicente de Lorenzo de Armas, María de la Candelaria de Armas, Juan Lorenzo de Armas, Bautista Lorenzo de Armas and his twin sister, Maria Teresa de Armas.

María Teresa married Francisco Xavier Peres de Casanova, son of Canary Islanders José Antonio Peres and Paula Granados. After her husband's death, she married Manuel Berban on May 18, 1778. Manuel served as a city councilman in 1796 and as an attorney at law in 1801. Teresa de Armas died on November 8, 1811, and was buried at Campo Santos, now under the Santa Rosa Hospital.

MARCOS CABRERA

My ancestral lineage comes from Juan Manuel Cabrera and was passed on to his son Marcos, born in 1724 in Lanzarote, Canary Islands, Spain. He was six years old when his physical descriptions were taken. He was of olive complexion and had a round face, black hair and eyebrows and a Roman nose. Arriving in San Antonio de Béxar at such a young age, for Marcos, there was nothing to prepare him for the daunting task that lay ahead for him. He had already learned that a man must learn to handle and ride a horse, be vigilant of Indians at all times and become proficient in shooting a rifle. These things were important in order to defend his family.

Marcos enlisted as a royal soldier at Presidio de Béxar, just as his brother Josef had done. Marcos was not interested in political issues or in following the steps of his uncle Antonio de los Santos, who became *alcalde* in 1733, or Don Ignacio Lorenzo de Armas, his sister's husband, who was elected as *alcalde* in 1738. Marcos chose to become a royal soldier, serving in the Presidio of San Fernando de Béxar; defending the town, able to ride out on patrol with his fellow soldiers; and defending all the families from Indian attacks, which had grown worse each year.

On April 6, 1747, Marcos was about twenty-three when he married María Magdalena de Ábila, daughter of Philipe de Ábila and Idelfonsa (Aldonsa) del Rincón. Baptismal godparents were Miguel de Castro and

María Hernandez. Her family had come from Saltillo, Mexico, and settled in San Fernando de Béxar. The wedding godparents were José Antonio Rodriguéz and Antonia del Toro. Witnesses were Juan Paulino Margués, Luis Menchaca and Joseph Leal.

Also in 1747, Marcos sold the family lot to a fellow Canarian, José Perez-Casanova, also a Presidio soldier. In the official document, Marcos stated that he was selling it to his cousin José Pérez. Marcos sold the property for the price of two good gentle rein horses. At this time, it was of great importance to have good, reliable horses, especially if you were a soldier.

Marcos and María Magdalena had the following children, born in La Villa de San Fernando de Béxar: Juan Manuel Cabrera, born in 1747; José Manuel Cabrera, born in 1748; Juan Cabrera, born in 1750; María Josefa, born in 1753; and Ana Phelipa de la Trinidad, born in 1755. She married Spanish lieutenant Don Francicso Amangual, a well-known explorer and pathfinder to the Province of New Mexico. Another daughter, Prudencia San José Cabrera, was born in 1758, and son Juan Francisco Cabrera was born in 1760. Another son, Manuel Cabrera, was born on December 25, 1750, and baptized on January 1, 1751, in San Fernando Church. His godparents were Juan Andres Travieso and María Ana Curbelo (nephew and aunt). The Isleños still stood by one another in social events and daily life.

María Magdalena's widowed mother, Idelfonsa (Aldonsa) de Ábila, married José (Joseph) Antonío Perés Casanova, son of Domingo Peres Casanova and María Granado. Their daughter, Gregoría Perés Casanova, was born in about 1740. After Idelfonsa died, José Casanova married Paula Rodriguez Granado in about 1737–40. José Casanova married again in 1759 to Juana Gertrudes de la Zerda.

María Magdalena de Ábila died on December 10, 1762, in La Villa de San Fernando de Béxar. In about 1768, Marcos Cabrera married Seledina de Bargas, also known as María Celedina Vasques. Their only child, María Dionicia, was born on October 7, 1768, and died on December 1, 1769, listed in the San Fernando Church burial records.

Marcos Cabrera was killed by the "*Indios enemigos,*" as the death certificate stated, a name by which the Apache Indians were known. His patrol was ambushed by the Apaches on March 8, 1769. He was forty-five years old and, ironically, one day shy of the thirty-eighth anniversary of his family's arrival on March 9, 1731, from the Canaries to San Antonio de Béxar.

His son Manuel Cabrera contributed to the building of San Antonio de Béxar, as we can see his talents and accomplishments in the following article

from the Sunday edition of the *San Antonio Daily Express* on December 30, 1906, in which Manuel was lauded and acknowledged for his skills:

MANUEL CABRERA, THE ARTISAN, MADE THE VERAMENDI DOORS
A Skilled Artisan in Pioneer Days

During the times when the old adobe buildings were built, no architect was employed to draw plans for their construction or to superintend their erection. This fact has not prevented their being substantial and lasting. Some of them have endured for more than two centuries and are good for several more. All of them were constructed on a previously proven and well-defined principle insured their durability.

The old Veramendi Palace is an evidence of this fact. The names of but few of its builders are remembered, but there was one who was the most prominent of them all. It was he who constructed the wonderful and artistic double doors that formed the portal directly in front of where brave Ben Milam was killed just as he was about to enter.

These doors are famous for their beauty and durability. They were made entirely by hand, at that time there being no machinery here for making doors, either blinds or sashes, all of which had to be made piecemeal and in detail. The man who made them did other ornamental and substantial work that made him be remembered long after his death, which took place in 1821. Besides the doors of the Veramendi, he built the balustrades of the first bridge across the San Antonio River. This was on Commerce Street and at the point where the present bridge spans that stream. At that time, the level of the street was much lower than at present and the bridge itself much nearer the water. Several very damaging floods, one of which swept the bridge away, induced the raising of the level of the bridge and street to their present altitude. The original bridge was wooden. The balustrades were ornamental and their composite parts had to be turned on a very primitive style of lathe.

The man who made the doors of the Veramendi Palace and the balustrades of the First Commerce Street Bridge was Manuel Cabrera. He was known for many years as the most skillful artisan of San Antonio. He never required an architect to superintend his work. Those for whom he worked told Don Manuel what they wanted and he constructed it, and invariably to their entire satisfaction.

Besides making the doors for the Veramendi, he constructed the frames for the windows and hewed the huge beams that form supports for its floors or

enter into other parts of its formation. It is not unlikely he did similar work on the old Garza Building in Veramendi Street and adjacent buildings of similar design and materials.

My friend and fellow Canary Islander John Ogden Leal sent this article to me before he passed away. He sent it because he said that Manuel Cabrera was related to me, an uncle from long ago. John Leal was the ex-archivist for the County of Bexar and wrote that the Veramendi Palace on Soledad Street was built by Fernando Veramendi, who came from Spain to Texas and married a Granado girl from the Canaries. The Veramendi Palace on Soledad Street was built in about 1791 and torn down in 1910 by order of the City of San Antonio. The doors were saved and put on exhibit inside the Mission de Valero, called the Alamo. Mr. Veramendi bought the land from a soldier with last name of Castro. He then built the old palace, where his children and grandchildren were born and raised, including Ursula Veramendi, who married James Bowie at the San Fernando Church in 1831. James Bowie was killed in the Battle of the Alamo, while Ursula and her father, Juan Martin Veramendi, as well as his wife, María Navarro, and other family members, died in their ranch in Monclova, Coahuila, during a cholera epidemic.

VIZENTE FERRER CABRERA, SOLDIER AND EXPLORER

Vizente Ferrer Cabrera, son of Marcos Cabrera and María de Ábila, was born on October 28, 1762, and baptized on November 4, 1762, in the San Fernando Church. His godparents were Santiago Perez and María Josefa Leal. He was an infant of two months when, on December 10, 1762, his mother, María Magdalena de Ábila, died in La Villa de San Fernando de Béxar. His father, Marcos, died on March 8, 1769, killed by the Apache Indians. It is ironic that at the age of six, Vizente was an orphan, just like his father, Marcos—another ancestor who did not have the nurturing a child needs growing up. Vizente learned to be tough, a man accustomed using his own wits. He grew up learning the ways of the Indians from the many converts in the mission, even learning their language. Vizente had become familiar with the hill country around San Antonio de Béxar. He was about twenty-one years old when he married

María Encarnación Peréz in about 1783. The godparents were Santiago Perez and Maria Josepha Leal. Canary Islands descendants were still supporting one another at this time.

The redheaded twenty-two-year-old Vizente Cabrera was assigned by a royal *cédula* to take part in an expedition beginning on June 17, 1785. The mission was commissioned by order of King Charles III of Spain to Governor Domingo Cabello, who requested the expedition. The expedition was to be led by Pedro Vial and Francisco Chaves. They were to ride into the hostile Indian Territory called *La Comanchería* near the Red River and secure a peace treaty between the Comanches, Taovayas, Taguacanes, Izcanis, Flechazas and other tribes living in the *Comanchería*. Due to the hostile environments, no one had ever dared enter this hostile territory uninvited. Many Spaniards had been captured, maimed or killed by these Indians. Governor Cabello had been unable to stop the violence until he met the Spaniards Francisco Xavier Chaves and Pedro Vial. Chaves had been kidnapped as a child and raised by the Indians, becoming familiar with the customs and languages of most of the different tribes. Pedro Vial had traded with the Indians for years and even lived among them. He also spoke the Taovayas language, which all Comanches understood, as well as Spanish and French. These two men were trusted and perfect for this mission.

The journey was very dangerous due to the flooding of the rivers, and there was great difficulty in fording them. The expedition was escorted by twenty-five soldiers. Vizente Cabrera and Mariano Gomez were not soldiers at this time but were considered expert horsemen and *carabineros* (riflemen); they knew how and where to ford rivers, making certain that the soldiers, their horses and equipment could cross the swollen rivers safely. They were in charge of the huge cargo train, which contained all the gifts for the Indians. In their diary, Vial and Chavez had written a report to the king of the great difficulty of fording the rivers, noting that had it not been for Vizente Cabrera and Mariano Gomez, they would have found themselves in much more stressful situations.

Vizente witnessed Chaves and Vial face two of the most famous Comanche captains, Capitán de la Camisa de Hiero (Iron Shirt) and Capitán Raspada (Shaved Head)—one side of his head was shaved, while the other had very long hair. Chaves and Vial passed a peace pipe filled with tobacco around the circle to the *Capítanes Grandes*, as well as the *Capítanes Chiquitos*, making their propositions of peace, promising that if they agreed to make peace, Spain would forgive all previous Indians raids, killings and thefts of horses and livestock. This proposal was repeated in about twelve more Indian villages.

A private council that lasted all night was held by the Indians. Bonfires could be seen throughout all the Indian camps. At daybreak, the Comanche chiefs announced that they had agreed to make peace with the *Capitán Grande* of San Antonio and the Spaniards.

The expedition returned to San Antonio. Four days of briefings followed with Governor Domingo Cabello, Chaves and Vial in which they gave the governor a diary that they had kept with all the notes they had made. Also included were the observations of Vizente Cabrera and Mariano Gómez, who received seventy-four pesos against six reales per day earned on the journey. This diary and all the documents were sent to Santa Fe and then to Chihuahua, Mexico. Eventually, they ended up in the Archivo General at Simancas, Spain, until they were transferred to the newly established Archivo General de Indias in Seville, Spain.

After his return, Vizente Ferrer Cabrera enlisted voluntarily for ten years as a private in the cavalry company at the Presidio of San Antonio de Béxar in October 1, 1785. This was one of the documents my cousin Lucinda gave us after her father died. These military enlistments gave us the link to our Canary Islands ancestors—from La Bahía to San Antonio, Texas. The enlistments of Vizente Cabrera and his son José Manuel Cabrera were crucial to making that connection from Mariano Cabrera to his father, José Manuel Cabrera, and then to Vizente Cabrera. The following document is Vizente Ferrer Cabrera's military enlistment:

Filiación

Vizente Cabrera, son of Marcos [Cabrera] *and Magdalena de Ábila, a native of the presidio of San Antonio de Béxar, under governership of the province of Texas. His trade* [is] *del campo; his height is 5 pies and 1 pulgada; his age, 22 years; his religion, Roman Catholic and Apostolic; his physical traits are as follows: stocky build, red hair, eyebrows, and eyes black; ample forehead; complexion, light triqueño.* [He has] *a mark from a wound under the left eye. He enlisted voluntarily and not under duress, for ten years, at this presidio of San Antonio de Béxar, as a private in the cavalry company stationed here, on the 1st of October, 1785. He was read the penalties prescribed by the ordinances. And not knowing how to sign, he made the sign of the cross, having been advised that it was binding and that no excuse* [to the contrary] *would be of any avail to him. Witnesses were Alferes Don Marcelo Valdés and Privates Juan Cadena and Antonio Bergara, of the same company. He was given his term of enlistment paper.*

In 1798, Vizente Cabrera served under the command of Colonel Manuel Muñoz, part of a detachment sent to Nacogdoches to patrol the Louisiana border against illegal trade. In 1802, Vizente deserted with soldier Manuel Flores but later returned to the Presidio de Béxar. He was pardoned for the offense in 1803. In 1816, he served at the Presidio of La Bahía del Espíritu Santo as a *carabinero*; he became entangled in the early days of the discontent before the revolution by helping four friends who desperately needed horses. Anyone who aligned themselves with insurgents was considered a traitor against Spain. Vizente helped friends who had been branded as insurgents and consequently was arrested and jailed in Monterrey to await trial. But by 1822, Mexico had won the revolt, and Vizente began serving under Mexico, assigned to the Presidio Espíritu Santo at La Bahía as a *cabo* (corporal) until he was honorably discharged on April 12, 1827, at the age sixty-five. No record of his death has been found.

CHILDREN OF VIZENTE CABRERA
AND MARÍA ENCARNACÍON PEREZ

María Ignacia Perez Cabrera was born on August 15, 1784. She married José Antonio Bustillos on February 9, 1804, in La Villa de San Fernando de Béxar; he was the son of José Bustillos y Zevallos and María Salinas. José Antonio Bustillos was born on August 8, 1775, in Béxar. María Ignacia Perez Cabrera died on July 9, 1815, in La Villa de San Fernando de Béxar. Their children were José María, born in 1804; José Antonio, born in 1807; and María Josefa de Jesus, born in 1808.

José Manuel Cabrera, son of Vizente Cabrera and Encarnación Pérez and grandson of Marcos Cabrera, was born on June 24, 1786, in la Villa de San Fernando de Béxar and baptized on July 2, 1786. The godparents were Manuel Berban and Teresa de Armas, daughter of Martin Lorenzo de Armas and María Robaína de Bethéncourt. José Manuel had enlisted in the royal military in 1805 and was assigned to the Presidio of La Bahía.

The following is a copy of his retirement document; he was forty-one years old:

> *On behalf of His Excellency Don Anastacio Bustamante, of the State of this republic, and Commandant on all inspections of the active troops of all the garrisons, I, General Ma. Ybarra present this cédula to Jose*

Manuel Cabrera, soldier of the company of the Presidio La Bahía del Espíritu Santo is granted with eleven pesos monthly which is due him. The said, José Manuel Cabrera, soldier of the Presidio of La Bahía del Espíritu Santo, son of Vizente Cabrera and Encarnación Perez, native of the Presidio of La Bahía in the state of Téjas, residing thereof.

His height is 5 feet tall, nineteen years of age, His description is: olive complexion, grayish/brown eyes, brown hair, a small scar at the beginning on the left hairline, Roman nose, small beard. His post: campista in the Central Plaza. His was a voluntary enlistment. He is retired with an honorable discharge on October 30, 1827.

José Manuel's wife was Gertrudes de Castro, who was born sometime between 1770 and 1786 in Mexico. The children of José Manuel Cabrera and Gertrudes de Castro included Mariano Cabrera, born in 1811 in San Antonio de Béxar; Celestina Cabrera; and Manuel Cabrera, born in about 1835. Another son, Juan Cabrera, is listed as a messenger from the Alamo under the command of Juan N. Seguin with the Second Regiment of Texas Volunteers, Ninth Regiment. Many joined the Texas cause due to Seguin, who had grown up with the majority of them, and trusted his decisions.

José Manuel's son Tómas Cabrera could not sit by while the Texans began stealing everything the Mexicans/Hispanics had worked for all their lives. Years later, after the loss of Mexico to the Texans, he fought the courts throughout the 1850s to keep his property but finally lost it in Brownsville to the Texans, who used their courts to take Mexican lands or used violence to subdue them.

Tómas joined Juan Cortina, a close friend of his family. Tómas became his first lieutenant, and together they stood against tyranny and oppression. They wanted to curtail the troubles caused by the Anglo American and restore Mexican authority north to the Nueces River. They did not go against honest citizens—their objective was to chastise those who persecuted and robbed the Mexicans without any cause or for no other reason than being of Mexican origin. Cortina organized a small army of angry Mexicans and virtually infiltrated and isolated Brownsville from the outside world. He seized the United States mail and sent the town into a state of panic. It was strange that the town officials begged assistance from the government in Matamoros, Mexico. It responded by sending Mexican militia of fifty men across the river to protect U.S. citizens from an irregular army of Mexicans being led by a man who considered himself a U.S. citizen and had once been a

member of the Matamoros militia. It was confusing to those in Austin and Washington alike.

The crisis could have ended there, but on the morning of October 12, 1859, First Lieutenant Tómas Cabrera rode upriver toward Cortina's Rancho del Carmen. The sheriff recognized Tómas as Cortina's chief lieutenant. Tómas was captured and arrested and thrown in jail. Captain William G. Tobin and his Texas Rangers arrived in Brownsville in 1859, a sorry lot responsible for the hanging of sixty-year-old Tómas Cabrera. This hanging helped to generate much of the violence that followed.

Soon after, Cortina gave up control of Brownsville after he was persuaded by José María Jesús Carvajal, one of the most influential men on the border, to stop the violence. In the end, the Mexican Commission absolved Cortina of cattle stealing, concluded that he had been the victim of a smear campaign conducted by Texans with ulterior motives and allowed him to leave the United States and cross the Rio Grande into Mexico. Cortina established his niche in history as a hero to his people; his legacy will long remain an integral part of the Texas/Mexican border. Tómas Cabrera will also share in that legacy and remain a hero to our family because of his determination to end the brutalization of Mexicans in Texas.

I could not find the appropriate words to end this, so I will let this poem, written by Sandy Lamere Solari, speak for me.

ANCESTRAL PROMISE

I will show importance to their existence, even though some paths are marked by a trail of sorrow, left a lonely tear.
I will walk along paths marked in stone to delve in paths existed and left alone.
I will search so that time cannot erase ancestors of yesteryear, who have left without a trace.
These are promises I will keep dear in my heart, for only a short time will we be apart.

Chapter 6

OUR FAMILY SEARCH
FOR TIES TO EARLY TEXAS

By Hector R. Pacheco

It wasn't until a short five years ago that I found out how our family had ties to Texas history. Many hours of research by a handful of members of the Pacheco family provided much information about our rich cultural heritage and beginnings here in this great state of Texas. I will tell you the story of just how we discovered our heritage and the role our ancestors played in Texas history.

LANZAROTE ANCESTORS

You will read at least one more story in this book about my ancestors in some detail all the way back to March 9, 1731. Of course, this region was inhabited by American Indians thousands of years earlier. Only my ninth-generation great-grandmother María Rodríguez-Provayna Granadillo and five children made the trek from Vera Cruz, Mexico, by foot to the Spanish Province of Texas. One of her children died en route, as the trip was nine months long. They were accompanied by Spanish royalist soldiers, as this was Indian country. There were many tribes here in this region and south in present-day Mexico, mostly Apaches and Comanches. Their trip was facilitated by King Philip V of Spain, and his reason for sending these Islanders (also known as Isleños) to Nueva España in North America was to populate this region.

The Spanish were very good at recording events and people. Some of the following information can be found at bexargenealogy.com and the archive records at the Bexar County Archives. My ninth-generation great-grandfather Juan Rodríguez Granado did not complete the trip because he died just as he and his family reached Vera Cruz, Mexico, of *el vomíto* (tropical fever) in 1730. He was born in 1669 in Lanzarote. My ninth-generation great-grandmother María Robaína de Bethéncourt was born in 1709, the daughter of Manuél and Paula Umpienes (Umpierre), natives of Lanzarote, and was twenty-seven years old, according to the November 8, 1730 Quatitlán list. "She claimed to be a descendant of Jean de Bethéncourt who, early in the fifteenth century, achieved the conquest of the Canary Islands for Henry III of Castile. The Bethéncourt family dates back to circa 1200 in Normandy, France where the first Bethéncourt joined the Duke of Normandy in the invasion of England in 1066."

María was of good figure, slender, and had a long face, fair complexion, black hair and eyebrows and a thin nose. "As a descendant of the first conquerors and rulers of the Canary Islands, she was without question the social leader of the Villa of San Fernando de Béxar." Since she was still a young widow, she eventually married another Canary Islander named Martín Lorenzo de Armas and had another family with him. Her original grant was on the Plaza of the Íslas, facing west and north of the Casas Reales, extending east along the south side of the street going to the Valero Mission (now Commerce Street). She was the head of the fourteenth family. She was buried in San Antonio on January 26, 1779. A copy of her will was found dated January 5, 1779. In it, she requested to be buried under the baptismal font (still standing) at the church of San Fernando (which later became the San Fernando Cathedral).

The Granado home was built in a typical style, with a patio and arched corridors. The furnishings were worthy of the most beautiful of modern homes of the time, most of them being brought from the Canary Islands as heirlooms. María wore jewels worthy of mention for those pioneer days: a rosary and earring set with emeralds, a cross with small stones and pearl bracelets. She had a strand of emeralds set in gold, five strands of pearls, a pair of garnet bracelets, golden lockets and an ivory fan. She also had a cigarette case of made of burnished gold. "According to family tradition, the widow María Robaína de Bethéncourt had letters to the viceroy, Don Juan de Acúña, Marques de Valero, for whom she named one of her sons, born in Quatitlán, Juan de Acúña, later called Juan Francisco." Her eldest son was Pedro Rodríguez Granadillo (Granado), born in 1719 and died in

1784. Her other children were Manuel Francisco Rodríguez Granadillo, Josefa Rodríguez Granadillo, Paula Rodríguez Granadillo and María Rodríguez Granadillo.

The family owned a tract of land near San Antonio on the other side of Cíbolo Creek called San Antonio de Cíbolo. It was bounded on the east by the ranch of Vizente Álvarez Travíeso. The other tract of land was adjacent to this and was called the Palo Quemado. They owned cattle, and through documents discovered in the Spanish Archives, our family discovered that our ninth-generation great-grandmother María Robaína Rodríguez-Bethéncourt contributed cattle to General de Galvez in Louisiana to feed his army during the American Revolution. Her son Pedro Granado also contributed to the war effort. Both of their names were added to the Texas Society of the Daughters of the American Revolution Monument at the Texas State Cemetery in a ceremony in Austin on September 8, 2017.

RECENT ANCESTORS

Let me begin by talking in general terms about the Pacheco families (present day) here in and around San Antonio. We all had humble beginnings. Our families grew up living in many of the small towns all around San Antonio, and I learned that there are thousands of us. Some of us grew up in the Catholic Church, and others, like my family, were Protestant. In any case, the Pachecos raised their families in this area for hundreds of years. We were here 104 years before the Battle of the Alamo took place. My siblings and I first heard part of our family history from my paternal grandfather, Aléjandro Pacheco. There were parts of our history that were not known to us until a few short years ago. But before I recount the story and role of our family in Texas history, please allow me to give the reader an insight into our family life very early on. It's important to have this written down for posterity.

For the most part, my paternal grandfather, Aléjandro, and his brothers raised their families in Floresville and San Antonio. Aléjandro Pacheco was a farmer and owned land in Wilson County, which is southeast of San Antonio. Grandfather was born Aléjandro Zámora Pacheco in 1895 in Wilson County, Floresville, Texas. Aléjandro was born to great-grandfather José Donato Pacheco (born in 1870 in Graytown, Texas) and his wife, Martina Zámora (born in 1870 in Bexar County). They married on October 30, 1887, in

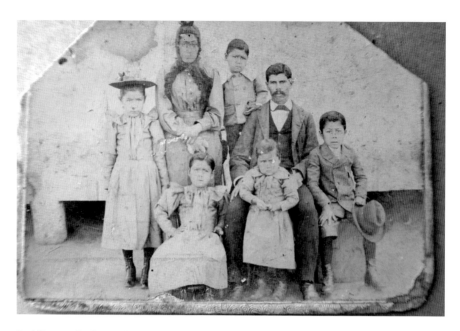

José Donato Pacheco's family. *Front row, left to right:* Sara Pacheco Muniz, Librada Pacheco Alfaro and Santiago R. Pacheco. *Back row, left to right:* Tulitas Pacheco Martinez, Martina Zamora Pacheco, Aléjandro Z. Pacheco and José Donato, circa 1900. *Courtesy of Sara Pacheco Muniz.*

Bexar County. José Donato was a farmer, and Martina was a housewife. José Donato was born to great-great-grandfather Favian Sebástian Granado Pacheco (born in 1834 in Wilson County). Favian's wife was Francisca Salinas (born in 1842). They had eleven children. Aléjandro married Estér Herrera on December 26, 1917, in Floresville, Wilson County, Texas, and had seven children. The parents of grandmother Estér Herrera were Ignacio Herrera and Julia Muníz, both of Fairview, Wilson County, not far from Graytown or the town of Floresville. And our fourth-generation great-grandfather was José Leonício Granado Pacheco (born in about 1806), and his wife was María Antonia Anastácia Conde (born in about 1813).

This next part is oral history, given to me by my uncle Estévan Pacheco (Uncle Benny). Aléjandro was a farmer in Floresville just like his forefathers. They were unlike many families who lived in that community in that they raised a large family. He worked very hard to provide for his family on the land that he inherited. He owned very little livestock, and he grew mostly corn and peanuts on his land. He even helped others who could not till their own land. This provided him with income. Grandma Estér was a housewife and cared for their seven children. The local grocer in town always extended

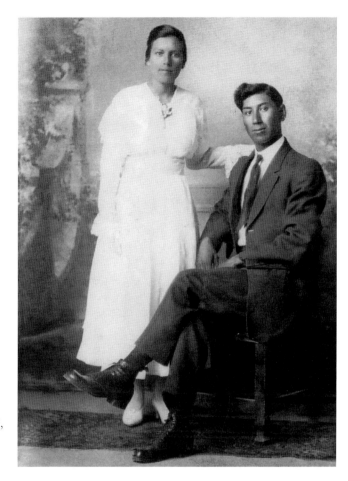

Estér Herrera Pacheco and Aléjandro Zamora Pacheco, taken on the day of their marriage on December 26, 1917, in Wilson County. *Courtesy of Hector R. Pacheco.*

him credit in exchange for crops and money. He, like others in those days, bartered for goods and services with their neighbors. The family grew up in the Methodist church in Picoso, Wilson County, Texas, called the Iglésia Evangélica Mexícana. This church was the first church that his family attended. All his siblings and their families were Methodists too. It was simple living, and their love for the church sustained them. By many standards, they had a very comfortable life. In 1940, he decided to move the family to San Antonio to find easier work. San Antonio was just thirty miles northwest of Floresville. Dad was just fifteen years old when they moved to San Antonio. Aléjandro's brothers and sister followed suit and moved their families to San Antonio, except my great-aunt Sara Pacheco. We saw our cousins all the time since all the families attended the same church in San Antonio, Pollard Memorial United Methodist Church.

In addition to farming, grandpa was a talented carpenter and soon found a good job working for the government at one of the local military bases. The U.S. government required that males born after April 28, 1877, and on or before February 16, 1897, must register for military service. Aléjandro fell in this group, as he was born on April 24, 1895, and he was called up for active duty at the age of twenty-two. He was married in that same year, and Grandma was already pregnant when he left for military service to Tallahassee, Florida. He spent six months there. During this time, World War I ended, and he was transferred back to Fort Sam Houston, Texas, and spent a few more days there. He was not allowed to go home to nearby Floresville, and as a result, he was not present for the birth of his first child, a male whom they had named Samuel. He died at birth. Aléjandro never saw his first child, as they had already buried him before he got discharged and was allowed to go home.

His registration card is interesting. I mentioned that he was twenty-two when he was called up for military service. This card shows that he was forty-seven years old and lists his employer as the War Department, Air Corps, SAAD Duncan Field, San Antonio. His serial number was U 735. This document indicates that he signed this *after* he was discharged from active duty. I don't have an explanation for this, but that is his signature.

Not many family birth certificates show that my ancestors were born in Mexico. That is because this region was ruled by Mexico starting in 1821 for

Military registration card, circa 1940. *Courtesy of Hector R. Pacheco.*

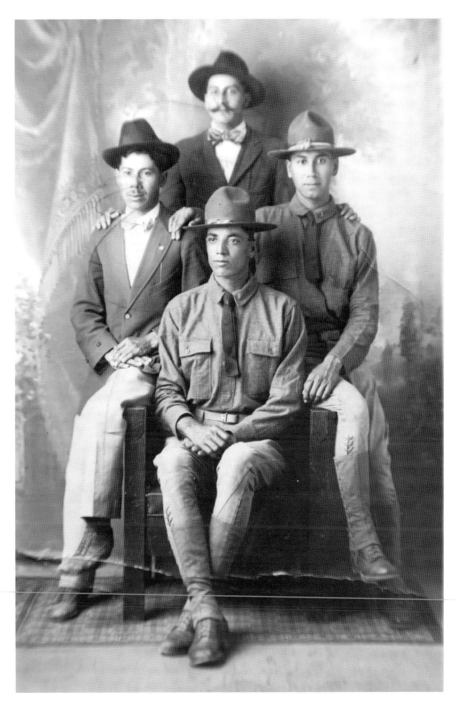

Santíago Zamora Pacheco (*left*) and Aléjandro Zamora Pacheco (*right*) in soldier's uniform on either side of two unknown men, circa 1917. *Courtesy of Sara Pacheco Muniz.*

only about a decade before becoming the Republic of Texas. Before Mexico ruled this land, it belonged to Spain. It was known as Nuéva España, or New Spain, and Spanish was spoken here long before English was accepted as the more common language. I found many of my ancestors' records and names at the Wilson County Courthouse, as well as through census records, baptismal records, birth certificates and such. Graytown was a very small community in Wilson County and is mentioned in many of the family records. It lies just twenty-eight miles southeast of San Antonio, Bexar County, Texas. There is a cemetery named the Picoso Cemetery, and the land the cemetery is situated on was originally owned by great-great-grandfather Favian Sébastian Granado Pacheco. It was acquired by the Martinez family of Floresville. They are cousins to the family. The cemetery is located just seven miles from my present home in Graytown (Wilson County), Texas, off FM 536. There you will find many of the Pacheco and related family ancestors buried. Other Pacheco families' ancestors are buried here and at the Graytown Cemetery nearby. The grandparents I mentioned earlier are buried at Picoso Cemetery all the way back to third great-grandparents. This is where I want to be buried because I feel so close to my ancestors. A short distance and right turn from the cemetery is FM 2579, and I live off this road on County Road 126. So, I live on or close to my ancestors' places of birth, baptisms, marriages, residence and final resting place.

My parents, Abel Herrera Pacheco and Hilaria (Lala) Puente, were born in rural communities just southeast of San Antonio in Floresville and Falls City, respectively, in 1925. They married in San Antonio, Bexar County, Texas, on October 18, 1946. My mother's parents, Julian Puente and María Remédios Flores Puente, were Catholic but converted to Methodism early in Mom's life. Both her parents were born in Mexico—Julian in San Luis Potosí and María Remédios Flores somewhere near the northern border of Mexico and the United States. My siblings and I were all born in San Antonio. Both my mom and dad had high school diplomas, and Dad found work as a police officer with the San Antonio Police Department. Mom worked for the City of San Antonio Health Department. They worked thirty-three and thirty-two years, respectively, in their fields. I will say to you that it has been only recently that our families had college graduates. I can recall that only one of Dad's first cousins was college educated. That all has changed. Many of the descendants have careers in sales or advertising or as teachers, lawyers, administrators, pharmacists, business owners, speech therapists/pathologists, communications majors and in other fields in the tech industry. We are as diverse as the rest of the country.

EARLY HOME LIFE

Our early life was also very simple. Our family lived with my maternal grandparents, Julian and María Remédios Puente, until I was twelve years old. That's because my parents were saving for a down payment on a home. In those days (the '50s), my dad had a '51 Chevy with standard shift. Dad had not yet landed a job with the police department. He would pile us in the car and take us to the local park, Concepcíon Park. The San Antonio River runs right through the park, and he would park his car at the edge of the river. As we children played in the water, he would wash his automobile with the river water. I can remember my Uncle Abígael bringing his family to the river and washing his automobile as well. It was a nice diversion, and we really enjoyed the water with our cousins during the hot summer days. A few years later, the City of San Antonio built a swimming pool right there, and it was free to all the kids. Dad had joined the police department in 1956, and he bought a brand-new 1957 Chevrolet station wagon the following year. I remember the family taking a vacation trip to California with my Uncle Abígael and Aunt Cora and family in the summer of 1958. That was some real fun. I remember those times with fondness.

No matter how poor our different families were, everyone was dressed in their best for Sunday morning church services. We boys wore ties, and Dad wore a suit just like his brothers and father. My grandfather and his brothers wore Stetson hats to church. I practice that today, although not every Sunday, but I still wear a suit to church. We also enjoyed Halloween every year in our neighborhood. I can't recall any of our neighbors not participating. We waited with anticipation for dusk to begin on Halloween night. We would walk the neighborhood for our candies and other goodies. In those days, many people gave us pecans, pennies and fruit, as well as the usual hard "ribbon" candies and bite-size chocolates. Our costume masks were all the same. They were usually "cutouts" of the face of Handy Andy. His was the comical face that was on each grocery bag of the local grocer by the same name. That was the most popular grocer in San Antonio in those days. Mom would just take her scissors, cut out the paper bag face and attach it to our ears with rubber bands. Sometimes we wore sheets over our heads or mom would paint our faces. We were poor, but we never knew it. No complaints.

Grandpa Julian had a small patch of ground behind the house where he grew corn and other vegetables. He also had a "chicken coop." When Grandma was in the mood for chicken, she would call one of us children to

tell Grandpa to kill a chicken. If it was my turn, I waited in the chicken coop with Grandpa until he caught one by the neck and twisted it off with circular motions of his arm. Then he would call me over to take the chicken by the feet while it bled out. Then I would take it inside for Grandma to put in hot water before plucking it afterward. We had no problems eating it. Fresh vegetables and poultry are so delicious! Grandma was real good at making *menudo*, a soup of tripe and pigs' feet with hominy, red chili powder and other seasonings. We had this often in our home. We usually ate homemade corn tortillas with this soup. But Grandma and Mom would also make fresh flour tortillas, pinto beans, *nopalitos* (cactus) and other ethnic foods of Mexico. And everyone we knew also ate *bárbacoa*, which is the cheek meat of a beef head, and *cabríto*, the meat from a kid (goat). Those were the favorites. We usually would buy these from local vendors. One of my favorites was calf tongue (*lengua*). Mom would slow cook it and then cut it in slices and bread it with flour. She would then fry these and serve them fresh. Such a culinary delight. We ate our wild game too. Dad would sometimes take us with him when he and his brothers would go to nearby Floresville for a rabbit hunt. I learned to shoot a .22-caliber rifle early in my childhood. One of my uncles would take a skillet to cook the freshly killed "cottontail."

Every spring, Dad would buy us all kites at "La Luz" frutería on Nogalitos Street. This was a very large fruit and vegetable stand not far from our home where we always bought the annual Douglas fir Christmas tree. To this day, when I smell a Douglas fir, I am reminded of those early Christmas holidays and the particular ornaments and candy canes that decorated the tree. One of my friends who grew up in Elmendorf remembers that the Methodist church in Floresville decorated the Christmas tree with oranges, caramel apples and candy canes that the church always shared with the kids after the Christmas program. Anyway, we always bought our kites at the fruit stand. They were made of balsa wood and paper. Kites were ten cents, and the string cost five cents. Grandma had a small storeroom (*el quartito*) in the backyard, and she allowed us to cut strips of old linen for the kite tails. We had the ideal place to fly them also. Just half a block away was St. James Catholic Church, and it had an ample open area behind the church. My two brothers and I along with our three childhood friends the Ramirez brothers would all fly our kites there to see how many spools of string we could use to fly them. We always lost them if the winds were strong. No matter—Dad always bought us more. On summer breaks from school, we also would walk together to Concepcíon Park's swimming pool for a cool swim. We had to walk because our parents were all working. Our

parents would give us money to buy *raspas* (shaved ice with flavored syrup served in a conical cup) at the concession stand. We would usually wait for these treats when we got ready to walk home because it was not fun walking the ten blocks back in the midday late summer sun, as none of us owned a bicycle.

Our primary language was Spanish because it was the language of our ancestors. Spanish was primarily spoken at our church, too, even though it was a bilingual Methodist church. We children were bilingual before entering the first grade. Like many of my elementary friends at Hillcrest Elementary School, we grew up speaking Spanish at home, and the teachers at school were very strict with us and demanded we speak only English while at school. It made sense, of course, but not to little first graders who were not used to talking too much English, especially with a Spanish-speaking grandmother at home. So when I started the first grade, Mom remembers that I was so upset that I could not speak Spanish at all. I told her so after my first day at school. She laughed and explained why it was important to follow all the rules at school. It was about that time that Mom and Dad bought the very first family television set for our household. My siblings and I increased our vocabularies in no time at all. One of my brothers was the Hillcrest Spelling Bee champion in about the fourth or fifth grade, I remember. I had no trouble making good grades at school after that, and I actually excelled in many subjects. By the time I was in high school at nearby Luther Burbank High School, many of us had forgotten our primary language because of disuse and the demands of the current mindset of society to use English. We now know better, and we do not discourage our children to learn Spanish, as it is very useful to be bilingual in South Texas and other parts of the United States.

Another thing I remember about grade school is that all elementary school children in San Antonio and the surrounding communities got an annual tour of the local bakery, ButterCrust. It was everyone's favorite place to visit. The owners treated all the children with a big slice of hot bread with butter after the tour, and we each received a wooden ruler and two pencils as a gift. It was perfect PR for the company because many of us, including our family, were sent us to school with sandwiches made with ButterCrust bread.

I have lived in San Antonio most of my life and in Graytown for the past twenty-six years. Over the years, I was frequently asked if I had any relatives who lived near and around Mission San Jose or Mission Concepcion. I now know that all the Pachecos in San Antonio and the surrounding areas are my cousins. I am still meeting new cousins today.

Our families are very consanguine, meaning that if we are related by blood, then the mothers, fathers, children, uncles, nieces, nephews and their brothers and sisters were all known to us. Our forefathers shared this information at all family gatherings. All of us knew our cousins and their family tree. And my dad made sure we stayed in touch with our cousins when we were growing up. Often, the whole family would travel to Floresville to visit with our cousins. But on Saturday mornings, after we did our chores that Mom laid out for each of us, we would hop into the family sedan and take the short trip to Grandpa and Grandma's house on the south side of San Antonio to pay our respects. I guess we did this for Dad's side of the family because we lived with Mom's parents until our preteens. Even though we always saw Dad's parents at church on every Sunday, we continued this practice until our early teens.

It was always midmorning when we would arrive. My grandparents usually had their breakfast early. Grandpa Pacheco would then sit and read his Bible before going out to the wooden toolshed that he built in the backyard to work on his latest project. He loved woodwork and carpentry and had acquired many different tools for this type of work. He took pleasure at showing us his toolshed and would explain each tool and their use. They had a very small but modest home on West Harlan Street on a very small lot on the south side of San Antonio. All the homes in that neighborhood were small and old. I don't know when his house was built, but Grandpa always kept up with its maintenance. Grandpa was always the first to greet us at the door when we arrived, and we children would greet them with hugs and kisses on the cheek. We spoke Spanish to them, even though they understood English. My father, Abel, as well as his brothers Abigael, Estévan and Efraím and his sisters Lucilla, Celia and Alicia, could all read, write and speak perfect English with no accent. Spanish helped dad in his police career. On several occasions, he was called on to give public service announcements to the Hispanic community or, at least, help other officers to translate the message from English to Spanish for others to read. They knew dad spoke fluent Spanish and used words in the proper context. To this day, he prefers to speak in Spanish and hear sermons in Spanish.

Grandpa would invite us all to sit down in his parlor. I remember the portrait of great-grandfather José Donato on the left wall just inside the front door. His picture is indelibly imprinted in my mind. Some pictures of his grandchildren hung on other walls of the small house. My older brother Carlos and I had our portrait studio pictures hanging on one such wall. We were about one and a half years old when my mother had our pictures taken.

There were many other pictures on their walls of their sons and daughters, as well as the grandchildren.

On our Saturday visits, if we got lucky, some of our cousins were visiting at the same time, and we would be very excited because we knew there was going to be some "playtime" after Grandpa's talk sessions. But all would first listen to Dad as he reported any new news about our family for the past week. Grandpa was always so courteous, and we all knew to sit and listen to him before we were allowed to play outside with the cousins. As I mentioned, Grandpa preferred Spanish when speaking to us. He was always interested in what we had to say and would ask each of the children to share any stories with him. It was easy to talk to him. We were not shy at all. He always smiled, and we could tell he was very happy we came by to visit them. He addressed the male grandchildren as *mijó* and the females as *mijá*, even though he knew all our names. Somehow it made it more personal for him to call us *mijó* and *mijá*. I still greet my daughters and grandchildren in this manner. Grandma was so quiet, even when we greeted her. Dad would ask how she was feeling, and her answer was always the same. She would say in Spanish, "*Pues poco mal, pero estoy bien,*" or, "I've been a little sick but I'm doing okay." She talked very softly all the time. Dad would tell us later at home that Grandma wasn't really sick and that we shouldn't worry about her.

Their home was very modest. In their parlor, they had a small worn sofa and a few upholstered armchairs, but it was comfortable sitting there nonetheless. After our family news, Grandpa would then open his Bible that rested on the end table by his side. Grandma never sat down. She just leaned on the door to their bedroom adjoining the parlor with her arms crossed on her chest. She would listen to Dad's news for just a little while, and then she would retire to the bedroom or the kitchen to finish up her chores for that morning. After our family news, we all listened quietly as Grandpa read from the Bible. He did this not only because he was a Sunday school teacher at the church but also because the Bible talks about the patriarch of a family as being the scriptural father. He would end his scriptural readings with *consejos*, or advice, explaining to us what the Bible says about many different topics, events and people of the Bible and how it might apply to our daily lives. I sometimes wonder about my childhood friends and if they ever had this kind of instruction from their parents/grandparents. If not, I think they were not as lucky as my siblings and me. I always found it interesting. It was at these sessions that he would sometimes talk about our family name. He and my great-uncles would tell us every so often that our family name was not Pacheco but rather Granado. When asked how this was, they said they did

not know, as it was passed down through word of mouth. No one ever took the time to look into or research this fact. I guess because no one had a clue where to look or find records. It was always at the back of my mind though. Grandpa did not talk about the ancestors who were soldiers because neither he nor my great-uncles knew this history. It's funny how this information did not get passed down to the descendants.

Family Research

Joel Escamilla, a fellow church member at La Trinidad United Methodist Church (my present-day church), talked to me one day. He asked me if I really knew the history of my family name in early Texas history; he renewed my interest in this topic. Joel had edited a book entitled *Pacheco vs. Menchaca (1780): Colonial Texas Litigation Associated with a Cattle Drive to Louisiana during the American Revolution*. Joel had his book published in 2008. He and his wife, Sylvia, are both members of the Order of Granaderos y Damas de Galvéz (Founding Chapter, San Antonio, Texas). This organization was formed to make Americans aware of Bernardo de Galvéz, who was a Spanish governor of the Louisiana territory (a Spanish patriot) in 1779. Long before any formal declaration of war, General Galvéz sent gunpowder, rifles, bullets, blankets, medicine and other supplies to the armies of General George Washington and General George Rogers Clark that fought the British. Once Spain entered the war against Great Britain in 1779, Bernardo de Galvéz raised an army in New Orleans and drove the British out of the Gulf of Mexico. At the time of the editing of his book, Joel Escamilla was the governor of this chapter. He cited his information from two books. One is *Los Mestenos* by Jack Jackson. The other is *The Texas Connection with the American Revolution* by Robert Thonhoff. This book is based on recent research of original Spanish documents in the Bexar Archives at the University of Texas–Austin. Our family name "Granado" is mentioned several times in this book. Almost immediately, I started researching my family history after reading Joel's book.

My research started with information from two members of a genealogical society in San Antonio. They showed me the published books they had in their library. Although there was some information on the Pacheco name, most of the history was found at the Texana Section at the main public library on the sixth floor. I found old Spanish documents on microfiche that I made copies of, and although I read Spanish, these

documents were written in "old Spanish," which was difficult to decipher. Again, I was given help by the society I had then joined, and I was well on my way to finding out many facts about the family name. I was hooked. I started talking about my research to other older family members, and they gave me additional information. I also received a family tree from my cousin Ignacio Herrera of San Antonio. I built on that, and then someone gave this to Julia Muñiz Castro, a first cousin who is a freelance writer for the *Wilson County News* in Floresville. An article she wrote caught the attention of Ralph Anthony Pacheco of Austin, Texas, and he gave me a call one day and identified himself. I told him I had family research of the family that dated back to 1790, and he mentioned all the names I found. He informed me that he had additional information all the way back to 1731. Also, I got goose bumps when he asked if I had ever heard any relatives tell us our family name was not Pacheco but Granado. I couldn't believe what I was hearing. I got very excited when Ralph told me that he knew what had happened in history and that we should get together soon to discuss. But again, he made no mention of the roles our ancestors played in Texas history. I had already determined that our ancestors were from the Spanish Canary Islands but not much else. I was able to obtain old pictures and other documents on the Pachecos through various sources. I utilized other sources online to gather more family information.

I was interviewed by freelance writer Carmina Danini for the *San Antonio Express and News* in March 2015, along with other people who contributed to her article. Following is an excerpt of her article.

New Momentum for Historical Ties Between San Antonio and Canary Islands

Until just a few years ago, San Antonio native Hector Pacheco didn't know much about his ancestors. But when he joined a local genealogy society in 2013, he soon stumbled upon leads that sparked his interest. After hours and hours of studying old books, birth certificates and other antique documents, Mr. Pacheco was able to trace his lineage back 10 generations to a lady hailing from the Canary Islands—Maria Robiana de Bethencourt. The story of her and 55 fellow Canary Islanders who came to the Spanish province of Texas, more than a hundred years before the Battle of the Alamo, is among the lesser-known chapters of San Antonio's rich history. Recently reinvigorated efforts by the Canarian government, including a planned documentary film, might change that.

Although the first group of Spanish explorers came to the river they called Rio San Antonio in 1691, San Antonio was not founded until 1718, when the mission of San Antonio de Valero (now known as the Alamo) and first presidio were established at San Pedro Springs. Intending to Christianize and populate the province of Texas, King Philip V of Spain ordered families from the Canary Islands to migrate. They sailed some 5,000 miles across the Atlantic Ocean and reached Cuba in the summer of 1730. 25 families stayed in Havana, and 16 families consisting of 56 Canary Islanders continued to Veracruz, Mexico, from where they marched 800 miles northwards. They arrived in the Presidio San Antonio de Béxar on March 9, 1731.

"María Bethencourt's first husband, Juan Rodríguez Granado, died of tropical fever after the ship landed in Veracruz," said Hector Pacheco, who serves as president of the Canary Islands Descendants Association San Antonio. "But she still made the trek to Texas with her five children and was granted a homestead on the southeast corner of Main Plaza and Commerce Street. A few years later, she married Martin Lorenzo de Armas, who was one of four men who had come to Texas without a family."

Among the first actions of the Canary Islanders was laying out the site of San Fernando Cathedral, which stands today as one of the oldest cathedrals in the Unites States and the oldest, continuously functioning religious community in the state. Shortly after, they formed the first civil government in Texas, the Villa de San Fernando, which later became San Antonio.

Today, signs of the Canary Islanders can be found all over the city, if one knows where to look. A historic marker on Main Plaza, for example, a small woven fabric at the Spanish Governor's Palace listing the names of the first 16 families, the Aula Canaria at the UTSA downtown campus, and most notably, San Fernando Cathedral, built in part with funds and labor from the Canary Islanders. The Virgin of Candelaria statue in the back of the cathedral, which depicts the Patron Saint of the Spanish archipelago, is a replica of the original one brought by the early settlers, which was destroyed in a fire in the 1800s.

Nearly life-sized, the statue as it stands today was gifted by former Canary Islands President Manuel Hermoso in 1986, and had not been given a makeover until a few weeks ago, when Candido Padrón Padrón, Minister of Foreign Affairs of the Canary Islands, visited San Antonio and brought new gowns for the statue. Assisted by members of the Canary Islands Descendants Association, the minister himself made sure that

the handmade dress and robe were put on appropriately—a well-known procedure on the Canaries, where the omnipresent Virgin of Candelaria statues receive new clothes every year.

"Over the years, we have had many cultural, educational and economic exchanges with Las Palmas and Santa Cruz de Tenerife, our two sister cities on the Canary Islands," said the City of San Antonio's Chief of Protocol and Head of International Relations, Sherry Dowlatshahi. "But mutually beneficial partnerships require continuous fostering, which is why we welcome the Canary Islands' plans to reinvigorate their efforts. This relationship is very important to us."

10th-generation Isleño Hector Pacheco hopes that Minister Padrón's visit, and the upcoming documentary will draw more attention to the story of his ancestress Maria Bethencourt and the 55 early settlers from the Canary Islands.

"It could be the beginning of a new chapter," he said.

Just using the information that our family was here in Texas when it became the Republic of Texas, we are now able to join the Sons (SRT) and Daughters of the Republic of Texas (DRT) and are eligible to become members of the Sons and Daughters of the American Revolution as well. The SRT/DRT consist of members who prove to be of direct lineal descent of those who settled the Republic of Texas prior to February 19, 1846, when Texas merged with the United States as the twenty-eighth state. The SRT traces its origins back to April 1893 and the Texas Veterans Association, which was composed of members who actually lived in the Republic of Texas.

One day, I met with the SRT historian, Christopher Lancaster, and he told me about encountering the Pacheco name on rosters of military units that existed about the time of the Republic of Texas and afterward. I had some knowledge of this because I had read Jesse O Villarreal's book *Tejano Patriots of the American Revolution 1776–1783*. Of course, I was very excited about any new information, and I shared it with my Floresville cousins. And so, we began looking for more information about our ancestors and what role they might have played in Texas history. Much of our information came from Ralph's second cousin Robert Pacheco. Robert was a principal at Harlandale High School in San Antonio for many years. He started his research in the early '70s when he had met and became good friends with the Bexar County clerk of archive records, John Ogden Leal. Mr. Leal had found many old records on the 1800s that were written in old Spanish, and he translated much of

Affidavit of Captain Juan N. Seguín, attesting that Luciano was a "private" in the company of Captain Juan Seguín at the siege and storming of Béxar. *Courtesy of Bexar County Archives.*

this information into English. It was a treasure-trove of old documents. He shared all of that information with his second cousin Ralph, and Ralph continued to do more research on top of what Robert had provided him. In a very short time, Ralph found the information about our ancestor José Sebastian de Jesús "Luciano" Pacheco. He is my fourth great-granduncle and brother to my fourth great-grandfather José Leonício Pacheco. He and two other brothers participated in different battles: Battle of Gonzales, Battle of Concepcíon, Molíno Blanco, Siege of Béxar, Battle of the Alamo, Tejano Republic Rangers (Antonio Menchaca's Mounted Gunmen) and the Civil War from 1861 to 1865. The two other brothers' names are José Francisco Granado Pacheco and José Wenséslao Granado Pacheco.

The most interesting document that was found was a written affidavit from then Captain Juan Seguín, a famous soldier of the Battle of the Alamo, who affirmed that Luciano was a courier for him and was sent on an assignment by Seguín to retrieve a trunk outside the Alamo. This document was shown to a Tejano historian and author, Dr. Jesús F. De La Teja, a professor at Texas State University in San Marcos, Texas. Also, Dr. Bruce Winders, curator at the Alamo, reviewed the affidavit. They both authenticated the document. I commissioned historian, author and painter Gary Zaboly in 2015 to paint a picture of Luciano as he might have looked like in 1836. In order to do this, I provided the artist with pictures of my grandfather Alejandro as a young man.

José Sebastian de Jesús "Luciano" Pacheco, baptized José Sebastian de Jesús Pacheco in 1819 in San Antonio, was given the nickname "Luciano" as an infant by his family, a name that he would use all his life. Luciano was raised by his mother, Doña Encarnación Pulído, who was widowed in 1823 by former city councilman Don Alvino Pacheco. Luciano was the youngest of their five Pacheco sons.

after the date of the service rendered—Affiant never heard that Pacheco aided or assisted the Enemy or that he had at any time left the Country but he seems to have Continued to live permanently in a remote & isolated ^settlement^ L. Pacheco is an uneducated man who does not understand a single word of the English Language.

Juan N. Seguin

Sworn to and subscribed before me this 6th February A D 1875

Witness my hand and seal

Jno V Rosenheimer

Notary Public B. C.

State of Texas } Before me Jno Rosenheimer a Notary public in &
County of Bexar } for said County & State personally appeared Ignacio Espinosa to me well known who having been duly sworn by me upon his oath declares & says that Luciano Pacheco who makes the foregoing application for Military Pension is the same & identical man who together with witness was a private in the Company of Capt. Jno N Seguin at the siege & storming of Bexar that he served for several months in said company that he never left the Country nor did he aid or assist the Enemy—Witness declares that in his opinion said L. Pacheco is as much entitled to the pension which he applies for, that he believes that Pacheco has never received any compensation both in land or money for his Military service up to the present moment

his
Ignacio + Espinosa
Mark

Sworn to and subscribed before me this 6th February A D 1875

Witness my hand and seal

Jno V Rosenheimer

Notary Public B. C.

Second part of the affidavit of Captain Juan N. Seguín. *Courtesy of Bexar County Archives.*

Depiction of Luciano on horseback, receiving orders from Captain Juan N. Seguín at the Alamo. *Drawn by and courtesy of Gary Zaboly.*

When the call for rebellion against the tyranny of the Mexican central government went out, Luciano and his brothers rallied to the side of a family friend, Juan Seguín, early in the rebellion. The young seventeen-year-old Luciano was to see action at the Battle of Concepción and the Siege of Béxar with many other Tejanos. He entered the Alamo with Seguín. With the unexpected arrival of Santa Anna's army, however, Luciano was sent on an assignment by Seguín to retrieve a trunk. Early in the siege, he was easily able to slip by the Mexican patrols. Upon his return, however, the patrols had been increased, and try though he might, he was unable to make it back to his comrades.

After the fall of the Alamo, as the Republican Army fled to the east, pursued by Santa Anna, the young Luciano was left to hide among the residents of the city. It was not until the return of Captain Juan Seguín that he learned of the victory of the Texans against the army of Santa Anna. After the Alamo, he continued his service to Texas by joining one of the early Texas Ranger units under Captain Antonio Menchaca. It was while

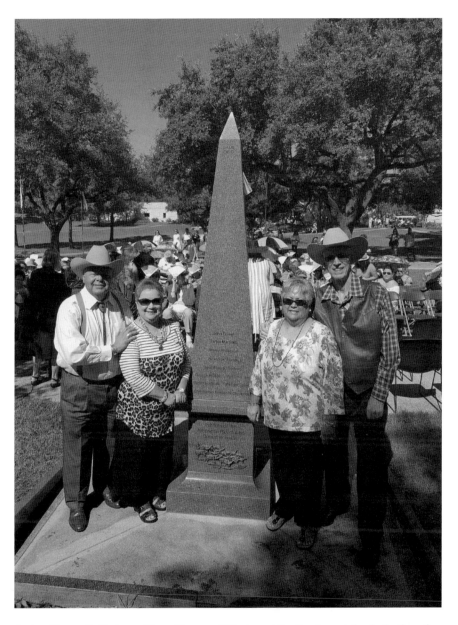

Author Hector R. Pacheco, Grace Perez and Gloria and Jim Lawhon at the dedication of our ancestors' names added to the historical monument at the Texas State Cemetery in Austin, Texas, on September 8, 2017. *Courtesy of Hector R. Pacheco.*

riding with Menchaca that Luciano saw his older brother Francisco die in 1837. After the battles were over, Luciano took up arms one final time to defend his state during the Civil War.

When Luciano died in 1898 at the age of seventy-nine in Wilson County, he was one of the last three Alamo defenders and the last of the Tejano defenders to die. By the end of his long life, Luciano had been a veteran of the Texas Revolution, an Alamo defender, a Texas Ranger, a Civil War veteran and, finally, active in securing recognition for his fellow Tejano veterans for their service against Santa Anna. His is listed as a witness in three Republic pension requests.

Luciano's descendants can still be found in Bexar and Atascosa Counties today. These words are an excerpt of an article written by Ralph Anthony Pacheco in the *Wilson County News* dated July 29, 2015. I subscribe to the Texas State Historical Association (TSHA), and I found that Luciano's role at the Battle of the Alamo is now included in the 180th anniversary edition of "The Battle of the Alamo" and can be found at the website of the TSHA. For more than a century, the Texas State Historical Association has played a leadership role in Texas history research and education, helping to identify, collect, preserve and tell the stories of Texas. It has now entered into a new collaboration with the University of Texas–Austin to carry on and expand its work. In the coming years, these two organizations, with their partners and members, will create a collaborative whole that is greater than the sum of its parts. The collaboration will provide passion, talent and long-term support for the dissemination of scholarly research, educational programs for the K-12 community and opportunities for public discourse about the complex issues and personalities of our heritage.

Background Information

As of January 2017, the University of Texas–San Antonio has seven students looking at centuries-old documents headed by project archaeologist Clinton McKenzie of the Special Collections Department, Peace Library. They are cataloguing records dating back to at least the 1700s of deeds, judgements and grants to piece together the history of the segment of downtown San Antonio surrounding Main Plaza in front of the San Fernando Cathedral. When they are finished, they will have

created interactive story maps that will serve as tools to allow amateur as well as professional historians, and the public at large, to explore the region's rich archaeological and historical sites. The story maps will be published online, showing how land and ownership have changed in San Antonio over time and documenting the thousands of years of history that predate the city's tri-centennial. The Bexar Archives, the official collection of Spanish documents up to 1836, will also serve as references for individual projects, which explore different groups of people, including mission communities, Native Americans and Canary Islanders. The Bexar Archives was one of the main sources of information that was utilized by Robert Pacheco over many years of research.

I am the past president of the Canary Islands Descendants Association (CIDA), which has been featured in the local newspaper many times. Currently, as a member of the executive board of CIDA, we are working with the City of San Antonio for the preparation of the 2018 tri-centennial celebration. The city is hoping that officials from Spain and the Canary Islands will visit during the yearlong event. There is an initiative called the San Antonio Founders Monument, whose vision is to erect a permanent historical monument that will be created to honor the communities that founded San Antonio. The monument will interpret the "Welcoming of the Canary Islanders by the resident Native, Presidio and Mission communities." The monument would be placed downtown, within the historic Civic Center of San Antonio, where the communities began.

San Antonio has two birthdays: May 1718, to commemorate the founding of the Mission San Antonio de Valero by Franciscan missionaries and the Presidio San Antonio de Béxar by Spanish settlers, and March 9, 1731, to commemorate the founding of the Villa San Fernando de Béxar and the first civil government in Texas by the Canary Islands colonists.

Conclusion

For me, this has been a joy to write. I loved reading about my ancestors, where they came from and where they have taken us in history. Our story is not unique. Many of the descendants of those original Canary Islanders have such wonderful stories too. We all had to dig hard to find the stories of our families and to trace our genealogy. I just wish this knowledge was more widely known to us, the descendants, years ago while we were growing up

in San Antonio and that our history had been recorded in history books for us children to read and identify with. I'm happy that we can leave posterity with this knowledge now.

> *For historians ought to be precise, truthful, and quite unprejudiced, and neither interest nor fear, hatred nor affection, should cause them to swerve from the path of truth, whose mother is history, the rival of time, the depository of great actions, the witness of what is past, the example and instruction of the present, the monitor of the future.*
> —*Miguel de Cervantes*

Chapter 7

THE PACHECO FAMILY HERITAGE

By Robert Pacheco, member of the Canary Islanders Descendants Association (CIDA)

INTRODUCTION

Before I begin this narrative of the Pacheco family history, I think that it is fair to give credit to a vital female member of the fourteen Canary Islands families who answered the call from King Philip V for volunteers to come to Texas. These families would help to establish the first civil government in Texas.

This young woman was María Robaína de Bethéncourt. Maria must have been a brave woman to give up the comforts of home in Lanzarote to come to an uncivilized wilderness in hopes of providing a better life for her and family. However, things were not going well at home—pirates were always a threat to families with young and beautiful women. This and other factors affecting the economy and the living standards of the island made the offer by the king hard to turn down. However, little did they realize that this venture would lead to unbelievable adversities. This group of families was not to be denied, though, as they saw a new beginning that would bring them land and social positions that were not available on their island. María lost her husband, Juan Rodriguez Granado, in Cuautitlán, Mexico; however, she and her five children endured the hardships until she arrived at the Presidio de Béxar in 1731. She and others then began the process of establishing the first civil government in Texas.

María Ruíz married Pedro Granado and bore a son named Manuel, who later married Josefa Seguro. In later years, Manuel and Josefa had a child named Hípolito Alvino Granado. I am assuming that because of not meeting the strict social standards of the family, Hípolito was adopted by his aunt Barbara Ruíz and Juan Joseph Pacheco. Because of this adoption, the family used the name interchangeably; however, over time, the name Pacheco remained and is in use as of today. Biologically, the family name is Granado, and this has qualified us as member of the fourteen original families of the Canary Islands. It is with pride that our descendants have contributed historically to the founding of our great city of San Antonio.

The Pacheco Family Story

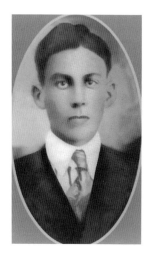

Photo of Alvino Pacheco, father of Robert G. Pacheco. My father would say, "Mijo no Somos Pacheco, Somos Granados."

I am extremely gratified and honored that I am able to contribute to the Pacheco family story as we approach the 300th anniversary of the founding of San Antonio. In 1731, due to a royal decree by the king of Spain, the Canary Islanders played an important role in the establishment of the first civil government. As a member of one of the fourteen families who endured this migration, I will attempt to provide names of my ancestors, documents and pictures depicting their contributions. I will also explain their involvement in city government, their use of land grants and contributions in military confrontations.

I commend Mr. Hector Pacheco, former president of the Canary Islander Descendant Association (CIDA), for embarking on this endeavor. Before I continue, I would like to give credit to my father, Alvino Chapa Pacheco, who inspired me to research our family history. For generations, the validity of our surname was never questioned until one day, when he stated that our name was not Pacheco but Granado. It was this revelation of our family heritage that started this incredible journey of research into the archives of the City of San Antonio de Béxar and the translation of church records.

The information provided by my father did not generate very much interest at the time since I was young and considered it just one of many folklore stories that were passed by word of mouth from generation to generation. Little did I know that these stories were true and have been validated by extensive research.

"MIJO NO SOMOS PACHECO, SOMOS GRANADOS"

In the absence of a formal education, many of the traditions and cultural folklore were passed down by word of mouth by the elders. Many of them could trace their family lineage to some of the most prestigious ancestors who were involved in the forming of the first civil government in what is now San Antonio de Béxar. However, many of these historical treasures were obscured in old Spanish documents, left to age and not made available to the general public. Even if these records were available, many would not have been able to read them because they were in old Spanish and contained endless abbreviations, which made it difficult to read. The reason for the use of extensive abbreviations was due to the shortage of paper. Many of these documents can still be researched at the Bexar County Courthouse in the basement of the Archives Department. However, there was an agreement between the City of San Antonio and Austin to translate the old Spanish records from Spanish to English since they were in disarray and in very poor condition. The agreement was a loan from the Barker Library (now the Briscoe Library), not to keep them permanently.

In view of what's been said, I decided to embark on a fact-finding mission of endless research that led me to the Bexar County Archives. The translations of church records of persons baptized in Graytown, Cañada Verde and Elmendorf between 1854 and 1923 were copied by Reverend John Katherine, CSSR, as well as the original books in June 1938. The translations of the San Fernando records were done by Mr. John Ogden Leal. For those who are interested, copies of Mr. Leal's books are currently available on the sixth floor of the San Antonio Public Library.

John Ogden Leal

My story and the story of others who are contributing to this book gives credence to research done by master genealogist John Ogden Leal. Mr. Leal was proud that he was a descendant of Mr. Juan Leal Goras, who led the families in a perilous journey from the Canary Islands to Texas. Mr. Leal was initially the curator of the Spanish Governor's Palace and was eventually the Bexar County archivist. Due to his interest in the early settlers who founded the city, he was able to get permission from the San Fernando clergy to translate the family church records from Spanish to English. This was quite a project, as the books were faded and contained abbreviations. Mr. Leal displayed an uncanny ability to read the contents of these books with great accuracy. It was because of his knowledge of Spanish and his labor of love for genealogy that has generated an interest in who we are and where we came from. Mr. Leal has passed, but he left us with a legacy that has made it possible to do our research with greater accuracy. For those who are interested in his translations, they can be found at the Daughters of the Republic of Texas Library and at the Central Library's Texana and Genealogy Department. Mr. Leal and a group of Canary Islands descendants also made a trip to Lanzarote in the Canary Islands. This trip was a great joy for John, as he met with dignitaries from the island and went to places of interest where his ancestors were born.

I say with great remorse and sadness that cancer claimed the life of one of the greatest archivists and translators of San Antonio history. John should be known as a city genealogist, as he spent many years reviewing fragile San Antonio Spanish mission and church records and translating them so that other genealogists could read them. His interest in San Antonio history began with stories he heard as a young man living on a ranch in Poteet, Texas. Since there was no television, his family would sit and talk at night when it was cooler. He remembered those stories about how the family came from these islands. The word *island* didn't mean much to him until later, when he learned about the Canary Islands. After extensive research, John was able to trace his lineage to Juan Leal Gorás, who was the leader of the families from the Canary Islands and became San Antonio's first mayor.

Mr. Leal applied for and became the Spanish archivist for Bexar County, a position he held from 1981 to 1991. This position allowed him to research documents handwritten in what he called "flowery Spanish" on a vintage IBM typewriter. Because of his position, he was able to translate military and civilian records from the Spanish period. In addition to the translations

of the records of San Fernando, he also translated the records of the Mission San Antonio de Valero (known today as the Alamo), Mission Concepcíon, Mission San José and Mission Espada, as well as translating the church records of El Carmen and the Santísima Trinidad Church in Von Ormy. Many genealogist have the records on microfilm, but his translations are in book form and are easier to read.

When I started researching my own family genealogy, I was in a quandary, as I didn't know where to begin my research until I called the San Antonio Catholic Chancery. Ofelia Tennant (the archivist of the Archdiocese of San Antonio) referred me to John Ogden Leal, who at this time was a curator of the Spanish Governor's Palace. Every Saturday, I would meet Mr. Leal at the Governor's Palace, and he would provide me with rough drafts of his most recent church translations to read. In these documents, I would find my family surnames and where they originated. I did this for several months until I realized that some members of our family played an important role in establishing the first civil government in Texas. Little did Mr. Leal realize that his labor of love for genealogy and early Texas history would eventually help link many of our family members as descendants of the early Canary Islanders. This lineage has allowed many family members to submit applications for membership to organizations such as the Daughters of the Republic, Sons of the Republic and the Canary Islands Descendants Association (CIDA).

Recently, it was found that one of our ancestors, Luciano Pacheco, was a survivor at the Battle of the Alamo. Luciano lived in Christine, Texas, and died in 1898, but not before applying for a pension from the government of Texas. Mr. Leal can look down and smile because his legacy is what has given credibility to the ongoing research on the validity of the early settlers of San Antonio de Béxar.

MARÍA ENCARNACIÓN PULÍDO

The Pacheco family story would not be complete without a mention of the name María Encarnacíon Pulído. She was as a lady of great significance. It was her marriages to Juan Timitio Barrera and Alvino Pacheco that would produce half siblings who would be involved in many historical events that shaped the first civil settlement in Texas, San Fernando de Béxar. I will not go into great detail about these events, as they were well documented in

church records at the Bexar County Archives and in other research. María's sons Melchor, Alvino, Weneseládo and Luciano moved to Atascosa County after the Indians no longer presented a threat to them and their families. Graytown in southern Bexar County is where many of these families of the four brothers settled and tended to their farms and ranches. This way of life continued until many families moved to other communities in Atascosa and Wilson County, where hundreds of descendants now live.

One day, an acquaintance of mine, Jesse Pacheco Rios, called and stated that we were cousins and asked if he could add my name to his genealogy website. This site had an unbelievable program that allowed families to research their genealogies with great accuracy. This program, under Jesse's direction, provides updates on new members, family birthdays and other personal data that Pacheco members use as a source of information while filling out their biographies.

Graytown–San Jose Mission

My great-grandfather's father, Alvino Granado Pacheco, was born in Graytown, Texas, and was married four times: Teresa Deleon, Teresa Vara, Teresa Juarez and his final wife, Teresa Gil. Due to being young, his fourth wife had to ask permission to marry Alvino. After this marriage, our family started to live at the missions. Teresa Gil's mother was Olaya Flores, who married Seferíno Huízar. After the church secularization, Seferíno granted a piece of land inside mission plaza to Teresa Gil. She later sold her share to the Sisters of Charity of the Incarnate Word. With the money, she bought the land on Mission Road in 1892, and a home was built between White Avenue and Huff Avenue. The home is still there as a homestead and has been declared historically important by the historical society.

My grandfather used to farm from Mission Road to South Flores Street. One day, Captain Poor told my grandfather to fence the property, which he never did, and eventually the land was lost to land speculators. The people around the mission were buried in front of the church (San José) until there was no more space. My grandmother Teresa Gil gave part of her property to build a cemetery between Roosevelt Highway and South Flores Street. The Franciscan priest called it the "Mexican Cemetery," where many of our ancestors are buried. Many of the people who are buried there are from the Pacheco, Huízar, Guerrero, Salcedo, Reyes, McCumber and Casias

families. For years, these families were buried there until they began using a new cemetery called Mission Burial Park South. This cemetery became the main place of employment for many of the residents of the mission. After many years of neglect, people were starting to be baptized at Mission Espada instead of San José. Many of the stones inside the church were taken away to build family homes. However, Mission Espada was where my father, Alvino Chapa Pacheco, was baptized.

My father, Alvino Chapa Pacheco, was an outstanding baseball player. He played semi-pro baseball for the Aztecs at the Van Daele Stadium and professional baseball for the Victoria Rosebuds and the Corpus Christi Colts. It is while he played for the Corpus Christi Colts that he met and then married my mother, Manuelíta Pacheco. The place where I was born on Mission Road was like a little farm. Uncle Frank raised pigs, Uncle Ralph raised goats and cows, Uncle Jesse Bueno raised horses and my dad raised chickens and ducks. We were pretty self-sufficient and went to the store only for certain items. The families of the missions were very close and were related by marriage and other church sacraments required for church confirmation. Therefore, they became *compadres* and *comadres*. My father once told me that one of our ancestors from the mission community, Antonio Conde, was a blacksmith and built the belfry (the cross on top of Mission Espada); it still stands today. He also told me that Raphael Chapa was buried inside San Jose Church, as there were no floors at the time, and he would take flowers to his grave when he was about ten years old.

LA VILLITA

Many soldiers of the Alamo company who had married Indians began to establish their homes in the vicinity or near the Alamo. Spaniards then purchased the old mission lands, and gradually a new town grew, called La Villita. In addition to the homes of the soldiers, the villa became quickly populated by the residents of San Fernando after their homes around the Plaza de La Islas were completely swept away by the flood of 1819. It was then that Alvino Granado Pacheco petitioned Governor Antonio Martinez in July 20, 1819, for a tract of land that was situated near the barracks of San Fernando. The following is an excerpt from the land grant to Alvino Pacheco:

According to the Grant of Land of 1819, Alvino was taken by the hand and given possession of the parcel of land that he requested and was allowed to call it his own. As it was customary, the said Alvino Pacheco, duly established and constituted on land granted to him, dug earth, pulled weeds, set stakes placed boundaries, uttered shouts and performed other ceremonies necessary to make him lawful owner of land requested. This land grant gave me great pride being, that I attended many social functions by social clubs and city sponsored activities thru out the year. The Pacheco property was on the Southwest corner of Hessller and Womble west thru to National bounded north by Hessler and east Womble and South by National. This property remained in the family until the death of Alvino, in 1823. Hs wife Incarnation Pulido and son sold their shares in 1839 to Andrew Neill. This ended the Pacheco residency in this historical land mark. After he died his son Jose was made sheriff of the Alamo and La Villita. This appointment was made due to his leadership and fine character.

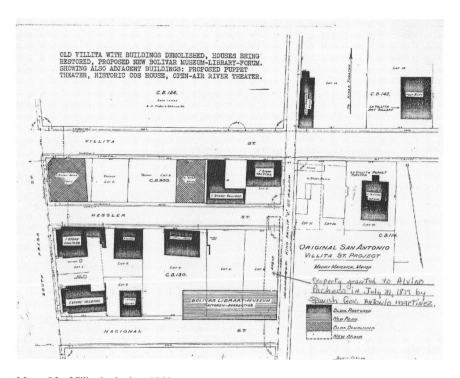

Map of La Villita in the late 1930s.

Several families played an important role in establishing the first civilian township in the state of Texas, and there was a strong bond between the residents of San Antonio and Nacogdoches. Antonio De Ybarbo, the captain of Nacogdoches, had a second wife, Guadalupe de Herrera, and they had no children. However, Guadalupe had a daughter, Antonio's stepdaughter, named Encarnacíon Pulído. Guadalupe had this daughter from a previous marriage to Bartalo Pulído, who was from Punta de Lampazo, Mexico. Encarnacíon was first married to Juan Timitio and then later married Alvino Pacheco. It was from this marriage that she gave birth to four sons, who then settled and started families in Bexar and surrounding counties.

PACHECO FAMILY DNA

A lot of credit goes to my nephew Leo Pacheco, as he paid for a study with the National Geography Society to trace the DNA of the Pacheco family. According to the report, we belong to the Haplogroup R1b1c. As per the map, it has been confirmed that we originated from the Canary Islands. This makes us descendants of Celtic, Irish, French and Spanish people.

I hope that this research settles the question about our heritage and how we played a significant role in establishing the first civil government in Texas. This study has qualified our family to become members of the Canary Islands Descendant Association (CIDA). All of my documents were submitted to Anthony Delgado (CIDA membership chair), who confirmed our heritage. In addition, Robert Benavides also reviewed and confirmed these family documents, which qualified me to become a member of the Sons of the Republic of Texas. I encourage other descendants to apply to each of these organizations based on our Pacheco-Granado family genealogy.

PACHECO FAMILY REUNION

On November 7, 2015, a family reunion was held at the Floresville Event Center after a year of planning. Various meetings were held by Ralph Anthony Pacheco to determine the rental of the convention center and other activities, as well as the individuals who would chair them. This reunion, to the surprise of many descendants, was attended by more than one thousand

family members, which made it one of the largest reunions in the state of Texas. This was the culmination of years of family folklore and land grants of people living in Graytown and surrounding areas. Many of these people are descendants of Alvino Pacheco, Melchor Pacheco, Wensaládo Pacheco and Luciano Pacheco. Families of these ancestors were identified by wearing different-colored T-shirts with their ancestors' crest designs. Many of the families were reunited after hearing for generations stories of long-lost relatives. In my opinion, it was one of the best reunions ever held. As per rumors, plans are being made for the next one.

CONTRIBUTORS TO THE PACHECO STORY

Another person who deserves recognition is Ralph Anthony Pacheco, a second cousin who took the family research to a new level. He has used his resources and knowledge to bridge families and their contributions to the first civil government in San Antonio de Béxar. These contributions are chronicled in the archives in Austin and San Antonio, Texas. There are several others who share family stories and documents to substantiate three hundred years of the founding of San Antonio.

CONCLUSION

This story of the Granado-Pacheco family is brief, but it does give a summary of the contribution of the first settlers to establish the first civilian township in the state of Texas. It's been several years since local historians and genealogists have taken a genuine interest in uncovering the early Spanish history of San Antonio. There are many active organizations present in San Antonio that I hope will one day provide and build a center where different groups can research and enjoy the historical attributes of this unique and beautiful city. I submitted this story to be included in the book by Hector Pacheco as part of the 300th celebration of the arrival of the Canary Islanders on March 9, 1731.

Chapter 8

CHRONOLOGY OF THE CANARY ISLANDS DESCENDANTS' FOUNDING AND THE SAN ANTONIO 250TH ANNIVERSARY COMMITTEE CELEBRATION

By Robert M. Benavides, CIDA President, 1984–86

This chapter is a chronology of the Canary Islands Descendants Association (CIDA). While the early years of the organization are detailed, the primary focus of this chronology is on the story of the City of San Antonio's 250th Anniversary Committee and its impact on CIDA since 1981.

The three primary topics are:

- The first fifteen years (1977–92) of Canary Islands Descendants Association (CIDA);
- The detailed story of the origins of the City of San Antonio's 250th Anniversary Committee (or CCL Committee; CCL are the Roman numerals for 250) commemorative events, celebrated in March 1981;
- The resulting impact and legacy of those community events on the traditions, growth and development of the Canary Islands Descendants Association in San Antonio and recognition both locally and in the Canary Islands.

THE FIRST FIFTEEN YEARS (1977–92) OF CANARY ISLANDS DESCENDANTS ASSOCIATION

The Canary Islands Descendants Association was founded by Miss Adela Navarro in 1977. CIDA was officially incorporated by the State of Texas on September 26, 1977, and was issued the State of Texas Charter Certificate no. 416194. The first CIDA president was Henry de León, who served from 1977 to 1978. Adela Navarro was the executive director.

Unfortunately, from the beginning, there have been periodic losses of CIDA documentation, official minutes, books, flags, folkloric clothing and other items needed to better detail its early organizational history. Help is needed to add more detailed chronology of these early years of the CIDA. New documentation is sought from anyone who is willing share copies (with credits) of their own papers regarding the Canary Islands Descendants Association from 1977 through 1992. (The author may be contacted at rmbtex@hotmail.com.)

Newspaper articles, programs and photos used in this chronology are from the Robert M. Benavides Archival Collection. Other such supporting items will be very welcomed and shared.

An *Express-News* article about Canary Islands Descendants Association on February 10, 1978, read, "Free classes in Texas and Hispanic history will be held each Saturday morning from Feb. 18 through April 29. Sponsored by the Hispanic Institute of Texas and the Canary Islands Descendants, the classes will be held at 10:30am on the second floor of the International Building, 318 W. Houston St."

The second CIDA president was Roselio Perez Negrete, who was elected in 1978 and served until 1982. An *Express-News* article on October 22, 1978, noted that "the club's purpose is to research family pedigrees and the history of the city." A membership of three hundred was stated by Negrete.

A March 7, 1980 *San Antonio Light* article read, "The Canary Islands Descendants organization will mark the 249th anniversary of the founding of San Antonio. High Mass will be said at 9:30 a.m. in San Fernando Cathedral. A reception will take place that night at the [Spanish] Governors Palace at 7:30 p.m. for members and invited guests. R.P. Negrete, president of the Descendants, will present Norma Ward, curator of the Governors Palace, with a special award. Special guests will be Stanley M. Hordes, curator of Colonial Archives Louisiana Historical Center and William M. Hyland, historian from St. Bernard Parish, La."

THE STORY OF THE CITY OF SAN ANTONIO'S 1981 250TH ANNIVERSARY CELEBRATION COMMITTEE

In 1980, Robert M. Benavides purchased a rare original 1949 edition of "Yanaguana's Successors: The Story of the Canary Islanders' Immigration into Texas in the Eighteenth Century" by Samuel M. Buck. He later discovered a small San Antonio newspaper clipping inside the book's pages. The 1951 clipping described the donation of a very large and thick red leather-covered scrapbook to the San Antonio Library by San Antonio businessman Edward W. Heusinger. The article described the contents of the large scrapbook being donated as items from the 1931 bicentennial celebration of the arrival of the Canary Islanders in today's city of San Antonio. Following research into the library holdings, Benavides also found that Heusinger also was author of "A Chronology of Events in San Antonio" in 1951, in which the foreword stated that the author also had been in 1931 the "president of the One Hundred Committee of the Bi-Centennial of San Antonio, commemorating the Two Hundredth Anniversary of the founding of the Municipal Government of San Antonio and the establishment of Missions, held March 4 to 9, 1931." It was Heusinger's continued interest in the many events of that bicentennial celebration (originally described in the 1931 official souvenir program) that resulted in his 1951 "Chronology of Events in San Antonio" publication. It turns out that his wife was a Canary Islands descendant of Joseph Cabrera.

Considering the rare book's title of "Yanaguana's Successors," Benavides began his search to locate the large Heusinger-donated scrapbook in the history department of the city's downtown public library, formerly located at the corner of St. Mary's and Market Streets. Mr. Marie Berry, the history department head, after reading the description of the scrapbook's large size, suggested that it may have been among the remaining book collection that had been left on the reserved back shelves when the San Antonio Main Library had moved several years before. The original library location was in the Andrew Carnegie Library Building at Market and Presa Streets and also housed the large and unique Hertzberg Circus Collection on the second floor.

The next day, Benavides visited the old Carnegie Library building, currently the Briscoe Western Art Museum, to continue with his research. When he asked the city custodian at the front desk about the large scrapbook described in the old newspaper clipping, she smiled widely and said, "I

The City of San Antonio's 250th Anniversary Committee (CCL) logo. *Courtesy of Robert Benavides.*

was wondering when y'all were coming back for it!" Perplexed and surprised, he followed the custodian upstairs and into a large back room with numerous rows of mostly empty old bookshelves. Suddenly she stopped and turned into a row. There it was! The old dusty red leather scrapbook was just as large and thick as described but was much heavier than expected. The 1931 artifact was dusted off, placed on an old wooden library cart with wheels and then rolled to a desk for reading. Being employed at the nearby City Public Service Office downtown (now CPS Energy) just three blocks away, Benavides excitedly made daily visits at lunchtime and after work to do research and write notes from the scrapbook on all the many citywide activities that occurred in San Antonio during the 1931 commemorative events that marked the arrival of the sixteen Canary Islands families. Although the bicentennial celebration events occurred during the Great Depression, the extensive scrapbook contained many photos, magazines and newspaper articles describing the extensive 200th anniversary celebrations that recognized the descendants of the 1731 Canary Islander founding families, the three transferred missions from East Texas and stories about other early settlers in our historic city.

Once the initial 1931 research findings were assembled, Benavides, a new member of the Bexar County Historical Commission, visited San Antonio historian and WOAI radio and TV announcer Henry Guerra to share the scrapbook information. As chairman of the Bexar County Historical Commission in the 1980s, Guerra read the information and excitedly made an appointment for both of us to meet with San Antonio mayor Lila Cockrell to discuss this uncovered Canary Islander and city historical information. With signed permission from the San Antonio Main Library, Benavides loaded the large scrapbook onto a luggage dolly and went with Henry Guerra to meet the mayor at her city hall office in September 1980. With all the surprising 1931 materials presented by Robert Benavides, and at Henry Guerra's urging, Mayor Cockrell immediately took action, issuing a

requested proclamation and passing a city council ordinance establishing the city's 250th Anniversary Committee for celebrating the year of 1981.

As a result, the San Antonio 250th Anniversary Committee began working in weekly meetings at city hall starting on October 31, 1980, and continuing until the March 1981 celebration events.

THE 250TH EDITION OF "YANAGUANA'S SUCCESSORS"

After reading the rare 1949 first edition of "Yanaguana's Successors" that had been out of print for decades, Robert M. Benavides republished and updated the book in November 1980, just in time for the 1981 celebrations. He presented the first new 250th edition copies of "Yanaguana's Successors" to San Antonio mayor Lila Cockrell and all city council members.

On the eve of the 250th anniversary year, an official City of San Antonio letter was received from Mayor Cockrell:

December 23, 1980
Mr. Robert M. Benavides
16411 Ledge Oaks
San Antonio, Texas 78232

Dear Bob:

I wish to take this opportunity to express my appreciation to you for the work that resulted in the reprinting of Yanaguana's Successors.

This is such an appropriate time to have a book of the history of the City available. Additionally, the cover is so rich that it will be prized for its appearance as well as content.

Thank you again for presenting us with the copies and for all your work on the 250th Anniversary Committee.

Sincerely,

LILA COCKRELL
Mayor

"Yanaguana's Successors." City council book presentation with Mayor Lila Cockrell. *Courtesy of Robert Benavides.*

On January 9, 1981, after months of community members working on the proposed celebration event plans, the first City of San Antonio press release was issued describing the 250th Anniversary (CCL) Committee Programs and Projects. The city's cover page and extensive press release read as follows:

January 9, 1981

To: Assignment Editors

Attached is a press release on the up-coming 250th anniversary celebration of San Antonio. We respectfully request that you utilize as much, if not all, of the material as stated in this press release, especially the genealogy submittals by the descendants of the original sixteen founding families from the Canary Islands.

We will be coming up with additional press releases between now and the 5th of March when additional information in regard to the celebration will be available.

Thank you for your cooperation.

Jerry James
Public Information Officer
JJ/mak
Attachment

The 250th Anniversary Committee is a civic project sponsored by the City of San Antonio.

Contributions for funding may be sent to:

Mayor's 250th Anniversary Committee
ATTN: Mrs. Eleanor Savage
P. O. Box 9066
San Antonio, TX 78285
"AN EQUAL OPPORTUNITY EMPLOYER"

Page 12
January 9, 1981

THE CITY OF SAN ANTONIO WILL CELEBRATE ITS 250TH ANNIVERSARY IN MARCH 1981

On March 5 through 9, 1981, the City of San Antonio will celebrate its 250th birthday. This anniversary has a three-fold importance. It was on March 5, 1731, that three of San Antonio's Spanish Missions were transferred from East Texas and re-established at sites along the San Antonio River. They are the Missions of La Purisima Concepcion, San Juan Capistrano and San Francisco de la Espada. At eleven o'clock on the morning of March 9, 1731, sixteen families of Canary Islanders arrived at the site of the Presidio San Antonio de Bexar [Plaza de Armas area]. *By royal decree of the King of Spain, they founded the first civil municipal government in Texas.*

In order that all citizens of our city and state be made more fully aware of the historical heritage that the first official settlers left, it was proposed that a 250th Anniversary Committee be organized and sponsored by the City of San Antonio. The Mayor and City Council have established such a citizens committee to coordinate the many activities and events being planned for a city-wide anniversary celebration.

The 250th Anniversary Committee members were nominated by the Mayor and the City Council District members to be representatives of all types of civic, religious, historical, military, ethnic, patriotic and social organizations. By ordinance, it was determined that the Committee's activities would center on events to be held from Thursday, March 5, through Monday, March 9, 1981. In addition, the events to be celebrated

will be the 250th anniversary of the transfer of three Franciscan Missions from East Texas to sites along the San Antonio River, and the arrival of 56 Canary Island immigrants to the Presidio site where the present City Hall stands. These founding families were given the royal titles of Hidalgos and were instructed by royal decree of the King of Spain to inaugurate the first civil municipal government in the province of Texas, La Villa de San Fernando. This first City Council (Ayuntamiento) with its councilmen (Regidores) and Mayor (Alcalde) later evolved into the City of San Antonio municipal government.

A tentative schedule of celebration events follows:

March 5: Re-enactment of the formal Acto de Posesión *by which Spanish government officials assigned Franciscan missionaries as trustees of the spiritual and temporal welfare of the local Indian cultures. The combined ceremonies of the three celebrant missions will take place at the plaza of the San Jose Mission in late afternoon.*

March 6: A salute to San Antonio's military heritage will be given with a U.S. Air Force military review at Lackland AFB at 10 a.m.

March 7: A Gala Ball honoring the Canary Islander founding of the first municipal government in Texas will be held at the Iberian Ballroom of La Mansion del Rio Hotel. This event will be sponsored by the Order of Granaderos and Damas de Gálvez.

March 8: A 4 p.m. performance of Canary Island Dances followed by a reception offered by the City of San Antonio for visiting dignitaries.

March 9: 9:00 a.m.—A Commemorative High Mass in the Plaza de Armas area between the back of San Fernando Cathedral and the City Hall. Archbishop Patrick Flores to concelebrate with visiting Church prelates.

10:30 a.m.—Entrada ceremony with descendants commemorating the arrival of their Canary Island ancestors will take place in front of the Spanish Governors' Palace.

At exactly 11 a.m., the bells of San Fernando will ring out announcing the time of Arrival of the Canary Islanders at the military presidio 250 years earlier. A military salute by the U.S. Air Force will be given with a squadron flyover and by the ceremonial music to be played by the U.S. Air Force Band of the West.

11:30 a.m.—Unveiling of the 250ᵗʰ Anniversary Commemorative Plaque by the Chairman of the 250ᵗʰ Anniversary Committee.
12 noon to 3 p.m.—A planned event by the government of Spain.
4 p.m. to 6 p.m.—A reception at the Spanish Governors' Palace.
8 p.m.—A performance by Canary Island Dancers.

Additional programs and events are being developed by some of the sub-committees. The details will be forthcoming in future news releases. Postmaster John J. Saldaña was named Chairman by Mayor Lila Cockrell at the first meeting of the 250ᵗʰ Anniversary Committee on October 31, 1980. Mrs. Mary Ann Castleberry was then appointed Vice Chairwoman of the Committee by Saldaña. Assignments of members into working sub-committees were given at the first meeting and some other sub-committees have been created subsequently to accomplish specific project goals of the Committee.

A list of the sub-committees and descriptions follow:

The Villa de San Fernando Committee. *It will plan all of the events relating to the San Fernando Cathedral and the Spanish Governor's Palace for Monday, March 9, 1981.*

The Committee on the Spanish Missions. *It will plan all of the events relating to the Missions of La Purisima Concepcion, San Juan Capistrano and San Francisco de la Espada.*

The Committee on Historical Arts and Pageants. *It is planning a Curriculum study guide in cooperation with San Antonio area school districts. Concentration on the Canary Islands in relation to San Antonio's history is to include a children's pageant, folklife festival, art and essay contests.*

The Committee on Military Events and Review. *A Military review will take place at 10 a.m. Friday, March 6, 1981. A U.S. Army firing team from Ft. Sam Houston and a joint forces color guard will assist at both the Commemorative Field Mass and the Entrada ceremonies in the Plaza de Armas. A U.S. Air Force flyover salute has been requested for the Plaza de Armas at 11:00 a.m. March 9, 1981.*

Sub-committees continued:

The 250th Anniversary Ball Committee. *The Order of Granaderos and Damas de Galvez will sponsor the ball to-honor the founding of the first civil municipal government in San Antonio at the Iberia Ballroom of La Mansion del Rio on Saturday, March 7. Invitations to visiting dignitaries will be extended by the City of San Antonio.*

The Committee on the State of Texas
The Committee on Civic and Social Organizations
The Committee on Commemorative Markers
The Committee on Anniversary Events and Records
The Genealogy Committee for Canary Islander Descendants

The Villa de San Fernando Committee requests genealogy submittals by all descendants of the sixteen official founding families from the Canary Islands. The Genealogy Committee will coordinate its documentations with the History Department of the San Antonio Main Library. The submitted genealogies should be typewritten, double spaced, and have a 1½" margin on the left side of the sheets. The names and dates of the family tree should include traceable reference sources. The Bexar Archives, San Fernando Church Records, Chabot's "Makers of San Antonio," Castaneda's "Our Catholic Heritage in Texas" series, and many other similar reference works yield the best documentation. Mrs. Charles Myler is the coordinating secretary for the genealogy project. She will receive the submittals at the History/Genealogy Section of the San Antonio Main Library (299-7813). The Library will supply reference material listings and format advice for patrons who wish to complete documentation of their Canary Island family research.

Although genealogy submittals will continue to be received through 1981, a deadline of February 15 is necessary for those who wish to participate in the March 9 ceremonies. The genealogies received will be authenticated, recorded, and organized into sixteen volumes corresponding to the sixteen immigrant families sent from the Canary Islands by the King of Spain to found the first civil municipal government in Texas–La Villa de San Fernando.

The Villa de San Fernando Committee will make a list of Canary Island descendants from the genealogy records compiled at the San Antonio Main

Library. Participation in this genealogy project will entitle the verified descendant to be extended an invitation to the official 250th Anniversary Entrada and Commemorative High Mass ceremonies on Monday, March 9, 1981. The Commemorative High Mass will be dedicated to the descendants of the Canary Island immigrants living in the San Antonio area 250 years after their ancestors founded the first civil municipal government in Texas, now the City of San Antonio.

Immediately following the Mass (approximately 10:20 a.m.), the Entrada participants will be staged on Dolorosa Street at the San Pedro Creek. With a military escort, they will march one block and enter the Plaza de Armas. The descendants will be grouped behind sixteen banners representing the name of each founding family from whom they are descended. There will be a "Roll Call of Honor" announcing each of the family names of the Canary Island immigrants who arrived at the Presidio San Antonio de Bexar at 11 a.m., March 9, 250 years before. As each ancestor's name is called, their descendants will pass in review before the official reviewing stand and the "garrison" in front of the Spanish Governor's Palace. The garrison soldiers and the military escort will be portrayed by members of the Order of Granaderos de Galvez in authentic period Spanish uniforms and arms. After passing in ceremonial

CCL chairman J. Saldaña and General Billy Harris, vice-chairman of the Bexar County Historical Commission. *Courtesy of Robert Benavides.*

review, the descendants will be publicly honored and pronounced Hidalgos of San Antonio de Bexar. Hidalgo is the same nobility title given by the King of Spain to their ancestors and to their legitimate descendants in perpetuity!

The 250th Anniversary Committee requests that all Canary Islander descendants submit their genealogies to this special project that will leave a legacy of San Antonio's Spanish heritage in the History/Genealogy Department of the San Antonio Main Library for future reference and recognition by all our descendants.

#

Media Contact: John J. Saldaña, Postmaster / 229-5730

The CCL Genealogy Sub-Committee

During the months of CCL's work on projects prior to the January 1981 City of San Antonio press release, the Genealogy Sub-Committee for Canary Islander Descendants also was created by Robert Benavides, chairman of the Villa de San Fernando Committee, and approved by the CCL Committee. That CCL Genealogy Sub-Committee for Canary Islander Descendants consisted of Chairman Alexander Fraser, Esquire, SRT; Mrs. Charles (Jo) Myler as the San Antonio Public Library coordinating secretary for the genealogy project; and Mrs. Margaret G. Benavides, as the CCL Canary Islander genealogy application evaluator.

Creating an application form for CCL Canary Islander descendants, adapted from the genealogy application form used by the Sons of the Republic of Texas, Alex Fraser and Margaret Benavides collaborated with the San Antonio Public Library and released the free CCL genealogy project that was open to all who wished to visit the library to receive an application, do research and complete the form. Approved applicants were qualified as Canary Islands descendants for participation in the 250th anniversary events. The CCL press release was published, and both the library instructions and applications forms were printed for all interested applicants wishing to participate in the ceremonies on March 9.

The CCL Genealogy Library instructions and press release for Canary Islands descendants read as follows:

THE CCL GENEALOGY COMMITTEE PROJECT FOR CANARY ISLANDER DESCENDANTS

The Villa de San Fernando Committee requests genealogy submittals from all descendants of the sixteen official founding families from the Canary Islands. The Genealogy Committee will coordinate its documentations with the History Department of the San Antonio Main Library. The submitted genealogies should be typewritten, double spaced, and have a 1½" margin on the left side of the sheets. The names and dates of the family tree should include traceable reference sources. The Bexar Archives, San Fernando Church Records, Chabot's "Makers of San Antonio," Castaneda's "Our Catholic Heritage in Texas" series, and many other similar reference works yield the best documentation. Jo Myler, Library coordinating secretary for the genealogy project, well receive the submittals at the History/Genealogy Section of the San Antonio Main Library (299-7813). The Library will supply reference material listings and format advice for patrons who wish to complete documentation of their Canary Island family research.

VILLA DE SAN FERNANDO COMMITTEE REPORT

In January 1981, a Villa de San Fernando Committee report was submitted to 250th Committee chairman John J. Saldaña regarding the progress of CCL genealogy project, the planned March 9 ceremonies and other proposed projects for 1981. It read as follows:

Mr. John J. Saldaña
Chairman, 250th Anniversary
Committee of San Antonio

Dear Chairman Saldaña:

The Villa de San Fernando Committee has made a list of Canary Island family descendants from the genealogy records compiled at the San Antonio Main Library. The genealogies received through 1981 will be authenticated, recorded and organized into sixteen volumes corresponding to the sixteen immigrant families sent from the Canary Islands by the King

of Spain to found the first civil municipal government in Texas—La Villa de San Fernando.

Participation in this genealogy project prior to March 1, 1981, entitles the verified descendant to be extended an invitation to the official 250th Anniversary High Mass and Entrada ceremonies on Monday, March 9, 1981. The Commemorative High Mass, which begins at 9:00 AM (seating at 8:30 AM) will be dedicated to the sixteen official founding families and to all Canary Island descendants living in the San Antonio area after 250 years.

Immediately following the High Mass (approx. 10:15 AM), the Entrada participants will be staged on Dolorosa Street at the San Pedro Creek. With a military escort, they will march one block and enter the Plaza de Armas. The descendants will be grouped behind sixteen banners representing the name of each founding family from whom they are descended. There will be a "Roll Call of Honor" announcing each of the family names of the Canary Island immigrants who arrived at the Presidio San Antonio de Bexar at 11:00 AM, March 9, 250 years before. As each ancestor's name is called, their descendants will pass before the official reviewing stand and the "garrison" in front of the Spanish Governor's Palace. The garrison soldiers and the military escort will be portrayed by members of the Order of Granaderos de Galvez in authentic period Spanish uniforms and arms. After passing in ceremonial review, the descendants will be publicly honored and pronounced Hidalgos of San Antonio de Bexar. Hidalgo is the same nobility title given by the King of Spain to their ancestors and to their legitimate descendants in perpetuity.

The same Canary Island descendants can be invited to attend those Committee projects which will be dedicated later in this anniversary year. One event will be the official granting of the sixteen books of Canary Island family genealogies and the enlarged photographs of the family coats of arms to the Genealogy Section of the San Antonio Main Library. Another project to be dedicated later will be the opening of an exhibit at the Institute of Texan Cultures. The exhibit will include enlarged photographs of each of the Canary Islands, the family name banners used in the Entrada ceremony and possibly a display of seven sets of small mannequins (male and female) wearing typical folk costumes from each of the Canary Islands. A soil sample display and the planting of a native Drago tree from the islands are also being planned.

I hope for descendant participation to number in the hundreds, and that their attire for the ceremony will match this grand and special occasion that will never happen again in this century.

Sincerely,
ROBERT M. BENAVIDES,
Chairman, Villa de San Fernando Committee

Later in February 1981, an official CCL invitation letter was mailed to all Canary Islands descendant applicants who qualified their CCL genealogies by tracing back to the sixteen founding families of the Villa de San Fernando in 1731. The invitation letter was signed by the chairman of the 250th Anniversary Committee of San Antonio, the chairman of the Villa de San Fernando Committee and the chairman of the 250th Genealogy Committee. It read as follows:

Dear Canary Island Descendant:

On behalf of the 250th Anniversary Committee of San Antonio, it is my pleasure to inform you that the genealogy material you submitted has been verified and approved by the Genealogy Committee, and you are officially listed as a Canary Island descendant of the sixteen families who founded the first civil municipal government in San Antonio.

The Committee extends to you this official invitation to participate in the City's official celebrations on March 9, 1981. Enclosed is an invitation card which should be worn as an identification badge at the ceremonies. Plastic badge holders will be provided at the sites. This card is your special pass for reserved seating at the Commemorative Mass, and it will admit you to the Entrada staging area for invited descendants as well as the reserved seating area to be used after the Entrada and Roll Call of Honor.

After the March 9 ceremonies, these cards should be kept as special invitations to events to be announced later in this 250th anniversary year. Since participation in these activities is limited to descendants whose lineage has been documented by the Genealogy Committee, this invitation is not transferable.

Enclosed is an information letter which outlines the sequence of events for the Canary Island descendants who will participate on that day. Programs will be available at the ceremony sites.

COMMITTEE MEMBER:

Antonio G. Benavides

ENTRADA CEREMONY
PLAZA DE ARMAS
MARCH 9, 1981

NOTE:
You have submitted multiple entries for each of the different Canary Islander families from whom you are descended. Please bring this note with your invitation card into the Dolorosa Street staging area west of the San Pedro Creek.

For better representation and distribution among all the family banners, you are assigned to represent a descendant of *Antonio de los Santos* in the Entrada Ceremony.

Your multiple genealogies will be included in all the volumes for which you have submitted entries.

Congratulations again,

The Genealogy Committee

CCL descendant Entrada cards and banner instructions. *Courtesy of Robert Benavides.*

The Committee wishes to take this opportunity to thank you for your participation in the Genealogy Project. Your contribution joined with those of hundreds of other descendants will leave a permanent record in the Library's Genealogy Department of San Antonio's founding families for future research and recognition by succeeding generations.

John J. Saldaña, Chairman
250th Anniversary Committee of San Antonio

Alexander Fraser, Chairman *Robert M. Benavides, Chairman*
250th Genealogy Committee *Villa de San Fernando Committee*

Also in February 1981, an article appeared in the City Public Service magazine *Broadcaster*:

FOR FIVE DAYS IN MARCH, SAN ANTONIO REFLECTS ON 250 YEARS OF... HISTORY AND TRADITION

If ever there was a city rich in cultural diversity, San Antonio would be the one. The city we call home enjoys world-wide recognition as a center of mixing cultures. One reason that recognition has come to San Antonio is the number of individuals and groups who have steadfastly clung to preserving the history of this area.

One such individual who is gaining distinction as an avid historian and promoter of the city's rich past is Robert Benavides, Senior Engineering Technician in the Main Office.

Robert, however, has more than just a casual interest in San Antonio's history. He counts among the descendants of the originators of San Antonio's Spanish heritage. Robert has traced his family's lineage to the area's first alcalde *or mayor. It is this connection that sparked Robert's interest in the history of San Antonio's highest governmental office holders, an interest that has led to a number of prestigious honors for the 14-year employee.*

It was on March 9, 1731 that 16 families from the Canary Islands, off the coast of northwest Africa, arrived on the very site that was later to become San Antonio. The families settled in the area by royal decree of the king of Spain and proceeded to form the tiny settlement's first municipal government.

The 56 people who formed the fledgling government 250 years ago were rewarded by the king of Spain with titles of nobility. The proclamation issuing these titles stipulated that each of the descendants would also be designated with the royal title of designated with the royal title of hidalgo.

Today, the designation is mostly honorary as both alcalde *and* hidalgo *titles are presented to visiting dignitaries by the city's mayor and the county's judge. "From a technical standpoint, today's* hidalgos *are those descendants covered by the king's proclamation," said the amateur historian and member of the Bexar County Historical Commission.*

Robert's fervent zeal to preserve the history of the days of the first settlers from the Canary Islands has moved him to become active in the effort to formally celebrate the event that established the local governmental system. He has appeared before City Council to petition that body for support of a proclamation setting aside the week of March 5–9 as a time for special observance of the 250th anniversary of the arrival. His proclamation was unanimously approved and the wheels set in motion for the re-enactment of the event at the exact site where the first hidalgos located the new government.

Coincidentally, several days before the arrival of the Canary Islanders, three Catholic missions were re-established within miles of were re-established within miles of each other, within walking distance from the

site now occupied by City Hall. The three: La Purisima Concepcion, San Juan Capistrano, and San Francisco de la Espada were originally in East Texas, but were relocated near the then-lush San Antonio River.

Combining these two historic observances, the City Council named a committee of local persons to coordinate San Antonio's salute during the 250th year since the events took place. Not surprisingly, Robert Benavides was called on to play a major role in the coordination and implementation of the committee's plans. The plans, to say the least, are ambitious. The week of March 5 is packed with commemorative observances including a High Mass on the site of the first known military encampment in this area of Texas; formal presentation of the colors by a squadron of authentically dressed Spanish military escorts; and a presentation of genealogical histories by descendants of the original 56 Canary Islanders.

A part of this whole effort is the republishing of a historically accurate account of the Canary Islanders' trek across the Atlantic and their eventual founding of the local governmental system, the first in Texas.

Written by Samuel M. Buck, the book is a historical document that relates the story of several of the families chosen by the king of Spain for the trip to the New World. Called "Yanaguana's Successors" (Yanaguana is the name of the Indian village along the river that later became San Antonio), the book was recently published as the 250th Anniversary Commemorative Edition with a foreword written by Robert Benavides.

Included in the special edition book is the story of how the two governmental bodies within the San Antonio metropolitan area, the City of San Antonio and the County of Bexar, were granted separate coats of arms from the Spanish throne. San Antonio is certainly rich in history, and that richness is enhanced by the many individuals who devote time and energy toward preserving and promoting it. There is no question that among those stands Robert Benavides.

CCL Entrada Banners Project with the Canary Islander Heads of Families

At one of the CCL meetings, Robert Benavides, chairman of the Villa de San Fernando Committee, described the proposed program sequence for the March 9 *Entrada* ceremonies to mark the reenactment of the arrival of the descendants of the original sixteen families from the Canary Islands into

Robert M. Benavides with CCL banner, pole and stand. *Courtesy of Robert Benavides.*

the Plaza de Armas exactly 250 years later earlier. He described a CCL banner project for qualifying descendants to march under as they reenacted their ancestors' 1731 arrival. The sixteen banners were to have the heads of the family names with their native Canary Island. The banners were to be made in the red and gold colors of the Spanish flag.

Since there was not a budget allotted for this new project, Ms. Joanna Parish, who was then the president of the San Antonio Conservation Society, offered to take the project to her executive officers to consider a CCL sponsorship for the cost of this project. At the next CCL meeting, she announced that the San Antonio Conservation Society had voted to fund the banner project as a gift to the city's 250th Anniversary Committee. Once the banner project was approved and funded, one qualified Canary Islands descendant, Mr. Antonio G. Benavides, volunteered to purchase all the poles needed to make sixteen banners for the new Canary Islanders' banners and the additional wood needed for him to create sixteen wooden stands to receive and hold the CCL banners upon their arrival in the Plaza de Armas.

The Villa de San Fernando chairman, Robert M. Benavides, and vice-chairman, "Leo" Negrete, then president of the Canary Islands Descendants Association, worked together with Antonio Benavides to sand, stain and assemble the CCL banner poles and banner stands to be ready in time for Monday, March 9, 1981.

THE CITY OF SAN ANTONIO'S 250TH ANNIVERSARY COMMITTEE OFFICIAL PROGRAM

The city's official 250th Anniversary Celebration program foreword was as follows.

FOREWORD

On March 5 through 9, 1981, the City of San Antonio celebrates its 250th birthday. This anniversary has a three-fold importance. It was on March 5, 1731, that three of San Antonio's Spanish Missions were transferred from East Texas and re-established at sites along the San Antonio River. They are Missions La Purisima Concepcion, San Juan Capistrano and San Francisco de la Espada. At eleven o'clock on the morning of March 9, 1731, sixteen families of Canary Islanders arrived at the site of the

OFFICIAL CELEBRATION PROGRAM

MARCH 5th-9th, 1981 SAN ANTONIO, TEXAS

Cover of the 250ᵗʰ Anniversary
program. *Courtesy of Robert Benavides.*

Presidio San Antonio de Bexar (Plaza de Armas area). By royal decree of the King of Spain, they founded the first civil municipal government in Texas.

In order that all citizens of our city and state be made more fully aware of the historical heritage that the first official settlers left, it was proposed that a 250ᵗʰ Anniversary Committee be organized and sponsored by the City of San Antonio. The Mayor and City Council established such a citizens' committee to coordinate the many activities and events for this city wide anniversary celebration.

The 250ᵗʰ Anniversary Committee members were nominated by the Mayor and the City Council District members to be representatives of all types of civic, religious, historical, military, and social organizations. By ordinance, it was determined that the Committee's activities would center on events to be held from Thursday, March 5, through Monday, March 9, 1981.

The contents of the Official 250ᵗʰ Anniversary Celebration Program, with CCL members and subcommittees, included the following:

The Two Hundred Fiftieth Anniversary
Of the Arrival of the
Founding Families from the Canary Islands
The Formation of
Municipal Government in San Antonio
And the Establishment of the
Missions La Purisima Concepción, San Francisco
De La Espada and San Juan Capistrano

Mayor's Committee
Honorary Co-Chairmen:
Most Rev. Patrick F. Flores, D.D., Archbishop of San Antonio
Honorable Henry B. Gonzalez.
Congressman Honorable Abraham "Chick" Kazan.
Congressman Honorable Tom Loeffler, Congressman

Chairman:
Mr. John J. Saldana. Postmaster
Vice-Chairman:
Mrs. James Castleberry, Jr.,
Honorable Lila B. Cockrell, Mayor of San Antonio
Honorable Albert Bustamente, Judge of Bexar County
Dr. Felix D. Almaraz. Jr.
Mr. Charles E. Barrera
Mr. Robert M. Benavides
Ms. Mary Ann Bruni
Honorable Raul Gonzalez Galarza, Consul General of Mexico
Mr. Henry Guerra
Rev. Monsignor Balthasar Janacek
Mr. R.P. Negrete
Ms. Joanna Parrish
Mr. Frank B. Vaughan, Jr.

Representatives of Council Districts:
Mr. Carlos X. Camacho
Ms. Magdalena Eureste
Mr. Arnold T. Garza
Dr. John Igo
Mr. H.B. Johnson
Mrs. Walter Scott Light
Col. Herman I. Little, USAF Ret.
Mr. Walter N. Mathis
Ms. Adela M. Navarro
Ms. Rita C. Thompson

Supporting Committees

Civic and Social Organizations
Chairwoman: Mrs. Walter Scott Light
Vice-Chairman: Mr. Walter N. Mathis

Commemorative Markers
Chairwoman: Ms. Adela M. Navarro
Vice-Chairman: Mr. Carlos X. Camacho

FINANCE
Chairman: Mr. Curtis Gunn
Vice-Chairman: Mr. Mike Patton

HISTORICAL ARTS AND DRAMA
Chairwoman: Ms. Mary Ann Bruni
Vice-Chairpersons: Ms. Magdalena Eureste [and] Dr. John Igo

HISTORICAL CELEBRATIONS
Chairwoman: Ms. Joanna Parrish
Vice-Chairwoman: Ms. Vivian Hamlin

INVITATIONS
Chairman: Mr. Frank B. Vaughan, Jr.
Vice-Chairwoman: Ms. Rita C. Thompson

MILITARY REVIEW AND EVENTS
Chairman: Col. Herman I. Little, USAF Ret.
Vice-Chairman: Lt. Gen. John R. McGiffert Commander,
 Fifth US Army, Fort Sam Houston, Texas

SENOR MILITARY COORDINATORS
Gen. Bennie L. Davis
 Commander, Air Training Command,
 Randolph AFB, Texas
Maj. Gen. William P. Acker
 Commander, Air Force Military Training Center
 Lackland AFB, Texas

RECORDS
Chairwoman: Ms. Marie Berry
Vice-Chairman: Alexander Fraser, Esq.

SPANISH MISSIONS
Chairman: Mr. Henry Guerra
Vice-Chairman: Dr. Felix D. Almaraz, Jr.
Rev. Monsgr. Balthasar Janacek

STATE OF TEXAS
Chairman: Honorable Albert Bustamante
Vice-Chairman: Mr. Jack Maguire

250TH ANNIVERSARY BALL
Chairwoman: Mrs. Charles E. Barrera
Vice-Chairwoman: Mrs. Gilbert Carvajal

VILLA DE SAN FERNANDO
Chairman: Mr. Robert M. Benavides
Vice Chairman, San Fernando Cathedral: Rev. Edward Salazar, S.J.
Vice Chairman for Spanish Governor's Palace: Mr. R.P. Negrete

COMMITTEE MEMBERS
Mr. & Mrs. Rudolph Balderrama Ms. Ruth Groty
Mrs. Margaret G. Benavides Lt. Col. Doran Hopkins, USAF
Dr. Gerold Benjamin Mr. Robert Kelso
Maj. Boyd Burkholder, USA Dr. Guillermo F. Margadant
Ms. Gloria Cadena Rev. Bob Markunas, S.C.J.
Dean James N. Castleberry, Jr. Dr. Marian Martinello
Dr. Jean Chittenden Mrs. Pedro Miniel
Mr. Jose Cisneros Mr. Roy Montez
Dr. Rodolfo Cardona Mrs. Charles Myler
Mr. Pearson De Vries, Jr. Prof. Joseph W. McKnight
Ms. Nelda Drury Rev. Blaine O'Neil, O.F.M.
Mrs. John Flores Dr. Felipe Ortega y Gasca
Maria Carolina Flores Ms. Patricia Osborne
Sister Maria Carolina Flores, C.D.P. Dr. Francisco Morales Padrón
Ms. Elizabeth Podesta Ms. Eleanor Savage-Iñiguez
Monsgr. Bernard F. Popp Rev. Brennan Schmeig, O.F.M.
Mr. Thomas H. Robinson Dr. Matthew D. Strand
Rev. Manuel Roman, O.F.M. Ms. Shirt Thomas
Mr. Thomas F. Ryan Prof. Luisa Vila Viler
Ms. Sylvia Ann Santos Mr. Thomas A. Wilson

PATRONS
City of San Antonio City Public Service Board
San Antonio Conservation Society Texas Historical Foundation
Texas Commission for the Humanities Texas Industrial Services

Tobin Foundation Ms. Lucy Armstrong
Mrs. L. E. Bruni Ms. Mary Ann Bruni
Ms. Olivia Bruni Mr. Hobart Key, Jr.
Ms. Frances Walsh Mahla Gimbler Parti

Program Information

Thursday, March 5th
San Jose Mission
Mission Ceremonies
7:00 p.m.

Ceremonies to commemorate the establishment of missions La Purisima Concepcion, San Francisco del la Espada and San Juan Capistrano in San Antonio.
 Procession by parishioners from the mission communities.
 Reenactment of the Acto de Posesion *(Act of Possession) by which Spanish state officials assigned Franciscan missionaries as trustees of the spiritual and temporal welfare of indigenous cultures.*
 Performed by Teatro del Pueblo, Barrio Education Project.

8:30–9:00 p.m.
Reception hosted by the parishioners of Mission San Jose.

Friday, March 6th
Lackland Air Force Base
A Salute to San Antonio's 250 Years
Of Military Tradition
10:00 a.m.
Graduation Parade and Review

Lackland Air Force Base
Basic Military Training School
Col. Richard D. Paul, Commander
Maj. Gen. William P. Acker
Commander. Air Force Military Training Center
Lackland AFB, Texas

SATURDAY, MARCH 7TH
INSTITUTE OF TEXAN CULTURES
HISTORICAL ENCOUNTER
9:00 A.M.–4:30 P.M.

Spanish, Mexican and Texas historians and legal scholars exchange views on how San Antonio's history as a Spanish colony created the unique "ambiente" that San Antonio enjoys today.
 Co-Sponsors: Festival Calderon
 250ᵗʰ Anniversary Committee

IBERIAN BALLROOM OF THE MANSION DEL RIO
250ᵀᴴ ANNIVERSARY BALL

The Ball is given to commemorate the arrival of the founding families from the Canary Islands, the formation of municipal government in San Antonio and the reestablishment of the missions in San Antonio.

7:00 P.M.
Cocktail Reception

8:00 P.M.
Grand March: Mr. Robert M. Benavides, Marshall
Mr. Henry Guerra, Master of Ceremonies
Dinner
Dancing
By invitation of the Order of Granaderos and Damas de Galvez

SUNDAY, MARCH 8TH
SOUTHWEST CRAFT CENTER
CANARY ISLANDS ADVENTURE:
HUMANISTIC ENCOUNTER
12:30–5:30 P.M.

A series of conferences, performances, exhibitions, featuring Canary Island music, literature, handicrafts and dance.
 Co-Sponsors: Festival Calderon
 250ᵗʰ Anniversary Committee

MONDAY, MARCH 9TH
MILITARY PLAZA
VILLA DE SAN FERNANDO ANNIVERSARY CEREMONIES

8:30 A.M.
Entry procession for Commemorative Mass

9:00 A.M.
COMMEMORATIVE MASS
Military Plaza, between San Fernando Cathedral and City Hall.
Main Celebrant: Most Rev. Patrick F. Flores, D.D. Archbishop of San
Antonio
Escorts for Archbishop Flores and concelebrating prelates: Fourth
* Degree Knights of Columbus*
Homilist at Commemorative Mass: Rev. Edward Salazar, S.J.
Honorary Military Guard: Order of Granaderos de Galvez
Ushers for visiting and local prelates: Knights of St. Gregory
Ushers for visiting and local dignitaries: Order of the Alhambra
U.S. Military Honor Guard: Joint Forces Color Guard and the Army
Firing
* Team, Fort Sam Houston*

10:15 A.M.
Exit procession of church prelates and state dignitaries
Procession from the Commemorative Mass area along the South side of
City Hall and into the seating area between the Spanish Governor's Palace
and City Hall.
Ushers: ROTC Chaminade Guard, Central Catholic High School

10:30 A.M.
ENTRADA CEREMONIES
Master of Ceremonies: Mr. Henry Guerra
Introduction
Entrada music: "Conquest" March from [the film *Captain from Castile*]
U.S. Air Force Band of the West, Lt. Roy Breiling conducting.
The 250th Anniversary Roll Call of Honor: *Announcement of the*
names of each Canary Islands family head and his native island.

HEADS OF THE CANARY ISLANDS FAMILIES
and
THEIR NATIVE ISLANDS

JUAN LEAL GORAZ LANZAROTE
JUAN LEAL II LANZAROTE
JOSEPH LEAL LANZAROTE
JUAN CURBELO LANZAROTE
ANTONIO DE LOS SANTOS LANZAROTE
JOSEPH PADRON LA PALMA
MANUEL DE NIZ GRAN CANARIA
VICENTE ALVAREZ TRAVIESO TENERIFFE
SALVADOR RODRIGUEZ TENERIFFE
FRANCISCO DE AROCHA LA PALMA
ANTONIO RODRIGUEZ GRAN CANARIA
JUAN DELGADO LANZAROTE
JOSEPH CABRERA LANZAROTE
BETHENCOURT-GRANADO LANZAROTE
MELEANA-DELGADO LANZAROTE
FELIPE & JOSEPH PEREZ TENERIFFE
IGNACIO & MARTIN LORENZO DE ARMAS GRAN CANARIA

Reading of the Casafuerte Dispatch: Mr. Henry Guerra
The National Anthems of Spain and the United States

11:00 A.M.
SALUTES TO SAN ANTONIO'S 250TH ANNIVERSARY
Eighteen-gun salute by Joint Military Forces Guard and Firing Team.
Ringing of the bells of San Fernando Cathedral.
United States Air Force salute flyover: 12th Flying Training Wing,
Randolph AFB. Col. Wilson C. Cooney, Commander.

Welcome: Honorable Lila B. Cockrell
Remarks by visiting dignitaries
Proclamation: Hon. Albert Bustamante. Judge of Bexar County

All Canary Islands Descendants participating in the Entrada Ceremony
are declared to be Hidalgos of San Antonio de Bexar

Unveiling of Commemorative Marker: Hon. Lila B, Cockrell and Postmaster John J. Saldaña, 250ᵗʰ Anniversary Committee Chairman

"San Antonio": Rosita Fernandez and the U.S. Air Force Band of the West

THIRY AUDITORIUM. OUR LADY OF THE LAKE UNIVERSITY
OPENING NIGHT
INTERNATIONAL HISPANIC DRAMA FESTIVAL
8:00 P.M.

Pequeño Teatro de Madrid performing Pedro Calderon de la Barca's work "La Dama Duende"
 Co-Sponsors: Festival Calderon
 Institute of Intercultural Studies of Our Lady of the Lake University
 San Antonio Missions National Historical Park
 250ᵗʰ Anniversary Committee

PROGRAM INFORMATION ON THE VILLA DE SAN FERNANDO CEREMONIES

THE ENTRADA
As the Entrada music begins, the "garrison" files out of the Spanish Governor's Palace, forms in front of that site, and awaits the arrival of the Canary Islands family descendants. The garrison soldiers and the arriving military escort are portrayed by uniformed members of the Order of Granaderos de Galvez in authentic Spanish uniforms and arms.

Meanwhile, the Canary Islands descendants, grouped behind the founding family banners, re-enact the arrival of their ancestors on March 9, 1731. The procession crosses the San Pedro Creek, marches East on Dolorosa Street, and enters the Plaza de Armas. The ceremonies held today are on the exact site of the Presidio San Antonio de Bejar, where the 56 Canary Islands immigrants reached their destination 250 years ago.

THE 250TH ANNIVERSARY ROLL CALL OF HONOR
As the names of each Canary Islands family head and their native island are called out in the Plaza de Armas, each descendant group marches past

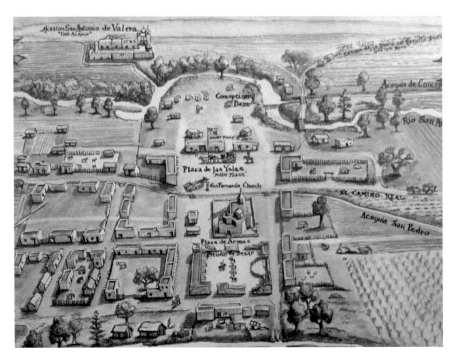

Author's photo from his drawing by Tom Jones, deceased. *Courtesy of Robert Benavides.*

the officials' reviewing stand, the military garrison in front of the Spanish Governor's Palace, and into a special seating area for the descendants being honored today.

THE CASAFUERTE DISPATCH

This key document from the Bexar Archives describes the instructions and law dictated to the Marques de Casafuerte, Viceroy of New Spain, by King Philip V of Spain. The purpose, status, and titles of nobility granted to the founding families of the Villa de San Fernando are detailed.

The second part of the Casafuerte document sets forth instructions to the Governor of the Province of Texas as to the manner of selecting members from the founding families to form the first City Council (Ayuntamiento) with Councilmen (Regidores), a City Manager (Mayordomo), a Chief Constable (Alguacil Mayor), a Secretary and Notary Public. These officials were given the power to elect two Alcaldes to administer Justice and head the Ayuntamiento.

Thus, in this form the government of the Villa de San Fernando, the first civil settlement in the Province of Texas, was established. The offices of

this first municipality were legally and officially recognized by the highest authority in New Spain.

Through successive governments, variations of form, and 250 years of development, the City Council of San Antonio and the Commissioners' Court of Bexar County have continued the tradition of representative government established on this Plaza 250 years ago.

SALUTES

At 11:00 A.M., March 9th, the exact time of arrival, the U.S. Army Firing Team will fire an eighteen gun salute. Simultaneously, all the bells of San Fernando Cathedral will begin ringing for sixteen minutes—a salute to the sixteen founding families.

This is followed by a U.S. Air Force Flyover—another military salute to the City's 250th Anniversary and to its military heritage.

Finally, the bells, horns, and whistles from all other churches, synagogues, offices and factories in the City will sound for two and a half minutes, symbolic of two and a half centuries of civil municipal government in San Antonio.

The text of the 250th Anniversary commemorative marker, unveiled on March 9, 1981, reads:

GROWTH OF A CITY

1731–1981

DURING MARCH 5 THROUGH 9, 1981, THE CITY OF SAN ANTONIO COMMEMORATED THE 250TH ANNIVERSARY OF THE ARRIVAL OF SIXTEEN IMMIGRANT FAMILIES FROM THE CANARY ISLANDS TO THE PRESIDIO OF SAN ANTONIO DE BEJAR AND THE TRANSFER OF THREE FRANCISCAN MISSIONS FROM EAST TEXAS TO LOCAL RIVER FRONT SITES. ON MARCH 5, 1731, SPANISH MILITARY PERSONNEL ASSISTED FRANCISCAN FRIARS IN REESTABLISHING MISSIONS LA PURISIMA CONCEPCION DE ACUNA, SAN JUAN CAPISTRANO, AND SAN FRANCISCO DE LA ESPADA. SHORTLY THEREAFTER, ON MARCH 9, 1731, SOLDIERS AND THEIR FAMILIES AT THE PRESIDIO WELCOMED THE ENTRADA OF 56 CIVILIAN SETTLERS FROM THE CANARY ISLANDS INTO THE PLAZA DE ARMAS. THESE ISLEÑO COLONISTS SUBSEQUENTLY INAUGURATED THE FIRST MUNICIPAL GOVERNMENT IN THE SPANISH PROVINCE OF TEXAS AT THE VILLA DE

San Fernando (San Antonio) August 1, 1731. Altogether, the Presence of Civilian, Military, and Missionary Components in a Frontier Society Contributed Significantly to the Multi-cultural Growth and Development of Modern San Antonio.

Villa de San Fernando 250ᵗʰ Anniversary Ceremonies and Photos

250ᵗʰ Anniversary Commemorative Field Mass

At 9:00 a.m. on Monday, March 9, 1981, the Villa de San Fernando 250ᵗʰ Anniversary Ceremonies began with a commemorative field Mass in the Plaza de Armas (Military Plaza, between San Fernando Cathedral and City Hall). The Mass altar was elevated on the backside walls of San Fernando Cathedral with the main celebrant, the Most Reverend Patrick F. Flores, DD, archbishop of San Antonio.

The escorts for Archbishop Flores and concelebrating prelates were the Fourth Degree Knights of Columbus. The homilist at Commemorative Mass was Reverend Edward Salazar, SJ, a Canary Islands descendant.

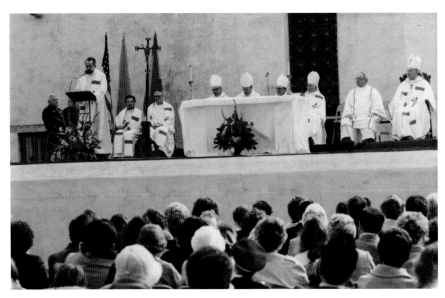

Elevated altar for the CCL Mass. *Courtesy of Robert Benavides.*

CCL Mass audience. *Courtesy of Robert Benavides.*

Archbishop and concelebrants. *Courtesy of Robert Benavides.*

Left: Homily of Father Salazar, SJ, at Mass. *Courtesy of Robert Benavides.*

Below: Knights of Columbus and Granaderos de Galvez. *Courtesy of Robert Benavides.*

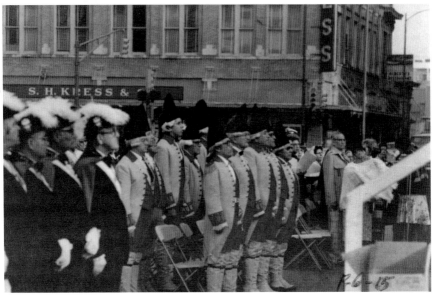

John J. Saldaña reading at the CCL Mass. *Courtesy of Robert Benavides.*

The presentation of gifts to Canary Islands descendants at the CCL Mass. *Courtesy of Robert Benavides.*

The Honorary Military Guard were the Order of Granaderos de Galvez. The ushers for visiting and local prelates were the Knights of St. Gregory. The ushers for visiting and local dignitaries were the Order of the Alhambra. The U.S. Military Honor Guard was the Joint Forces Color Guard and the Army Firing Team, Fort Sam Houston. The gifts for the commemorative were presented by two Canary Islands descendants in period dress.

250th Anniversary Entrada Ceremony

After the commemorative Mass, there was a procession of San Antonio and state dignitaries along the south side of city hall and into the Plaza de Armas seating area between the Spanish Governor's Palace and city hall.

The Villa de San Fernando ushers were the ROTC Chaminade Guard, Central Catholic High School.

At 10:30 a.m. the CCL *Entrada* Ceremony began. Canary Islands descendants assembled on Dolorosa Street under one of their assigned sixteen family banners. At the signal, Canary Islands descendants, Antonio G. Benavides and Robert M. Benavides, dressed in Spanish Granadero military uniforms, officially led off the 250th Anniversary

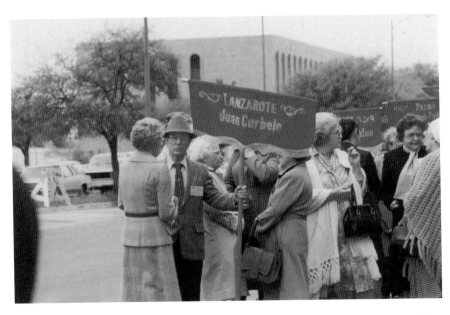

Curbelo and other descendants assemble for the *Entrada* ceremony. *Courtesy of Robert Benavides.*

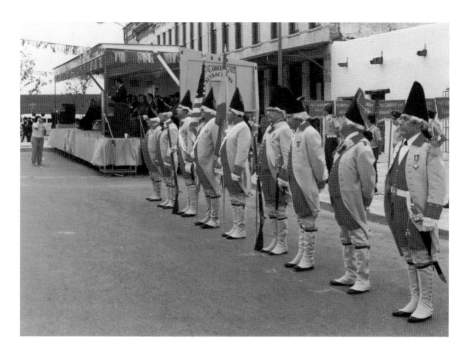

CCL Plaza de Armas, March 9, 1981. *Courtesy of Robert Benavides.*

Antonio Benavides leads in the *Entrada*. *Courtesy of Robert Benavides.*

John Leal leads in the CCL descendants. *Courtesy of Robert Benavides.*

Entrada Ceremony entourage of CCL Canary Islands descendants, with their ancestors' banners.

The *Entrada* music, the "Conquest" march from the film *Captain from Castile*, was played by the U.S. Air Force Band of the West. The CCL Canary Islands descendants' reenactment entourage proceeded east on Dolorosa Street, crossed the San Pedro Creek, turned into the Plaza de Armas and arrived at exactly 11:00 a.m. to begin the 250th Anniversary ceremonies.

On that 250th Anniversary morning, the new CCL red-and-gold banners displayed the sixteen names of family heads and their native Canary Islands as they were announced by Henry Guerra in family order:

JUAN LEAL GORAZ LANZAROTE
JUAN LEAL II LANZAROTE
JOSEPH LEAL LANZAROTE
JUAN CURBELO LANZAROTE
ANTONIO DE LOS SANTOS LANZAROTE
JOSEPH PADRON LA PALMA
MANUEL DE NIZ GRAN CANARIA
VICENTE ALVAREZ TRAVIESO TENERIFE

Left and below: CCL descendants.
Courtesy of Robert Benavides.

CCL descendants. *Courtesy of Robert Benavides.*

Descendants at Plaza de Armas. *Courtesy of Robert Benavides.*

Mayor Cockrell, March 9, 1981. *Courtesy of Robert Benavides.*

Unveiling the CCL anniversary marker. *Courtesy of Robert Benavides.*

SALVADOR RODRIGUEZ TENERIFE
FRANCISCO DE AROCHA LA PALMA
ANTONIO RODRIGUEZ GRAN CANARIA
JUAN DELGADO LANZAROTE
JOSEPH CABRERA LANZAROTE
BETHENCOURT-GRANADO LANZAROTE
MELEANA-DELGADO LANZAROTE
FELIPE AND JOSEPH PEREZ TENERIFE
MARTIN AND IGNACIO LORENZO DE ARMAS GRAN CANARIA

THE CITY'S CCL COMMITTEE LEGACY FOR THE CIDA IN SAN ANTONIO AND IN THE CANARY ISLANDS

The legacy of the 250th Anniversary Committee and the City of San Antonio's formal recognition of the Canary Islands Descendants Association officially began as a result of the community-wide programs and events of all the CCL Committee efforts and events achieved in 1981 and from which the CIDA has benefited ever since.

When the 1981 250th Anniversary Committee events were over, Robert M. Benavides took a copy of the library's genealogy application form that he created for use by Canary Islands descendants to qualify for the CCL March 9 events and joined the Canary Islands Descendants Association. He collaborated with CIDA president Leo Negrete to submit the new membership application form for approval by membership vote. The new membership application was incorporated into the bylaws as the first official CIDA application form became a membership requirement for both the existing members and all new member applicants going forward.

As a result of Benavides's initiative, where there had been no previous requirement of CIDA genealogical proof prior to 1981, the CCL descendant qualifiers, and their families, were subsequently invited to apply for membership in the Canary Islands Descendants Association. Many of them became new genealogically proven descendant members of the original sixteen founding families from the Canary Islands. All subsequent revisions of the CIDA bylaws have included this genealogy requirement for membership. Included in this membership growth were Antonio Gallardo Benavides and Margaret Garcia Benavides, parents of Robert Benavides,

"Yanaguana's Successors: The Story of the Canary Islanders' Immigration into Texas in the Eighteenth Century," 250th Anniversary commemorative edition. This edition features the official coats of arms issued to Bexar County and the City of San Antonio on the cover. *Courtesy of Robert Benavides.*

who also joined the Canary Islands Descendants Association. Both had served in contributory roles in the genealogy and banner projects of the CCL Villa de San Fernando subcommittee. Many other CCL-qualified descendants were invited, joined CIDA and contributed to its growth in the surrounding San Antonio community.

In June 1981, Robert M. Benavides, representing the Granaderos y Damas de Gálvez, was in royal audience with King Juan Carlos of Spain at his palace home outside Madrid. He presented gifts such as a color portfolio of the San Antonio Missions from San Antonio mayor Henry Cisneros and Robert Thonhoff's specially inscribed book for His Majesty, *The Texas Connection with the American Revolution.* The third and final gift for His Majesty was the 250th edition of Benavides's reprinted book of "Yanaguana's Successors." It was presented on behalf of the 250th Anniversary CCL celebration of the City of San Antonio and in recognition of all descendants of the sixteen families Canary Islands whose ancestors achieved in 1731 all the royally decreed goals ordered by His Majesty's own ancestor, King Philip V of Spain.

At the end of 1981, Benavides received permission from his postmaster cousin John "Jesse" Saldaña, the CCL committee chairman, to be the custodian of the sixteen CCL Canary Islanders family banners, poles and banner stands so that they would be made available for use by the Canary Islands Descendants Association to continue the CCL banner tradition at future CIDA commemorative events.

In 1982, Postmaster Saldaña completed his membership application and proudly became a new member of the Canary Islands Descendants Association. The next year, his son, Steven Saldaña, joined his father and cousin in the CIDA.

In October 1982, the Las Palmas de Gran Canaria government sent folkloric music and dance troupe *Roque Nublo*, a Canary Islands culinary chef and three Canary Islands history scholars for a cultural exchange in San Antonio and to participate in the City of San Antonio Parks and Recreation Department's *Semana de la Hispanidad* during the "Canary Islands Cultural Week" from Sunday, October 10, through Friday, October 15, 1982. Mr. Robert M. Benavides was appointed chairman of the mayor's coordinating committee for the Canary Islands Cultural Week.

On October 7, 1982, the *San Antonio Express News* published photos and an article titled, "Canary Islands Cultural Week." The article read as follows:

Lectures, exhibits and entertainment will highlight a multitude of activities as the city celebrates "Canary Islands Cultural Week" Sunday through Friday. The celebration recognizes the influential role of Canary Islanders in San Antonio's history and culture. Activities begin Sunday with a 9:30 a.m. ceremonial Mass at San Fernando Cathedral. A Plaza de las Islas observance begins at 11 a.m. at Main Plaza.

An exhibit, "San Antonio's Canary Islands Heritage," begins Sunday at the University of Texas' Institute of Texan Cultures and continues through Oct. 31. In addition to the exhibit, two performances by the folkloric dance group, Roque Nublo, will be held at 2:30 p.m. on Sunday and Thursday in the institute's dome theater. The group, which is based in San Antonio' sister city of Las Palmas, has performed and competed in numerous festivals.

Activites Sunday will conclude with a lecture in Spanish on the voyages of Columbus by Dr. Antonio Rumeo de Armas at St. Mary's University Treadaway Hall Auditorium at 7 p.m. Rumeo de Armas, a native Canary Islander, holds numerous prizes for his research and publications.

Monday events include a 9 a.m. tour of the Spanish missions by the U.S. Park Service. "Gastronomia Canaria," the opening ceremonies for a week of Canary Islands cuisine and music, will be held from 11:45 a.m. to 2:30 p.m. at Las Canarias Restaurant in La Mansion del Rio Hotel. The gastronomia will be held each day through Friday from 11:30 a.m. to 2:30 p.m. at the same location and will feature 12:30 p.m. performances by Roque Nublo.

RUMEO DE ARMAS
... native Canary Islander

DE BETHENCOURT MASSIEU
... university professor

MORALES PADRON
... Canary Islands scholar

Canary Islands historians, Sister City visit, October 1982. *Courtesy of Robert Benavides.*

Tuesday activities begin with a talk in Spanish, "Emigracion Canaria en America," at 9:15 a.m. in St. Mary's University Treadaway Hail Auditorium. The lecturer, Dr. Antonio de Bethencourt Massieu, is a professor at the National University in Spain and former president of the University of La Laguna.

Other Tuesday activities are a 2:30 p.m. Alamo Plaza tour and an 8 p.m. "Los Canarios y San Antonio"—a historical music review featuring multi-ethnic folk dances and songs at the Theater for the Performing Arts.

There will also be an 11:30 a.m. tribute to Columbus and Spain at Columbus Square followed by a 2:30 p.m. tour of San Antonio Museum of Art. The San Antonio Conservation Society will hold a 6 p.m. reception Tuesday at La Villita. Music and folk dances of the Canary Islands will be presented by Roque Nublo in an 8 p.m. program at Arneson River Theater. The program is sponsored by the Canary Islands Descendants of San Antonio.

Wednesday activities include a 9:30 a.m. tour of the University of Texas at San Antonio.

The tour will be followed by an 11 a.m. talk by Canary Islands scholar Dr. Francisco Morales Padron. He will discuss, in Spanish, "The Canary Islands in American History/The Americas in the Canary Islands" during the lecture to be held in the UTSA Humanities-Business Building, Room 2.01.44. He is director of the Royal Academy of Buenas Letras in Seville. There will also be a 2:30 p.m. tour of Witte Museum and Sunken Gardens and a 7:30 p.m. American-style party at Mama's Hofbrau Backyard.

Thursday activities begin with a tour of the Bexar County Courthouse, a Western Store, San Fernando Cathedral and Spanish Governor's Palace. The day will also include a Texas-style party for the entourage from Las Palmas de Gran Canaria.

On Friday, the final day of the celebration, the events include a 10 a.m. tour of El Mercado and a 7 p.m. lecture in Spanish, "Canarias en America—America en Canarias," in Treadaway Hall Auditorium at St. Mary's University. The lecturer is Dr. Francisco Morales Padrón, professor of history and geography at the University of Seville and a member of the school's trustee board.

Joined by members of the Canary Islands Descendants Association and others on Sunday and Thursday, Robert M. Benavides, chairman of the mayor's coordinating committee for the "Canary Islands Cultural Week," served as emcee for the Institute of Texan Cultures programs.

On Thursday morning, the *Roque Nublo* troupe visited San Antonio College to join in with SAC students, under Director Nelda Drury, in their folkdance classes before returning again after lunch to perform Canary Islands music and dance under the dome at the Institute of Texan Cultures.

A Canary Islands chef provided Canary Islands lunchtime cuisine at *Las Canarias* restaurant in the *La Mansion Del Rio* hotel overlooking the San Antonio River. *Roque Nublo* also performed for the dining customers daily at this meaningful venue.

The Canary Islands Cultural week featured a special program on Tuesday night, October 11, 1982, that was hosted by the City of San Antonio Department of Parks and Recreation and called "*Los Canarios Y San Antonio*" at the Lila Cockrell Theater for the Performing Arts. The Canary Islands folkloric troupe *Roque Nublo* began the series of performances for the evening.

The 1982 poster and program follow:

Los Canarios Y San Antonio

"Islas Canarias"
"Saltonas"
"El Paraguas"
"Mi Canaria Adios"
Performed by the visiting folkdance troupe Roque Nublo *Las Palmas de Gran Canaria*

"Los Canarios y San Antonio" program cover. *Courtesy of Robert Benavides.*

"La La Colette," Parks & Recreation Dancers
 Choreographer-Claudia Rivas
"La Danza de los Negritos," The Ballet Folklorico de San Antonio
 Director-Emma Ramos
"La Vieja," Ballet Artes de Mexico
 Director-Jesus V. Colunga
"Danza Azteca," Parks & Recreation Dancers
 Choreographer-Juan Casados
"El Carrejo," Ballet Folkloric de Navarro
 Director-Pete Ramirez
"Una Danza Nortena," "Huitzilin," Mexican Cultural Institute
 Choreographer-Teresa Vela
"Madre Canaria," sung by Roque Nublo

INTERMISSION
"La Torre del Oro," Parks & Recreation Dancers
 Choreographer-Javier Villegas
"When Irish Eyes Are Smiling," John & Shirley Donahue
"A German Medley," San Antonio College Dancers

Director-Nelda Drury
Accordionist-Chris Stark
"Huapango," Parks & Recreation Dancers
Students of Javier Villegas Choreographer-Juan Casados
"Orange Blossom Special," "Cotton Eyed Joe," DanzAmerica
Caller-Robert Zamora
Director-Vivian Zamora
"Bulerias," La Compania de Arte Espanol
Guitarists-Jose Linares & Alex Herrera III
Choreographer-"La Chiqui"
"San Antonio," Esmeralda Jaime-Vocalist

The City of San Antonio, Department of Parks & Recreation, gratefully acknowledges the cooperation of the performing groups who made this program possible. A special thanks to Mr. Robert M. Benavides, Chairman, of the Mayor's coordinating committee for the Canary Islands Cultural Week.

In November 1982, Eleanor Foreman was elected and succeeded R.P. "Leo" Negrete as CIDA president.

In October 1983, the Canary Islands Descendants Association, in collaboration with San Antonio city councilman Joe Webb, heading the City's Sister City Program, made its first official trip to the Canary Islands. At each tour stop, the *alcaldes* and *ayuntamientos* of *Las Palmas de Gran Canaria, Santa Cruz de Tenerife* and other cities and towns officials welcomed San Antonio councilman Webb and the twenty-one Canary Islands Descendants Association members.

During that week of government-sponsored touring of the two Sister City islands, there was much press coverage and interviews of the descendants of the Isleños who founded today's city of San Antonio and, who after 250 years, were returning to the land of their ancestors. At one of the island stops, the new president of the Canary Islands, Fernando Gimenes, presented male and female Canary Islands folkloric outfits from each of the two islands to the Canary Islands Descendants Association. Surrounded by CIDA members, President Eleanor Foreman received these gifts from President Gimenes on behalf of the organization to be used in San Antonio events.

"El Gorro Azul" (Blue Bonnet) Project

While on the 1983 Sister City tour of San Antonio's two Canary Islands Sister Cities, symbolic gifts were presented by Robert Benavides on behalf of the CIDA to each *alcalde* and Canary Islands government official who welcomed and hosted the Canary Islands Descendants of San Antonio, Texas. The small gifts were envelopes of Texas bluebonnet seeds that were grown in the San Antonio Botanical Gardens. Each seed envelope was attached to a local color photo of beautiful Texas bluebonnets with a poignant message in Spanish on the back:

La Hispanidad—1983
El Gorro Azúl—Simbolo de Amistad

> *This Blue Bonnet is the state flower of Texas. It grows in its most abundance in the areas surrounding the City of San Antonio. In 1731 fifty-six colonists from the Canary Islands arrived in Texas to establish the first civil municipal government called La Villa de San Fernando (today the City of San Antonio). Since that founding the seeds (descendants) of those Canary Islander families have grown until today thousands of Texans are proud of their blood and roots in these islands. This envelope of Texas seeds has arrived in these Canary Islands, just as has our group of descendants, to symbolize our recognition of both our Hispanic and family roots that exist between the people of both our countries.*
>
> *When these blue bonnet seeds are sown into the sandy soil of the Canary Islands (similar soil as in Texas) during October, close to the Hispanic Week, the resulting plants will grow and multiply every year just as have the descendants of the first families of the Canary Islands in Texas!*
>
> *With sufficient water, sun and loving care, the strong roots of this indigenous plant of Texas, sown in the land of these fortunate islands, will represent our Canary Islands roots in both countries. Every Spring, when these blue bonnets (symbols of our friendship) bloom, they will represent the blue water of the sea that connects us.*

The Canary Islands Descendants Association next elected Robert M. Benavides to be president. He served for two terms from 1984 to 1988.

In 1984, the San Antonio City Council passed an ordinance to rename the Plaza de las Islas as Main Plaza. The returning of the original name to that plaza and on the plaza and street signs was achieved mainly through

the efforts of Don Emiterio Padron, a native of the Canary Islands who then lived in San Antonio. For the city's rededication ceremony, working in collaboration with Dr. Alfonso Chiscano, the Canary Islands Descendants planned and participated in the historic event. Following a morning commemorative Mass in San Fernando Cathedral, costumed members of CIDA marched out into the Plaza de Las Islas with the sixteen CCL ancestors' banners for the program.

During the renaming ceremony, with festive music from the Canary Islands playing, eight costumed members of CIDA carried a very large Canary Islands flag horizontally all around the Plaza de Las Islas in recognition of the occasion. In addition, the CIDA extended invitations to all city representatives, program participants and CIDA members to a luncheon in the Hidalgo Room at the Four Seasons Hotel on Saturday, October 13, 1984.

On May 9, 1985, a revised CIDA constitution and bylaws were approved by the membership. On July 8, 1985, a certificate of amendment was issued to the CIDA by the Texas secretary of state.

In 1985, the membership voted its approval of an official CIDA logo featuring the state of Texas with a compass rose centered on San Antonio and the exact scale and latitude of the Canary Islands overlaid inside the Texas outline. This new logo was used for printing the covers of the CIDA constitution, bylaws and membership applications. The new artwork was also used to produce distinctive yellow, blue and white membership pins. These unique pins are still worn by those members who have saved them. This new CIDA Texas logo distinguished San Antonio's founding family descendants from other Canary Islands descendant groups in Louisiana and Florida. New membership rosters, also using this logo, were published for 1985–86 and 1987–88.

In the Texas sesquicentennial year of 1986, the Canary Islands Descendants Association continued to hold annual commemoration dates on March 9 and August 1. The four Canary Islands folkloric costumes received by CIDA in 1983 from Canary Islands president Fernando Gimenes were later

The 1985 CIDA constitution and bylaws cover with logo. *Courtesy of Robert Benavides.*

loaned by CIDA and displayed on mannequins in a Spanish Texans exhibit at the Institute of Texan Cultures.

On September 27, 1987, Their Majesties King Juan Carlos and Queen Sofia of Spain visited San Antonio, 256 years after the founding of the Villa de San Fernando completed his ancestor's royal decree for the sixteen families from the Canary Islands. This royal visit was originally scheduled for San Antonio's 250th Anniversary celebrations on March 9, 1981, but political events in Spain caused a postponement. On this historic occasion, the mayor and city council of San Antonio invited the president and members of the Canary Islands Descendants Association, along with local Spanish citizen-residents and other Spanish heritage organizations, to attend a reception at the Institute of Texan Cultures to honor Their Majesties. King Juan Carlos received several San Antonio gifts. CIDA president Robert M. Benavides presented a special gift on behalf of all 1,731 Canary Islands descendants still living in San Antonio and Texas. The CIDA gift was a framed and mounted drawing of the *Evolution of San Fernando Church to Today's San Fernando Cathedral*, elevated by the clouds of time. This original artwork was autographed by San Antonio artist Ramón Vasquez y Sanchez.

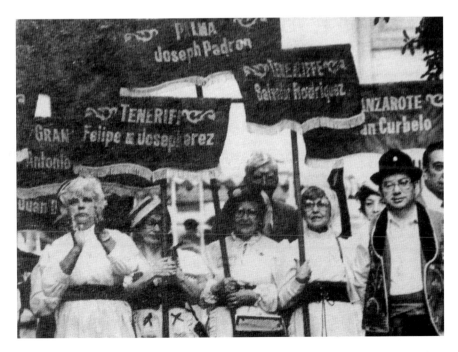

Descendants of Canary Islanders in November 26, 1989. *From* Express News Sunday Magazine.

The CIDA gift of a Vasquez y Sanchez San Fernando print, presented to Spain's King Juan Carlos during the September 1987 San Antonio royal visit. *Courtesy of Robert Benavides.*

Following the CIDA election in May, San Antonio postmaster John "Jesse" Saldaña was installed as president on June 9, 1988.

On June 24, 1988, former CIDA president Roselio "Leo" P. Negrete died. A commemorative Mass was said in San Fernando Cathedral, with attendance by all CIDA members and friends.

A November 26, 1989 *Express News Sunday Magazine* questionnaire featured a reader's question about the Canary Islanders and Thanksgiving. It read as follows:

Q: Did the 56 Canary Islanders, who established San Antonio's municipal government in 1731, ever celebrate something similar to the Plymouth colonists' first Thanksgiving?—D.L., Terrell Hills

A: "You bet they did," says John J. Saldana Sr., president of the Canary Islands Descendants Association. "They arrived [in what is now San Antonio] *about 11 a.m. on March 9, 1731, and the first thing they did was have a Mass. Right after that they got together whatever food they brought with them to celebrate and give thanks after their many weeks of travel," he says. Saldana, who served as San Antonio's postmaster for 12 years, says the descendants still celebrate that day and other milestones in the early colony's existence in the spirit of Thanksgiving.*

A CIDA *Express News* "Metro Section" article on March 10, 1990, read as follows:

1731 SETTLEMENT STIRS DESCENDANTS
By J. MICHAEL PARKER
Express-News *Religion Writer*

Descendants of 16 pioneer Canary Islands families gathered in prayer here Friday night to celebrate the religious faith that sustained their ancestors on the frontier 259 years ago.

About 75 people, including choir members, sang and prayed at a Mass in San Fernando Cathedral for the settlers who arrived March 9, 1731, to found the Villa de San Fernando, the first civilian government in what is now San Antonio. The descendants also will sponsor a champagne brunch at 1:00 p.m. Sunday in the Embassy Suites hotel near the San Antonio International Airport.

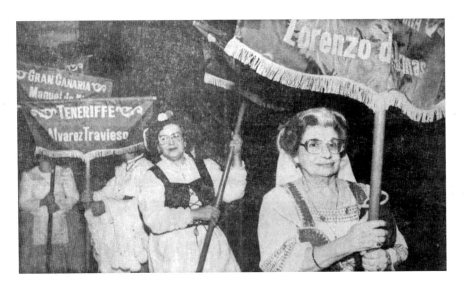

Angela Fernandez (*left*) and Margaret Benavides, descendants of the Canary Islands families who founded the Villa de San Fernando, carry their ancestors' banners in procession. Express News *photo by James S. Peterson.*

Roberta Barber of Sacramento, Calif., showed some of the grit and determination that had sustained her ancestors when she continued her journey to San Antonio despite a motor home fire last week in Tucson, Ariz., that destroyed her possessions. "I lost everything, and I barely escaped with my life. I just flew back to Sacramento and bought new clothes, a camera and a plane ticket to San Antonio," Barber said. "I was anxious to come. I was here last year."

Trini Fitzgerald, a native Canary Islander, said the annual celebration was a surprise when she first came to San Antonio. "I was very excited that a group in San Antonio cared so much for my islands," she said. "The setters who came here were sent by the king. They suffered a lot to come here, and they built something that has lasted centuries."

John Saldana, former San Antonio postmaster and president of the Canary Islands Descendants Association, said the church and the government that the settlers founded endure after 259 years. "The foundation of faith we see within these walls will continue to reinforce us so that our ancestors will never be forgotten," Saldana said.

In 1992, Steven J. Saldaña was elected and succeeded his father, John "Jesse" Saldaña, as president of the Canary Islands Descendants Association.

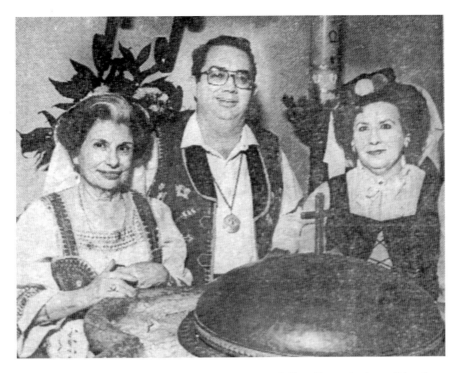

Margaret Benavides (*left*), Robert Benavides and Angela Salinas Fernandez in traditional costume at the Canary Islands Descendants Association reception at San Fernando Cathedral in March 1990. Express News *photo by James S. Peterson*.

CONCLUSION

From the documents and photos available to the author, this historical chronology details the first fifteen years of the Canary Islands Descendants Association and the historical origins of the City of San Antonio's 250th Anniversary Celebration with the community-wide volunteer contributions to the 1981 programs, projects and events. The legacy for the CIDA is that the success of the 1981 CCL Committee's efforts clearly increased the city's official recognition of CIDA and, along with its supporting contributions over the years, has helped to boost both the promotion and public education efforts by CIDA regarding the city's founding history and its heritage from the Canary Islands. Clearly these meaningful 250th Anniversary events have significantly contributed to the subsequent growth and development of the Canary Islands Descendants Association within the San Antonio community. Since 1977, the Canary Islands Descendants Association has

worked diligently to proudly honor the memory of the fifty-six ancestors and all the many thousands of descendants from these sixteen families since 1731 who have made sacrifices and important contributions to the city of San Antonio, to Texas and to the United States.

As stated at the beginning, this detailed chronology was written to help document the early years of the Canary Islands Descendants Association, along with the origins and story of the city's 250th Anniversary Committee (CCL) celebrations and the events that have affected today's CIDA membership requirements, its constitution and bylaws and commemorative traditions. Since 1982, the CIDA's traditional use (as custodians) of the sixteen CCL banners, with the Canary Islands heads of family names and native islands, have been key educational elements at annual commemorative events of the organization. These continuing traditional events, with similar CCL goals and objectives, have been incorporated into all subsequent anniversary events. They also are included in the proposed CIDA event being planned for the 2018 City of San Antonio's Tricentennial Celebration.

SOURCES

AGN Provincias Internas. Folios 121-121v. Arrival at Cuautitlán; concern about the Canarians, who were ill, and about the widow María Cabrera, who was suffering from dropsy. Center for American History, University of Texas–Austin.

Archivo General de Indias (AGI). Guadalajara, Legajo 178. *Nota información par Alice Calderon*, CRM: 0021492, Sevilla, España, pages 1–2. *Expediente sobre la remisión de familias de Canarias a la Provincia de Téjas.* Information e-mailed to Alice Calderon concerning the transport of families from the Canaries to Texas.

———. Guadalajara, Legajo 178. 7-3-2, letter from the viceroy of new travel orders for the Canary Islanders to go overland to San Antonio, Texas. Center for American History, University of Texas–Austin.

———. Indiferente General, Legajo 331. *Navio* (ship) *Santísima Trinidad Nuestra Señora del Rosario y San José* would transport the Isleños from Santa Cruz, Tenerife, to Havana, Cuba. This information was e-mailed to Alice Calderon from the Archives of the Indies, Sevilla, Spain, and included the list of descriptions of the Canary Islanders while in Cuautitlán.

————. 67-4-38, vol. 257 al 376. Apaches stole horses from Isleños camp. Center for American History, University of Texas–Austin.

————. 67-3-11, page 6, and 67-1-37, pages 1–6. Viceroy Casafuerte indirectly accused Aguayo of deceiving the king in letters of June 13, 1722. Center for American History, University of Texas–Austin.

O'Connor, Kathryn Stoner. *Presidio La Bahía, 1721–1846*. Austin, TX: Von Boeckmann-Jones Company, 1966. Judge White buys two acres of land from Manuel Cabrera at La Bahía.

Thompson, Jerry D. *Juan Cortina and the Texas-Mexico Frontier, 1859–1877*. El Paso: Texas Western Press, University of Texas, n.d.

ABOUT THE CONTRIBUTORS

ANTHONY DELGADO is a ninth-generation Tejano who is extremely proud of his familial connections to some of the most notable Hispanic figures in Texas history spanning the seventeenth, eighteenth and nineteenth centuries, including the first families who founded what we now know as San Antonio, Texas.

Anthony celebrates thirty-seven years working for the United States Air Force, for which he served as a human resource management business analyst and information technology project manager. When not at work serving our country, Anthony enjoys serving his community. He is the second vice-president of the membership committee for the Canary Islands Descendants Association; former board member of the Friends of Casa Navarro and former advisory board member and member of the board of directors of the Hispanic Heritage Center of Texas. Anthony is also a member, and former chairman, of the Los Bexareños Genealogical and Historical Society Board of Directors.

His passion for genealogy, with a concentrated focus on Hispanic genealogy, has afforded him opportunities to meet many wonderful individuals—all with a passion to learn and celebrate their family histories. He eagerly and proudly shares with others the fascinating and rich history he has come to learn and love.

ARMANDINA GALAN SIFUENTES is a proud Texan born in 1939 in Eagle Pass, Texas, to Jose Jesus Garcia Galan and Marina Julia Rodriguez. Her family lived in the area with connections to many founding families of Eagle Pass, Texas. She was married in 1958 to Xavier V. Sifuentes, and together they had three daughters. She retired from her nursing career in 2005 after forty years of service. Her interest in genealogy became a passion, leading to membership in the Daughters of the Republic of Texas, Canary Islands Descendants Association and Friends of Casa Navarro, as well as membership in several genealogy groups; she was a former officer at various capacities in many of these organizations. Her contribution to the Los Bexarenos Genealogical and Historical Society has included eight published research books from the church of Our Lady of Refuge. She is a proud sixth-generation Texan through her four DRT ancestors and tenth-generation of the Canary Islands connections. Family history preservation is a strong passion that she desires to pass on to her daughters, grandchildren and five great-grandchildren.

JOANN HERRERA was born in 1948 in Floresville, Texas, the daughter of Joe Torres Garcia and Remedios Garcia Ramirez. Her family has lived in this area of Floresville and San Antonio since the early 1700s. She can trace her lineage back to the 1718 expedition of Martín Alarcon and to four families of the original sixteen Canary Islands founders of San Antonio. One of her great-grandfathers is Juan N. Seguín. Last but not least, she can trace her Native American roots to Manuel Contís, a mission Indian from Espada. She is currently married and has two children and six grandchildren. She has recently become a great-grandmother.

JULIA RAY LOPEZ is a native of Victoria, Texas. After seventeen years of away from Texas, Julia and her husband, Lorenzo, a retired U.S. Navy veteran, now call Austin home. They live near their two children and five grandchildren. Julia is a State

of Texas–certified purchaser and is employed by the University of Texas–Austin. She is a member of Canary Islands Descendants Association; the Daughters of the Republic of Texas, Presidio La Bahía Chapter; Daughters of the American Revolution (DAR), Balcones Chapter; Texas First Families; and Tejano Genealogical Society of Austin. Among her many projects, she is chair for Veterans Programs of her DAR chapter and interviews veterans about their service for the Library of Congress Veterans History Project, a project she feels passionately about.

ALICE CALDERON RIVERA is a ninth-generation Tejano born in Goliad, Texas. She grew up near the historical Presidio Nuestra Señora de Loreto de la Bahía, the principal military post between San Antonio and the Rio Grande in 1749. She recently retired after proudly serving fifteen exciting years as an armed federal security officer for the Federal Bureau of Investigation. Alice also had the distinction of having been the Ladies Texas State Rifle Silhouette Champion, maintaining that title for four consecutive years. She and her husband, Pedro Juan Rivera, live in Katy, Texas. Alice has two sons, Steve and John McDonald, and four grandchildren. She has been a member of the Canary Islands Descendants Association since March 2000, the Daughters of the Republic of Texas since 2009 and Texas First Families since 2000. Today, Alice and Pedro are busy as the directors of Hineni, a Jewish/Christian praise group, founded by Alice in 1983.

HECTOR RAFAEL PACHECO is a tenth-generation Tejano who has lived in San Antonio, Texas, all his life. He graduated with a bachelor's degree in pharmacy from the University of Texas–Austin in 1976. He retired from the practice of pharmacy, having served the public for more than thirty-four years. He is also a retired lieutenant colonel, having served for more than twenty-nine years in both active and reserve United States Army and in two campaigns: Vietnam and Desert

Storm. Mr. Pacheco is a member of the Sons of the Republic of Texas (Alamo Chapter), past associate board member of the Hispanic Heritage Center of Texas and Board of Trustees member of the La Trinidad United Methodist Church in downtown San Antonio. He has also held positions and memberships with the Texas Pharmacy Association, the American Society for Pharmacy Law, the Texas State Board of Pharmacy (Compliance Division) and the National Skeet Shooting Association. He is also a graduate of the Army Command and General Staff College. He last served on active duty in 2006 through 2008, with his last command at Fort Leonard Wood Army Medical Center as the director of pharmacy operations. Mr. Pacheco also served as the pharmacist-in-charge of the express-scripts mail-order operations plant in Albuquerque, New Mexico, in 2009.

ROBERT PACHECO was born on May 20, 1934, and was raised in the community near Mission San Jose. Robert is a graduate of Harlandale High School and received his bachelor's degree in physical education from St. Mary's University on a partial baseball scholarship. While in college, Robert also played baseball for the Spanish American League and was named Most Valuable Player in 1953. Robert began his teaching career at Stonewall Elementary and later taught at Flanders Elementary. He later worked with the San Antonio Youth Organization with students at risk until 1971, when he received his master's degree in educational leadership from Our Lady of the Lake University. He then became the vice-principal at Harlandale High School and principal of Leal Middle School and later returned to be the principal of Harlandale High School, where he would remain until his retirement in 1994. Robert has received many awards and recognitions over the years, including the Luby Prize for Educational Leadership and the Congressional Record of the 103rd Congress, Second Session, honoring his retirement from the Harlandale School System, as well as the John Ogden Leal Family History Award for his lifelong commitment to preserving his family history. Robert is a member of the Sons of the Republic of Texas and the Canary Islanders of San Antonio. He is married to his wife, Mary, of fifty-two years and has three children, Robert, Diana and Susan. Mr. Pacheco continues to share his passion for his ancestry with his five grandchildren, Jacob, Cameron, Marissa, Lourdes and Natalia, as well as his great-grandchild, Penelope.

 ROBERT M. BENAVIDES is an eleventh-generation San Antonio native, married to wife, Sylvia, with a son Robert Jr., and daughter, Rochelle. He retired from the CPS Energy Downtown Electric Network Section of the Engineering Department after thirty-four years of service. Bob has had a lifelong interest in heritage, with contributions to San Antonio's heritage and history dating back decades:

- 1980: Served as editor/publisher of "Yanaguana's Successors: The Story of the Canary Islanders' Emigration to Texas in the 18th Century" for the 250th Anniversary of the Founding of the City of San Antonio, Texas.
- 1981: Served as author and director of the "Arrival of the Canary Islands Families in Plaza de Armas, March 9, 1731" pageant for the City's 250th Anniversary Committee and was chairman of the Villa de San Fernando Committee.
- 1984–88: Served as president, Canary Islands Descendants Association of San Antonio.
- 1986–88: Served as president, William B. Travis, Chapter No. 7, Sons of the Republic of Texas.
- 1988: Researched and authored "This Hallowed Ground: Alamo Plaza," a historical interpretive walking tour. Served as narrator for the San Antonio Living History Association and the William Barret Travis Chapter, SRT, and serves currently for the Alamo Chapter, SRT.
- 1989–93: Served as governor, Order of Granaderos de Gálvez.
- 1990–92: Served as chairman, Historical Markers Committee, Bexar County Historical Commission.
- 1994: Served mayoral appointment to the City of San Antonio's Alamo Plaza Study Committee.
- 1995–present: Serves as author/narrator of "Dawn at the Alamo," Commemorative Ceremonies in Alamo Plaza each March 6 anniversary of the fall of the Alamo.
- 1995: Served as historical and cultural consultant for *Inherit the Alamo* by author/anthropologist Holly Brear (University of Texas Press).

- 2000–2003: Served as historical consultant, translator and researcher for *New Orleans and the Texas Revolution* by author Edward L. Miller.
- 2008–present: Served as chairman of the "Historical Events" Committee for the Alamo Chapter No. 40 of the Sons of the Republic of Texas.

Benavides currently is chairman of the San Antonio Living History Association Board of Directors and is also a member of the History and Education Committee for the City of San Antonio's 300th Anniversary.

Visit us at
www.historypress.net